RON PADGETT

Joe

A MEMOIR OF
JOE BRAINARD

COFFEE HOUSE PRESS

MINNEAPOLIS

COPYRIGHT © 2004 by Ron Padgett
EDITING Christopher Fischbach
COVER DESIGN Linda Koutsky
BOOK DESIGN Allan Kornblum
FRONT COVER PHOTO © Christopher Felver
AUTHOR PHOTO © Jack Mitchell

Coffee House Press books are available to the trade through our primary distributor, Consortium Book Sales & Distribution, cbsd.com or (800) 283-3572. For personal orders, catalogs, or other information, write to info@coffeehousepress.org.

Coffee House Press is a nonprofit literary publishing house. Support from private foundations, corporate giving programs, government programs, and generous individuals helps make the publication of our books possible. We gratefully acknowledge their support in detail in the back of this book.

SECOND PRINTING: 2023

LIBRARY OF CONGRESS CIP DATA
Padgett, Ron, 1942–
Joe : a memoir of Joe Brainard/Ron Padgett.
p. cm.
Includes bibliographical references and index.
ISBN 1-56689-159-0 (alk. paper)
ISBN 1-56689-160-4 (alk. paper)
1. Brainard, Joe, 1942–
2. New York (N.Y.)—Intellectual life—20th century.
3. Padgett, Ron, 1942—Friends and associates.
4. Authors, American—20th century—Biography.
5. Artists—United States—Biography.
I. Title.
PS3552.R275Z84 2004
811'.54—DC22
2004012786

Joe

Table of Contents

PART VI: THE REAL JOE

Table of Illustrations

A Note on the Second Printing

Since the initial publication of *Joe* (2004), new information has come to light, allowing me to correct some dates and to reduce guesswork. My thanks go to the scholars, researchers, collectors, and friends who continue to give us a larger and better sense of who Joe Brainard was.

—*R. P.*

Acknowledgments

My debt to my wife (and Joe's friend) Pat is beyond measure. Much of this book is actually hers, in the form of her recollections, advice, research, and unspoken support. I also owe a great deal to Kenward Elmslie, Joe's lifelong companion. I hope he knows how much. John Brainard, the Executor of the Estate of Joe Brainard, has been endlessly helpful. Bill Berkson, Howard Brainard, Jim Brainard, Royla Zoe Cochran, Ann Lauterbach, Joe LeSueur, Keith McDermott, Mac McGuinnes, Alice Notley, Mark Polizzotti, Tony Towle, and Anne Waldman provided invaluable advice and information. Ed Baynard, Frank Bidart, Keith Binning, Olivier Brossard, Rudy Burckhardt, Bill Corbett, Alex Gildzen, Dick Gallup, Philip Gambone, John Giorno, Kimberly Goff, Morris Golde, Maxine Groffsky, Ira Joel Haber, Duncan Hannah, Nylajo Harvey, Yvonne Jacquette, Kenneth Koch, Joanne Kyger, Felix Landau, David Lehman, Shelley Lustig, Harry Mathews, Patrick Merla, Ken Mikolowski, Teresa Mitchell, John Moore, Elizabeth Murray, Darragh Park, Anne Porter, Stanley Posthorn, Mary Rattray, Max Regan, D. D. Ryan, Ned Rorem, Ed Sanders, Aram Saroyan, David Trinidad, George Tysh, Tom Veitch, Lewis Warsh, and Neil Welliver generously furnished helpful information and, in some instances, copies of Joe's letters and other material. Robert Cornfield's early reading of the manuscript supplied a healthy dose of intelligent criticism and good sense at just the right time.

I very much appreciate the support and friendship of Andrew Arnot and Eric Brown of the Tibor de Nagy Gallery, both of them unswerving in their admiration of Joe's art. Working closely with Constance Lewallen on the Joe Brainard traveling retrospective that she organized at the Berkeley Art Museum was not only an enormous pleasure for me, it became a call to understand Joe's life and work better. I have also benefitted from the insights of others, in addition to Connie, who have written about Joe's art, especially John Ashbery, Bill Berkson, Bill Corbett, Holland Cotter, Brad Gooch, John Gruen, Gerrit Henry, Thomas B. Hess, Nathan Kernan, Carter Ratcliff, Robert Rosenblum, John Russell, Peter Schjeldahl, James Schuyler, and Roberta Smith.

I am indebted to the Research Division of the New York Public Library and to the following university librarians: Lynda Claassen and Bradley Westbrook of the Mandeville Collection at the University of California

at San Diego, for the Joe Brainard Archive, as well as the papers of James Schuyler and Kenward Elmslie; Rutherford Witthus, director of the archives and special collections at the Thomas J. Dodd Research Center, University of Connecticut, Storrs, for the papers of Bill Berkson; Kathryn Beam, curator for the humanities collections, and Kathleen Dow, manuscript librarian, of the Special Collections Library at the University of Michigan, for the papers of Anne Waldman; Jean Ashton, Jane Siegal, and Henry Rowen at the Rare Book and Manuscript Library in Columbia University's Butler Library, for Lita Hornick's Kulchur archive and the journals of Ted Berrigan; and the Fales Library and Special Collections at New York University's Elmer Holmes Bobst Library, for the papers of Lewis Warsh. I am also grateful for access to the papers of Fairfield Porter at the Archives of American Art, and to Darragh Park, Executor of the Estate of James Schuyler, for permission to quote from Schuyler's letters; to Maureen O'Hara, Executor of the Estate of Frank O'Hara, for use of Frank O'Hara's letter; to Alice Notley, Executor of the Estate of Ted Berrigan; and to John Brainard, Executor of the Estate of Joe Brainard, for use of Joe's writings and art. I also thank Bill Berkson, Bill Corbett, and Kenward Elmslie for permission to quote from their material.

For the use of photographs, I thank Sam Allen, Howard Brainard, John Brainard, Kenward Elmslie, Lorenz Gude, D. D. Ryan, Steve Spicehandler (for Susan Cataldo's portrait of Joe), and Bill Yoscary. Many thanks also to Christopher Felver for the cover photo and to Jack Mitchell for use of his photo of me.

—R.P.

Preface

WHEN SOMEONE WE LOVE DIES, most of us do things to keep them from completely vanishing. We summon up memories of them, we talk about them, we visit their graves, we treasure photographs of them, we dream about them, and we cry, and for those brief moments they are in some way with us. But when my friend Joe Brainard died, I knew I was going to have to do something beyond all these.

Joe and I first met at the age of six, and when he passed away forty-six years later it was as if he and I—two Oklahoma boys who had gone to New York together at eighteen in search of art and poetry—had been blood brothers. His death made me want to write about him not only for his sake and mine, but also for the many people who knew Joe or knew something about him and would be happy to learn more about this man who was not only a gifted artist and writer but also a gentle, brave, and generous person unlike anyone I have ever known.

For approximately the last fifteen years of his life, Joe refused virtually every invitation to show or publish his work, quietly holding to his opinion that it was not good enough, much to the frustration of his friends and admirers. After his death we held a series of events that celebrated his life and work and began to make it available to new audiences. These events included the making of a film based on his book *I Remember;* "A Remembrance of Joe Brainard" evening and a group reading from *I Remember* at the Poetry Project in New York; multiple exhibitions at the Tibor de Nagy Gallery; essays on his work in *Art in America* and *ArtForum,* the latter devoting its cover to him;

a major retrospective, organized by the Berkeley Art Museum, that traveled to the Donna Beam Fine Arts Gallery at the University of Nevada in Las Vegas, the Boulder Museum of Contemporary Art, and New York City's P.S. 1, setting attendance records along the way; new editions of *I Remember* and his collaborative book with John Ashbery, *The Vermont Notebook;* special Joe Brainard issues of two magazines, *Pressed Wafer* and *The James White Review;* panels and readings at The Berkeley Art Museum, The New School University, The New York Studio School, and P.S. 1; and the creation of www.joebrainard.org. The popular and critical response to these activities confirmed our belief in Joe's work. "Pure delight," said Holland Cotter (*New York Times*) of the retrospective. Roberta Smith (*New York Times*) wrote, "The P.S. 1 show looks great" and described Joe's work as "an achievement whose pertinence and innovations continue to spread." Peter Schjeldahl (*Village Voice*) summed it up: "Touched by genius."

New exhibitions and publications are in the works. As time goes on and the legend of Joe Brainard grows, inevitably he will be transformed by that legend, and my own memories will drift into soft focus. Before that happens, I have tried here to recreate clearly and honestly the Joe I knew, the person I was lucky to have as my friend.

A NOTE ON THE TEXT: The unidentified quotations in this book are from Joe's letters and postcards to my wife Pat and me. I have quoted from them so abundantly that it seemed repetitious to identify us as the recipients of each and every one of them. Of course I have identified the recipients of other quoted letters.

Because Joe rarely dated his correspondence, I have relied on postmarks, stamps, addresses, internal evidence, and handwriting to establish its chronology, driven by a mania for exactitude that sometimes in my research made me forget that what matters most are not the precise dates of his letters, but what he said in them, and to whom he said it.

FOOTNOTES: In this book I have used asterisks for notes that apply to text on a specific page. I have used numbers for endnotes at the back of the book that refer mainly to citations.

I remember trying to figure out what it's all about. (Life.)

JOE

PART I
Tulsa

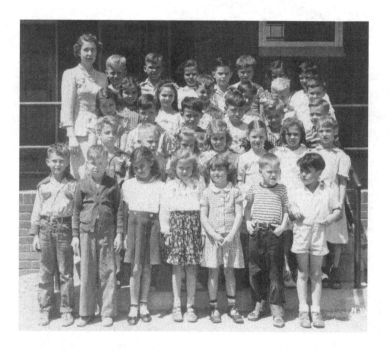

First grade class, Whittier Elementary School. Fourth row, far right: Joe Brainard. Third row, second from right: Ron Padgett. Tulsa, 1948 or 1949.

Way Back

SUDDENLY JOE BRAINARD WAS EVERYWHERE. His art decorated the school bulletin boards; he acted in the school play; between classes, he was chatting in the hall upstairs, and a moment later he was on the ground floor coming out of the main office. With his short dark hair and neat clothes, he looked like a number of our conventional 1950s high school classmates, but there was something more than his range of talents and his ubiquitousness that caught my attention.

Eventually a hunch led me to my old school photos, among them a 5 x 7 of my first grade homeroom class, about twenty-five of us posed on the steps of the portico that gave directly onto the school's playground. There I was, and there was Mary Ann, the blond I had a crush on. Then I saw, one row behind me and just to my left, smiling shyly, the six-year-old Joe. I don't recall ever speaking to him, and at the end of that year I transferred to another school.

Now, a decade later, in the fall of 1958, I had a crush on another classmate named Anne—Anne Kepler, a mysteriously aloof flutist who I thought looked like a Greek goddess. (Don't ask me which one.) In a November 11 letter-poem to her, I sang her praises, and then went on to say:

But your supreme position in the land of IT has to be shared with another: his name: Joe

.

He doesn't know my name

3

but I know his full well
and I think he is the *greatest* person
 in the whole school
you can tell by looking at his eyes
so meek and tender

.

and the way he walks and talks and looks
 and blinks
you can tell that beneath his flesh is the
 nicest person you'd ever want to meet.

.

and it is hard not to be jealous of such a person
so I try to look at him and just think how great
 he really is.

So great that, a month later, I gathered my courage and sent him a Christmas card. Shortly after the holidays, I walked up to him in the hallway and said, "Hi, you don't know me, but I sent you a Christmas card. I'm starting a magazine and I was wondering if you'd like to be the art editor." He waited a few heartbeats, then said, looking away shyly, "Uh uh uh uh O.K."

The time between that conversation and our friendship seems, in retrospect, only an instant. I can't recall getting to know him, other than learning that half of his talent—his acting ability—in fact belonged to his older brother, Jim, whom I had mistaken for Joe. Learning that there were two of them calmed my apprehension that Joe's variety of talents might overwhelm me.

His talent as a visual artist was enough. Joe's parents kept a special scrapbook for newspaper clippings about the many art contests he had won, beginning at an early age. A 1957 article from the *Tulsa World* stated, "Joe Brainard has won so many awards in painting and poster work the last few of his fifteen years that even he loses track of them."

Joe had been given private lessons by his elementary school art teacher, a woman with the wonderful name of Winifred Chick, but lessons do not produce the seemingly innate sense of line and design he had, as if his hand did the work by itself. In the dining room of

the Brainard home an oil painting took pride of place, a work that Joe had done at the age of fourteen or fifteen. In it a small ballerina in a white tutu is gazing out a window. The mawkishness of the subject is offset by the precociousness of this adolescent artist who could handle the difficult medium of oil. The painting, the only one of Joe's twelve entries not to win a ribbon in the state fair competition that year, has hung in his parents' living room for more than fifty years.

The first time I walked into the Brainard home, Joe's mother, Marie, smiled sweetly and said how glad she was to meet me. She was pleasant, attractive, and meticulous—in many ways an ideal 1950s housewife. She always seemed to have just baked a pie. His father, Howard, was usually at work or in the garage doing carpentry or mending something or tending to his collection of arrowheads. Once when he was gone Joe and I poked our heads into the garage, where rows of hard cigarette packs were affixed to the wall above a workbench, each containing a different size or type of nail or screw, neatly labeled—an arrangement reminiscent of Joe's many depictions, years later, of cigarette packs and ashtrays, some lined up in multiple views. I was unsure of Mr. Brainard's opinion of me. He didn't say much, which led me to the paranoid suspicion that he had doubts about Joe's associating with the son of a bootlegger. It's probable that he sympathized with Joe and me: in his youth Howard had wanted to be an artist.

Childhood and Adolescence

IN A 1958 AUTOBIOGRAPHICAL ESSAY entitled "My Story—Joe Brainard," probably written as a school assignment, Joe fictionalized his first home as a little cabin in the hills of Arkansas, but in fact Joe Howard Brainard was born on March 11, 1942, at home, a block from the main square in Salem, Arkansas. Salem, the county seat, had a population of around 500. His father and grandfather had come from Illinois to Arkansas, which during the Great Depression was billed as the "Land of Opportunity." That is, the federal government was giving land to those who were willing to homestead it. But in 1936, after living for three years in a small log cabin, the two men moved into the nearby town of Salem. There Howard met and married a local girl, Alice Marie Burrow. When Joe was born she was twenty-two, Howard twenty-six.

In the fall of 1943, at age one and a half, Joe, his three-year-old brother Jim, and his mother and father moved to Tulsa, where there were plenty of jobs—war jobs. Howard got one on the assembly line of a manufacturer of oil field equipment. The Brainards rented an apartment on the southern edge of downtown Tulsa. In 1947 Joe entered kindergarten and a year later, when the family moved across town to what was called the East Side, he was enrolled in first grade at Whittier Elementary School, in the same class as me, the class in the photograph. The parents of our classmates were blue-collar: pipe fitters, sales clerks, auto mechanics, waitresses, firemen, police officers, telephone operators, welders, carpenters, and even farmers.

6

Maybe the reason I didn't remember Joe from first grade was because he hardly ever spoke. From the time he had started learning to talk he had stuttered, to the degree that sometimes his brother had to interpret even for their parents.

Also at an early age, Joe liked to draw. According to his father, "Joe used to sit in church with his aunt Ruby and embarrass her by drawing girls' legs."

Two other children were born to Howard and Marie: Becky in 1951, John in 1954.

Although Howard had been promoted to a desk job, his salary remained modest for a family of six, and the thirty-five-dollar mortgage payment sometimes proved difficult. Unable to afford a car, the Brainards took the bus downtown every Sunday to the First Methodist Church, near their former residence. The children went to Sunday school and then to church.* The family's occasional treat was going out to dinner afterwards.

The Brainards couldn't afford a car until 1956 or 1957—a '49 Ford. And for quite a while after television came to Tulsa they had to go to a neighbor's house to watch it. Marie took in sewing. The Brainards were the very image of a respectable, hardworking family.

In elementary school Joe's grades, except in art, were average. To maintain these grades he had to focus on reading, writing, and spelling. Teachers must have liked this respectful student who also played the lead roles in the Christmas and sixth grade plays—he didn't stutter when he performed—and was elected president of the Red Cross club. He had a desire for success.

When he entered the seventh grade at Cleveland Junior High School, he encountered a new atmosphere. Puberty made the boys rowdier and cruder. "My junior high years were perhaps my most difficult. I always felt that kids had a warped sense of values and [I] didn't particularly enjoy being around kids my age."[1] I once asked Joe how he had managed to navigate the sometimes rough-and-tumble world of Cleveland Junior High. "The other kids thought of me as 'the artist.' They just left me alone." They wouldn't have scored points by picking a fight with someone so puny.

* At various times Joe was song leader, treasurer, vice president, and citizenship chairman of the church's Methodist Youth Fellowship club.

The Brainard house stood on a corner lot at 159 North Columbia Place, a one-story white frame structure with small front and back yards and a cyclone fence. Like most of the other houses in its working-class neighborhood, it was well-maintained but plain. I felt at home in the Brainard house. Until the age of six I had lived in this same neighborhood, where my father had grown up and where many of his friends still lived. Now it was a five-minute drive from my house to Joe's.

At fifteen, Joe and I were on the tall side, skinny and slouchy. We wore glasses—Joe had gotten his the year before—which in those days suggested that we were cerebral or unathletic or both.

The students in our high school, Central, came from a wide range of neighborhoods, from the well-to-do of Tulsa's South Side to the "hoody" kids of the North Side. Joe and I had our niches. Joe was the school's star artist and the president of the (small) Art Club; I was among the brainiest kids in the school and president of the (even smaller) Literary Guild. However, neither of us qualified for inclusion among the "soc's,"* those students whose family backgrounds, acceptable looks, and nice clothes gained them membership in social clubs.

Being the son of a bootlegger, I scorned membership in this conventional clique. I considered myself an outsider, swept up in poetry, jazz, existentialism, and iconoclasm. Joe—whose first response to the question "What are the three things you think about most?" was "What do people think of me?"—would have been happy to have been accepted by the soc's.[2] In his book *I Remember* he admits to having had a desperate desire to be popular.

In addition to his social class, there was another stumbling block: his stutter. In Tulsa in the late 1950s, a stutter was considered a display of ineptitude. In movies and on TV, the stutterer was jumpy, timid, or stupid, sometimes comic. Despite Joe's stutter, some soc's were friendly with him and admired his talent. His minor "handicap" didn't mean anything to me.

Although I didn't share Joe's social ambition, there were a few of our fellow students that I liked a lot, especially a pal named George Kaiser and a girl I was mad about, Pat Brown, but my "real-life" nonschool buddies were Dick Gallup, who had lived across the street from me

* Pronounced "soashes," short for *socialites.*

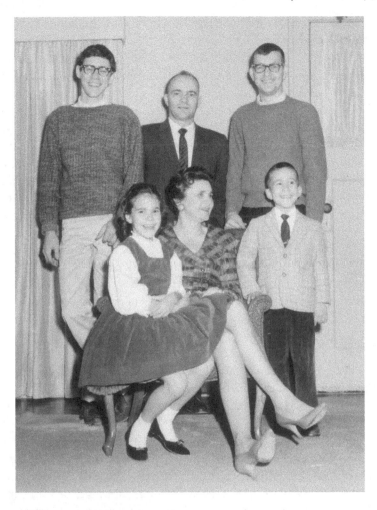

Back row: Joe, Howard, and Jim Brainard. Front row: Becky, Marie, and John Brainard. Tulsa, Christmas, probably 1959.

since grade school and who shared my interests in literature, science, and philosophy, and Joe.

Dick and I started the *White Dove Review*, a little magazine of contemporary poetry and art. I turned the art direction over to Joe, who was assisted by Michael Marsh, a talented schoolmate who played classical piano, painted, and idolized Truman Capote. Joe's cover design for the first issue—which appeared on February 21, 1959, only seven weeks after I met him—was a black-and-white geometric grid inspired by Mondrian. Eventually the *White Dove Review*, whose fifth and final issue appeared about sixteen months later, two weeks after Joe and I graduated, included poetry by Jack Kerouac, Allen Ginsberg, Robert Creeley, Gilbert Sorrentino, LeRoi Jones, and the virtually unpublished Ted Berrigan.

The magazine was the beginning of Joe's future collaborations with poets. However, the many book and magazine cover designs and poetry fliers he did after he moved to New York had even earlier precedents in the poster designs he had done since childhood, as he wrote in high school: "I'm kept busy painting signs, posters, and scenery for different clubs to which I belong. Among them are M.Y.F.,* the Key Club, Scalpers, the Art Club, the International Club, and the Advertising Board," as well as for poster contests sponsored by the Automobile Club of Oklahoma, the Tulsa County Public Health Association, and so on. The local paper described him as a "'veteran' poster artist."[3]

Since childhood Joe had wanted to be a fashion designer. When he was fourteen, a Tulsa newspaper had run an article about him, "Fair First Is Budding Dior," describing how this first artist to enter work—twenty pastels, oil and watercolor paintings, pen and ink sketches, woven goods, and ceramics—that year in the forthcoming Tulsa State Fair had a flair for designing women's clothing. In fact, his mother is quoted as saying:

> A great many of my clothes are from Joe's original sketches. He sketches a dress, helps pick the material and then I get out the pinking shears and sewing machine and go to work. He always looks for the unusual in design and even helps me pick accessories

* M.Y.F. was the Methodist Youth Fellowship, a church organization for secondary school kids; the other five were school groups.

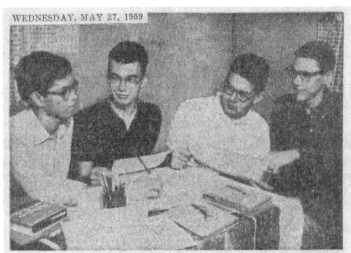

WEDNESDAY, MAY 27, 1959

A MAGAZINE IN THE MAKING—Four Central High School students, led by Ron Padgett (left), 16-year-old junior, discuss the fine points of editing a "little magazine." Their literary venture, the third issue of which will be published in October, is entitled the "White Dove Review." With Ron are (left to right) co-editor Dick Gallup, 17, senior, and co-art editors, Michael Marsh, 18, senior, and. Joe Brainard, 17, junior. (Tribune Staff Photo.)

White Dove Review: Editors Ron, Dick, Michael, and Joe. Tulsa, May 1959. Photo: *Tulsa Tribune.*

which will go well with his design. There's only one area of dis-
agreement between us and that is on shoes. Joe thinks it's terribly
unfashionable when I wear anything other than spiked heels.

The article added that "Joe is probably proudest of the white
evening gown he designed six years ago [at the age of eight!] for his
mother. The gown was of white faille in the 'Grecian goddess' style
and was worn with gold accessories." The accompanying photograph
of the "budding Dior" shows him looking up from his drawing
board, smiling, his hair crew-cut (the "in" style).[4]

It sounds to me that initially Marie and Joe's relationship was as
much mother–daughter as mother–son. At the age of nine, he began
relinquishing the "daughter" role to his newborn sister, Becky, whose
gender was prized by Marie.

Before Becky's birth, perhaps two years before, Joe had his
mother make him, for a costume party, an evening dress, not, I think,
because he was a nascent transvestite, but partly because he loved
gorgeousness and glamour, an impulse nurtured by his mother. In all
three years of high school, he worked part-time as a fashion illustra-
tor. His ink drawings—conventional illustrations that were as good
as those by professional commercial artists—appeared regularly in
local newspaper advertisements for Vandever's, a large department
store, and for Seidenbach's, one of Tulsa's finest clothiers. He was
planning on going to art school and then to college, to specialize
in fashion design and illustration, but meeting us local poets soon
changed his vocational aim.

Shortly after the first issue of the *White Dove Review* appeared,
I met Ted Berrigan, eight years my senior and then a graduate
student in English at the University of Tulsa, locally known as
T.U. Ted, along with another friend of mine named Lauren Owen,
introduced Joe, Dick, and me to other T.U. students—artists,
writers, folk music lovers, and general renegades, what few there
were. Soon we three high school boys were accepted by this older
crowd, most of whom were very serious about their art. The names
that issued from their lips—Pollock, Rimbaud, Goya, Joyce, de
Kooning, Shaw, Picasso, Stevens—were those of heroes who oper-
ated at an artistic level far above that of a Chanel, Givenchy, or
Dior. Thus Joe was quickly shamed out of fashion design. Doing

fashion would be trivial, a waste of his talent. The local newspaper quoted him as saying, "I hate to see a beautiful or talented person fail to take advantage of their gifts."⁵ Joe came to feel that he must push his talent to its limit, in an attempt to be *great*.

And to be great you had to be a realist, unafraid of facing the truth. As I wrote to Dick in February of 1960, a few days before Joe's remark about taking advantage of one's talent:

> My breach with Berrigan was due partly to the fact that he told me exactly what I was and I recoiled at hearing it. I see now that much of what he said is true. Tonight he gave Brainard the same treatment.

I don't recall exactly what Ted said to me or to Joe in these two instances, but I know that it was primarily Ted who preached the gospels of greatness, realism, and truth to Joe, telling him that he owed it to himself to take his talent all the way, and never to compromise. Joe:

> At the time [Ted] was terrific for somebody who was a little weak, in terms of just doing whatever you want to do and fuck what people think. So that was sort of his message, which I'd never learned. I had the instinct for it, but I really didn't have the guts.⁶

Ted's lectures were sincere and powerful, but part of their energy came from a combination of black coffee and Benzedrine or Dexedrine—the dynamo of speed, which he had recently discovered.

One night in the spring of 1960, sitting in a car in a parking lot outside The Rubiot, Tulsa's new, first, and only modern jazz club, Joe did a charcoal drawing of a cup of coffee. So far as I know, it was his first drawing that looked bold, aggressive even. His earlier pieces were finely articulated and delicately sure-handed, some stylized and some more realistic, but none had been done with the attack of this one. That night in the parking lot, Joe had taken a "benny" and found himself caught up in a rush of chemical power that drove his art so hard and fast that it shattered the "niceness" he was prone to and produced a rougher but more energetic result. I don't think that any of us ever forgot that cup of coffee, which became not only a symbol of stimulation but of artistic breakthrough.

A personal breakthrough was called for, as well. Joe's new friends felt that he was too passive, too compliant, too nice. In addition to my reference to Joe (in the letter-poem to Anne Kepler) as "the nicest person you'd ever want to meet," there was an untitled poem I wrote in August of 1960:

Joe's walk

(with all his troubles
and tired legs)

light
and
breezy

like
a nice guy.[7]

I laugh now when I recall the expression "light in the loafers," and I can't remember what Joe's "troubles" were. In any case, for him it was impossible to stand up to anyone or to say no. I admired his sweetness, but not what I sometimes thought of as his spinelessness, which I found quite irritating—a predictable response for a spoiled only child from a headstrong family.* I wanted him to be more like me, more of an outsider, a rebel.

Later Joe was to ascribe his acquiescence to his desire to please, to be accepted and loved, but it was due also to his being what was then called a "sissy." He was the kind of kid who had no athletic interest or ability. If you threw a ball to him, he froze in confusion. If he threw a ball to you, he did it "like a girl." He showed not the least sign of physical aggressiveness, which, in the macho Tulsa of the late 1950s, put him in a distinct minority.

Interestingly, not one of us other guys, who were obsessed with our own masculinity (or lack thereof), ever mentioned the possibility that he might be homosexual. The thought didn't even occur to me.

* Apparently he wasn't so spineless as I am depicting him, for when, in February of 1960, I showed him some paintings I had done, he made it clear that he didn't think much of them. But by then we were on an "honesty" kick.

Back then, kids in general were not sexually precocious, though of course most of us, especially the boys, were hormonally driven and anxious about the Big Moment. Real sex seemed a long way off.

To me Joe often appeared to be sexually oblivious. In the fall of 1959 he and I went to the Tulsa State Fair. As I wrote to Dick:

> I went to the fair with Brainard ... he didn't see one beautiful girl I pointed out to him ... he just stood around wide-eyed eating a candied apple. ...

In our junior year, a girl in his art class, Elaine Warren, took a fancy to him. The two of them went out on dates and to school events together, and although they got along well, they were just friends. In our senior year, Joe had a crush on a classmate named Marilyn Mounts, whom he dated a number of times. Marilyn was quite fond of Joe too. When they finally got to the kissing stage, he found himself at a loss, since, as he told me later, he began to wonder why he was kissing her: this tongue-in-the-mouth business seemed so abstract. He knew it was time to go further, but he felt oddly removed. At the end of our senior year, Joe and Marilyn parted friends and went their separate ways.

If Joe wasn't ready for heterosexuality, he wasn't ready for homosexuality either. One night a local artist named John Kennedy, one of the few true bohemians in Tulsa, had, in a moment of inebriation, made a gentle overture to Joe. John lived with his wife Betty, also an artist, and her four children from a previous marriage, in a funky six-room frame house. Betty resembled a white Eartha Kitt, but with eyes that looked sort of "Chinese." Although only in her thirties, she served as a mother hen for Joe and me, a nurturing soul beneath her sometimes streetwise manner.

The Kennedy household at 644 South Peoria continued to be a home away from home for us, as it was for others with a penchant for the bohemian. People dropped by, day and night, to talk about art and literature and music, to gossip, and to play the guitar or banjo and sing folk songs. When someone gave John and Betty an old printing press, they decided to publish poetry broadsides. They organized summer hootenannies in their front yard and began to

have art exhibitions in a one-room addition to their house. The first one, a four-person show, opened on October 18, 1959, at what they called Gallery 644, with the work of a young woman named Kate Maddy and two Tulsa University star art students, painter Johnny Arthur and ceramist Tom Manhart. The fourth artist was Joe, quite an honor for a seventeen-year-old kid. Johnny, Tom, and Joe silk-screened the 600 invitations for the event.

Another influence on Joe was Betty's first husband, Bob Bartholic. Bob was an artist Joe and I looked up to because of his quiet, even, friendly attitude: he was cool. We appreciated his willingness to spend hours talking with us about art and life. We also thought he was the best artist in town. Bob lived in a cottage behind a large house on a quiet street in a respectable old part of town no one ever seemed to go to. That was cool too.

In the summer of 1959 a small group of guys—maybe two from the university crowd and Joe, Dick, and I—chipped in and rented a garage apartment a few blocks midway between the university and where Dick and I lived. We used it as a "crash pad" that summer. Nothing notorious went on there, but the place did have an aura of bohemian abandon. On one wall Joe, inspired by Edvard Munch, painted a life-size nude figure of a woman with very long hair. The painting was visible from the street below, which we realized when we noticed cars creeping past, drivers gawking. The landlady asked us to paint over it. We didn't.

When Dick went to college in New Orleans in the fall of 1959, Joe became my best friend in town. We didn't have any classes together, but we hung out a lot. Sometimes the two of us went to dinner, often at a small Mexican restaurant called La Fiesta, whose husband-and-wife owners serenaded the customers. Occasionally my mother would go to a movie with us (we were all moved to tears by *The Diary of Anne Frank*). In general we seemed to have all the time in the world. As I reported to Dick:

> First I went over to John [Kennedy]'s to plan a big party for the opening of the White Dove Press. Then went to Crosstown Grill with Joe, came back here [home], watched a Cary Grant movie,

went to Earl's [café], drank coffee and talked for an hour or so. I began reading *Love against Hate* tonight. It seems very good. Also went to Woodward Park with Joe, and I played guitar and sang while he climbed a tree.[8]

Joe's next show came about through Marge Wheeler, a petite blond bombshell, around thirty years old, who hired him to help redecorate her home in Tulsa's affluent South Side. Her husband, Bert, a small, considerably older man with the lined and weary face of a heavy smoker and drinker, was said to be in oil.

It was hard to tell what Marge was up to. She seemed to find excuses to have Joe around, and several times he wondered about her intentions. Some of her outfits were suggestive, but it's possible that we were projecting. Maybe she was just lonely. In any case, she was highly congenial and she was paying Joe for his work, money he would need for art school. On Sunday, August 7, two months after our high school graduation, Marge held an auction of his paintings under the elms on her spacious, sloping lawn, to which she invited her socialite friends and acquaintances. Publicized by a photograph in the *Tulsa World*, the auction was a success, and Marge made sure that her friends realized that they were helping to support a future Picasso.

The signs were promising. In 1960 Joe had exhibited in seven shows and won a raft of awards in Scholastic's annual contest for high school students: first prize in the nation for his fashion designs and first in the state for his entire portfolio, along with ten blue ribbon awards, twelve gold key awards, and two gold plaque awards. He had also won the top national prize in AAA's traffic poster contest.

Near the end of the summer of 1960, Joe's first sexual experience came in the form of Royla Zoe Mullican Cochran, an art student who was part of the painters-poets-rebels group at the University of Tulsa. Royla was a cute gamine with olive skin, short hair, and impish eyes. She could relax around Joe, partly because he was one of the few guys who didn't come on to her. The two of them walked and talked or rode their bicycles around late at night, stopping sometimes at a diner. One night, for reasons that Royla no longer remembers, they

found themselves in her bed, but, as Joe describes—rather vaguely—
in *I Remember*, just as he was beginning to feel the onset of orgasm,
he excused himself and dashed into the bathroom, thinking it a
sudden urge to urinate. The next day, he told me that he had "spent
the night" with Royla, leaving the rest to my imagination. Forty years
later Royla told me that she had "touched" Joe, but that was as far as
it had gone.

Good-bye Tulsa, Hello Dayton

THERE HAS BEEN no passenger train service in Tulsa for many years, but in 1960 Union Depot was still active. Located downtown, it was a white stucco art deco structure that had opened in 1931, perched on a viaduct over the tracks. When I try to visualize the scene of our departure, all I can see is a film noir version of it: inside the almost deserted station is the open window of a newsstand, with dim light sifting down from milky globes high overhead, in the cool air of a late-summer evening. I can hear the clanging and hissing of the steaming locomotive—or am I fictionalizing? Joe and I climbed aboard with our modest suitcases. For our parents it was a pivotal moment in all our lives; for the two of us it was an adventure.

Our first destination was Dayton, Ohio, where Joe was to attend the Dayton Art Institute on a full-tuition scholarship. We took a room at the YMCA, then scanned the Rooms-to-Let listings in the classified ads. Joe rented the first place we looked at, a cheap room with a stove and refrigerator and an old linoleum floor, down-at-the-heels but clean. The landlady had a haggard, Dostoyevskian air. It was perfect for a romantic, impecunious, eighteen-year-old art student.

We then took a bus to nearby Springfield, where I knew a couple named Karl and Jeanne Braun, teachers who had chaperoned a group of high school students (including me) on a trip to Mexico the summer before. In fact, I had visited the Brauns after that trip, so for me this was somewhat familiar territory. Joe had never been east of Saint Louis, where his grandmother lived. For a day or two Joe and I stayed with the Brauns, and then we took what for both of us was a big leap—the Greyhound bus to New York City.

19

PART II

New York

New York

THE RIDE IS NOW A BLUR, but I do recall our first glimpse of Manhattan, just before we curved into the descent to the Lincoln Tunnel. For a moment it sat there in the distance across the glittering Hudson, like an immense smoking intergalactic battleship: New York City.

In addition to the current Port Authority Bus Terminal, there was in those days a smaller terminal, on Fiftieth Street, where our bus stopped and we caught a cab (later we would learn to use the word *taxi*) and told the driver to take us to the Village.

"Where in the Village?"

"Oh, the middle."

The bemused driver let us off at the corner of Sixth Avenue and Eighth Street. We looked around: a Whelan's drugstore, a Howard Johnsons restaurant . . . what is so picturesque about *this?* We had imagined thatched roofs! Our destination turned out to be only a few blocks away, at 91 Christopher Street, where a Tulsa artist named Paul England had a studio apartment. Paul lived in New York most of the year, teaching art and occasionally showing at small galleries, but he spent every summer with his mother in Tulsa. We had published his work in the *White Dove Review.* A few months back he had told us we could "crash" at his place—almost literally, as it turned out, since Joe and I were to sleep on the floor.

Paul was a tall, rangy fellow with gray hair and the face of an eagle. He spoke slowly and looked at you slowly. One of the first

things the three of us did was to descend into the Christopher Street subway stop, where Paul explained the subway map, noting that Manhattan was shaped like a penis, a remark that struck me as odd.

While I spent much of the next week looking up poets I had published in the *White Dove Review* and visiting the Columbia campus, Joe and Paul went to museums and galleries. Joe's postcard to a friend[9] in Tulsa had Henri Rousseau's painting *The Dream* on one side; in the message, Joe described New York as "great" and the Museum of Modern Art as "unbelievable." He also reported on seeing the 1931 film version of *The Three-Penny Opera*, *Psycho* ("no good"), *A Thurber Carnival* ("starring Thurber himself; literate nonsense/good"), Jack Gelber's play *The Connection* ("great, kinda"), and *The World of Sandburg* ("starring Bette Davis, enjoyable"). I saw the two movies and Gelber's play with him and Paul.

Then school beckoned to both of us, and on September 17 Joe took the bus back to Dayton and I moved into my dormitory room at Columbia. By Thanksgiving, Joe was back for a visit, sharing my room in the absence of my roommate. Dayton had been O.K., but it was nothing compared to New York, and one incident had made Joe question his choice of schools. The Art Institute faculty and students had shown their recent work in an annual outdoor exhibition, and, as it turned out, Joe's recent work consisted of depictions of his own body, seen through his eyes as he lay propped up in bed working, sometimes naked. These nudes were an early sign of Joe's growing desire for self-disclosure, a desire that would lead to his various published diaries and his autobiographical work, *I Remember*. Officials at the Art Institute, fearing community disapproval of male frontal nudity, gently asked him to remove these works from the show, which he did, without so much as a frown or a sigh.

But the incident confirmed his feeling about Dayton, and he decided to drop out. "I felt bad about quitting because I had a scholarship," Joe said later. "And also they were all very nice. I didn't want to hurt their feelings."[10] Around Christmas he notified school officials that his father (who was in perfect health) was dying of cancer, and that he would have to quit school and return to Tulsa. He immediately took the bus to New York.

On the Bowery

IN A 1977 INTERVIEW with poet Tim Dlugos, Joe listed his first New York residence as an apartment on Second Avenue at Sixth Street. I don't remember such a place, but I do remember the next one he rented, a storefront at 210 East Sixth Street, near Bowery.* It consisted of a small room and, behind it, an even smaller one with a gas range and a battered refrigerator. Off that room was a tiny bathroom. The place also came with street noise, wobbly furniture, decades of grime, and a horde of cockroaches, but the rent was around forty dollars a month. Joe hung a sheet over the plate glass window in the front room, which served as his studio. He slept on a small bed in the back room.

Joe didn't know how to cook, so when he wanted a hot meal he walked a few doors west to Tony and Lil's, a small coffee shop. The affable Tony and Lil took a shine to their new regular. Whenever it was clear that this young artist was short of money—why else order only French fries and water for dinner?—they told him to pay them later. At one point they had him paint some signs and wall menus, which settled his debt. In the middle of the largest city in America, Tony and Lil gave their neighborhood a small-town feeling.

Soon after Joe moved in, Ted Berrigan arrived from Tulsa, in January of 1961. He had been working on his Master's degree and teaching at a Catholic junior high school, where he had fallen in love with one of his students, a fourteen-year-old girl named Christine Murphy (the Chris of his book *The Sonnets*). Noticing his excessive

* Maybe these two apartments are one and the same.

Joe, East Sixth Street, New York City, March 1961.
Photo: Ted Berrigan.

Ted Berrigan, East Sixth Street, New York City,
March 1961. Photo: Joe.

attentions, her parents complained to the school's authorities, who gave him the opportunity to resign quietly at the end of the semester. In the long run it hardly mattered, because Ted knew that his infatuation would go nowhere and that it was time for him to get out of Tulsa, where he was suffocating. He was eager for a larger life and a larger poetry. New York sounded right, partly because Joe and I were there.

Ted spent weekends with me in my dorm room, when my roommate went home, and the rest of the week at Joe's. Ted and Joe followed the arrangement of Picasso and Max Jacob, who had shared a small studio in the Bateau Lavoir building in Montmartre before World War I. The bed there was large enough for only one person, so Picasso painted all day while Jacob slept, and Jacob wrote poetry at night while Picasso slept.

One afternoon Joe and Ted took a few snapshots of each other outside the East Sixth Street storefront. Joe was wearing a crewneck sweater and a white shirt, items from high school days. Ted's plaid flannel shirt and khakis reflected both his bohemian stance and his lack of money. Both Joe and Ted managed to find a romance in their poverty, because it was all for Art. The worst thing one could do was to "sell out," to lead a conventional, bourgeois existence. Besides, Joe had anticipated the artist's life. A spring 1960 article in the *Tulsa World* had quoted him as saying, rather glibly, "Artists have very little security. That makes them a little more independent than the average person."[11]

Financially, Joe's life in New York turned out to be more than insecure and independent. It was risky. Neither Joe nor Ted had a real job. At first Ted lived off the money he had brought from Tulsa, but later that spring when it ran out he shoplifted books, read them gently, and resold them. From time to time, he and Joe sold their blood (five dollars a pint), and when they were desperate they shoplifted from supermarkets.

At some point Joe began working evenings part-time at a neighborhood bric-a-brac shop owned by a Mrs. Sola. She also had him clean her apartment a few times, a job that was unnerving because, according to Joe, her eleven-year-old daughter seemed to have a penchant for walking around naked. But at the store he was alone

among the kinds of fascinating old objects that in a few years he would incorporate into his assemblages: crucifixes, costume jewelry, American flags, dolls, tintypes, antlers, etc. Paying him next to nothing, Mrs. Sola told him to take certain objects as compensation. Some of these he gave to friends and family.

Joe sent my parents a valentine in February of 1961, shortly after his move to New York. The front of the card showed a hot-pink heart shape, with the words "I'm not sending YOU a funny valentine!" Inside, it continued, "I think the fact that I'm sending you a valentine at all is funny enough." That Joe thought to send *my* parents a valentine (I didn't send one to his parents) shows how considerate he was, and that he found just the right card—one that showed affection but also a humor that kept it from being soppy—shows how discerning he was. My mother, who was always extremely fond of Joe, saved this valentine for the rest of her life.

In April of 1961, Joe returned to Tulsa for a visit and a small exhibition of his recent work. While there, he accepted an invitation from local artist Nylajo Harvey and her husband Bob to join them on a quick trip to Mexico. Joe sent a postcard (probably from Guanajuato) to my parents that read:

> Mexicans love their children, church, and flowers. Great people. Doing my *best* work here. Love it and life in general. Running out of money, leaving May 1. See you soon.

In Mexico he did a series of simple ink drawings of little girls in midair, pigtails flying, arms and legs flung out, circular heads with two dots for eyes and a big smile of joy. The style was faux naïf but as sophisticated as Klee, whose work they seemed to echo. A short article in the May 28, 1961, *Tulsa World* said that Joe's one-man show of paintings, drawings, and ceramics done in Dayton, New York City, and Mexico would be on view at Studio Arts and Frames, through June 9. Joe probably returned to New York a day or so after the show closed. My freshman year at Columbia had come to an end on June 1, so I saw him only briefly in Tulsa.

Near the end of May, Ted moved to his own place, a basement room at 5 Willet Street, below Delancey on the Lower East Side.[12]

By mid-June, our friend Dick, on summer vacation from Tulane, came to stay at 5 Willet. The two shared a kitchen with the building's super, a shriveled little fellow named Willy who complained whenever his box of Kellogg's Corn Flakes was suddenly lighter.

On June 16, Ted was joined by his girlfriend from T.U., Pat Mitchell, who had dropped out of graduate school after deciding that she didn't want to write a Master's thesis on Milton criticism after all. Her relationship with Ted had been on and off for several years, and she wasn't sure what she wanted to do. Pat had taken a forty-hour bus trip from Tulsa, arriving in New York with a suitcase, some traveler's checks, and a return ticket. When finally even the money from the pawned suitcase was gone, she, Ted, and Dick would play cribbage to see who would steal the food for dinner that night. Pat was so alarmed by the prospect that she never lost a game. One time in a supermarket Joe, whom she considered "dependable," had spontaneously dropped a steak into her open purse. Once outside the store, she exploded, berating him for acting like Ted. Mortified by his misjudgment, Joe apologized.

When Joe returned from Tulsa to New York, Pat spent more and more time with him, sitting for portraits, exploring Mrs. Sola's rat-infested storeroom of curios, and going to galleries and museums. Concerned by what she saw as Ted's excessive use of speed, Pat told Joe that Ted wasn't a "person" anymore.

Around this time, Royla arrived for a visit, staying with Joe and sharing (chastely) his twin bed. One evening, walking back from Ted's with him, she kept urging him to break free of what she saw as Ted's bad influence. Joe stopped and said, "I don't think we should see each other anymore," and strode away. This was a new kind of behavior for him, one that had more to do with his determination to take control of his life than it did with Royla.

That summer, Joe moved down East Sixth Street and around the corner to an unfurnished apartment at 93 First Avenue. A fifth-floor walk-up, it had two rooms and a toilet (the bathtub and kitchen fixtures were in the large room in front). The apartment was dingy and threadbare, but it had plenty of morning light and an interesting view of block after block of ghostly tenements across the street,

abandoned and awaiting demolition. The kicker was the rent: twenty-three dollars a month. Joe never had the electric service turned on, though the power company inadvertently left the gas hooked up. As on Sixth Street, he worked in the front room and slept in the back room, which was barely big enough for a bed and a wardrobe.

On Willet Street, things were not going well between Ted and Pat. The quarters were cramped, physically and psychologically, so she moved to Joe's vacant storefront place, which had a week or so left on its lease.

She felt that Ted was having a pernicious influence on Joe. Her protectiveness had been evident since our high school days. At a party one night during our senior year, he and I had gotten so unexpectedly drunk that Pat felt it was her duty to drive us home, forcing herself to overcome her fear of driving the old stick-shift Plymouth I had borrowed from my grandfather.

In Tulsa, Joe and I had seen her in group situations, but we never sought her out privately. At that time Pat was Ted's girlfriend, more or less, and she was, after all, more mature than us.

Undressing

BACK IN NEW YORK for the fall semester of my sophomore year, I rented a basement apartment with Ted and Pat at 81 Horatio Street in Greenwich Village. Ted had finished writing his Master's thesis, was reading and writing poetry, and began auditing a course in Ancient Greek at Columbia. Pat got a clerical job at *Progressive Grocer* magazine. At night she typed Ted's thesis.

One night that fall Joe came over to Horatio Street in an expansive mood, atypically drunk. The next thing we knew, he had gotten into the bathtub and covered his hands, arms, and face with emerald green food coloring, "just to see what I would look like." It was one of a number of things he would do to put himself in an extreme state, to jolt himself out of his niceness.

For the Christmas holidays, Ted and Dick (who had returned from New Orleans to New York) went to Providence to visit Ted's family, while Pat and I separately went to Tulsa to see our respective families. We must have given Joe the keys to our apartment, for it was there that he wrote "Self-Portrait on Christmas Night." Alone and high from two amphetamine pills that made him jittery, Joe poured out his soul, knowing full well that Ted would read the piece later. It began with Joe, in an almost frantic state of exalted despondency, listening to music so beautiful that it made him cry:

> At times like this I really know, though I rarely admit it to myself, I and the world are great and fucked. I'll never be happy or satisfied, I'll always be like this, so fucked. Yet so excited by everything. I'll

always know, yet will never really know. Will do great paintings, but will never do what I want. . . I'm damned, but can't change . . . Though I know beauty, I can't express it until I've undressed. Have so much undressing to do.

He talked about taking pills:

I know why Ted takes so many pills, and I know if I always had them I would too. But I nevertheless think they are basically evil; the effect they have on us is not "the way things are" but "the way we'd like them to be." It would be so easy if I always took them, and don't know why I don't *want* an escape. . . .

Then came a list of men he considered great—Rembrandt, Giotto, Michelangelo, himself, Ray Charles, Elvis Presley, Van Gogh, Stravinsky, Jesus, Dylan Thomas, de Kooning, and "perhaps" Franz Kline—followed by some examples of their negative qualities. Particularly interesting is Joe's criticism of Michelangelo: he was a homosexual.

Then he discussed how certain people back in Tulsa did not understand him because they took him at face value and did not bother to look deeper:

But I must take most of the blame; I was stupid, I was shallow, and for them I wore a "Don't touch" sign. . . . How sad that is, a whole organic complex interesting exciting and rewarding person [himself] out of reach.

Joe devoted a long passage to money and how unreal it is that a small piece of paper with a man's face on it can be exchanged for food and rent and art supplies, and how for others it takes on an unreal symbolic dimension. He wants the real, such as

painting an arrangement of modern Americanized bottled, wrapped, or boxed items especially prepared for our sterile and functional sense of the sanitary proper: 7-Up bottle, Pioneer instant coffee, and a Tareyton dual cigarette. Such items I often use in my paintings, because they are present, they are the ways of my country. . . .

His use of such iconography then and later was quite different than that of most of the Pop artists, whose attitude toward the same images tended to be cool, distant, critical, or ironic. Joe described himself as a realist, simply painting what was in front of him, but his depictions of Pop images suggest that not only did he love seeing, he was in love with what he saw.

In the diary, he characterized Tulsa as "where my family still lives and where nobody really knows me but where everyone thinks they have my spirit in a bottle and a mathematical equation explaining my art and life." There is no way his family can understand him, because

> they have a sturdy reason for being. My display of desire to not work [at a regular job] but only paint, to see the world, to be big for myself, to do everything, to love and be loved freely, to know beyond the practical and "safe," to paint honestly and therefore to them uglyly, to spend what little money I have foolishly, and to not prepare for the future, is to them a phase. A phase, just a phase; like when I used to wet my pants, when I liked school, and when I didn't like school, when I was in junior high, underdeveloped, awkward, and self-conscious, when I wanted to be a cowboy, a period when I liked math, when I wanted to be a fashion designer and illustrator, when I like all other developing boys felt attracted toward my own sex and thought myself evil and deranged, when I started smoking to feel big and secure, and when I began "seriously" painting because the romance of it all was overwhelming, it was too good, approval and praise at my fingertips. Time for childhood phases to end? I hope not.

Joe concluded the piece: "I'm 19 years old turning 20 on the 11th of March. And I, just like George Washington, am only a 'thing' to the world, but a god to myself."

Were Joe to read "Self-Portrait on Christmas Night" today, I think he would feel compassion for the tortured, awkward, sincere, romantic, melodramatic young man in it. But would he understand how, at the time, he seemed to have thought of his attraction for his own sex to be a passing phase? Was it partly because his close male friends were straight, all of us struggling to see ourselves as "real men"?

Whatever the answers to these questions, they should not distract us from the larger theme of this diary: the desire to grow and to be accepted for whoever you turn out to be. I don't think Joe was aware of this issue until he met Ted and me, who were already obsessed with such ideas. At the end of our senior year in high school, Joe had written in my copy of *Tom Tom*, the school yearbook (whose cover, incidentally, he designed):

> I've just read what you wrote in my *Tom Tom*. I know you want no thanks for making me happy, but it made me feel very wonderful anyway. Lately I've been wondering about our relationship. Thank God you've cleared a lot of things up. I would be stupid if I told you how great you are, etc. Because I've told you all this before. Ron, I think we have one big problem concerning our friendship, we can't accept changes made in each other's character. Ron, I do a lot of things now that I wouldn't have dreamed of doing when I first met you. And in relationship to my older self they seem "put on." You know, big show, follow the group, etc. They aren't. Ron, I don't go to flute concerts to show you up or run in the rain or go to cafes alone just to be dramatic. Nor do I accept habits, traits, ideas, etc. from other people (mainly you, you boob) without pondering their value. Ron, believe me, I'm sincere about all these things I do. (This whole thing is really a "turnaround." You know, me writing about myself in your book instead of about you. And I'm sorry. There really is a lot to be said about you. Most of which can't be said in a yearbook.) Not only have you made my senior year better, but you, along with a few other persons, have been my senior year. I guess a "thank you" from Joe Brainard has lost all meaning. For this I'm sorry, because what else can I say: you've been great. Thank you.[13]

A lot of the later Joe is already there: his sweetness, his consideration for other people and their feelings, his focus on defining himself, and, what was new for him, his willingness to be frank to his close friends when it was called for. At the very center of the inscription is the notion of our being restricted by the static image that people have of us. From a literary point of view, there is also his tendency, in the middle of a piece, to step back and comment on it.

93 First Avenue

JOE HAD MOVED to the First Avenue apartment, but we other Dust Bowl refugees (as we Okies called ourselves, after a Woody Guthrie song) had also been shifting around—rapidly.

In early February of 1962, Ted, who was having a secret affair, had driven to New Orleans with Columbia undergraduate and novelist Tom Veitch, to visit Dick at Tulane. There Ted met and within a week or so married a Sophie Newcomb sophomore named Sandra Alper, who had dated Dick a few times. When I moved out of the Horatio Street apartment and up to Veitch's vacant apartment on West 102nd Street, Anne Kepler, the flutist who had been my high school classmate, moved in with Pat on Horatio.

It was with Anne that Ted had been having the affair. To cover his tracks, Ted had told Pat that he was spending time at Joe's, and he had coerced Joe into corroborating this phony alibi, if necessary. Joe so resented Ted's pressuring him into agreeing to lie to a close friend that he painted big black letters across a wall in his apartment: "I HATE TED BERRIGAN."

Meanwhile I had taken up with Pat. Then Veitch suddenly reappeared, so I moved in with Joe on First Avenue. Around the same time, Ted's in-laws, in Florida, forced Sandy into a mental institution near them and had the sheriff run Ted out of town.

All this within a few months. We were like the cast of a melodrama that called for a major event in each episode.

But beyond the allegiances and betrayals, the comings and goings,

the jockeying for position, we depended on each other because we were a novice band apart that needed mutual support in what for us was a possibly overwhelming situation: New York City. For me the need was less, since I had come to New York for the express purpose of attending college, as had Anne. Joe's and Ted's roles—artist and poet—were more precarious, though perhaps not so precarious as Pat's. She was trying to keep us boys from self-destructing while also making major decisions about her own life.

Living with Joe on First Avenue, I spent much of the day uptown at Columbia, while he painted. At night, with no electricity, we lit candles or went out. Money was scarce. Occasionally he received a modest check from a woman he had met in Dayton, to whom he sent drawings and other small works in return, but it wasn't enough for him to live on. My weekly allowance of twenty-five dollars rarely lasted the week, since I spent too much of it on books and movies. I recall shopping at the corner grocery store, returning with cans of Chef Boyardee spaghetti and heating them on the stove. Joe did not cook at all. When I wasn't there his typical dinner consisted of a handful of candy bars.

Late one afternoon Joe and I took an unusual step (for us) and went to a neighborhood bar across the street. We had twenty-five cents between us, five cents more than enough for two small draft beers. With the beer came a bowl of pretzels. We drank slowly. The place was sleepy. After a while the bartender appeared with two more beers, explaining that they were compliments of the gentleman in the tuxedo at the end of the counter. We nodded our thanks to him and went back to munching. A few moments later the man slid onto the stool next to us and struck up a conversation. Oh, we were an artist and a poet? That was wonderful. On and on he talked. Despite his genteel old-world manners, we began to feel wary. When he learned that we were flat broke and hungry, his eyes lit up. He had a great idea. Why didn't we come back to his place? He would cook us a large dinner and then we could be "comfortable." A bell finally went off in our heads, and we assured him that we weren't *really* hungry, these pretzels were *very* filling. He looked woeful, but reached into his pocket and extended a

five-dollar bill. "Go ahead, take it. You can have dinner on me." After accepting his money and edging out the door, we breathed a sigh of relief and headed for Tad's Steak House on Fourteenth Street, where we had the steak, salad, potato, and garlic bread special for $1.19 each.

By this point Joe's work was showing the influence of Jasper Johns, at least in subject matter, such as variations on the American flag. In one work, when Joe simply glued an old flag to a piece of white masonite, the flag took on a surprising presence. In another he painted and collaged a billowing flag that seemed to be flying apart. In May of 1962 he did several small and beautiful flag works with Ted, who supplied the words. These collaborations were neater and more restrained than some of the other collaborations they did.

Ted wasn't interested in making art that was neat and tidy. In other collaborations with Joe, his loopy, idiosyncratic handwriting and amateur drawing style, coupled with his rowdy sense of humor and Rabelaisian attack on the work, not only forced Joe to roll with the punches but showed him that it was possible to capitalize on one's mistakes. Thus Joe learned how to make a mess and then rescue it, a technique he later used in many of his individual works and in collaborative comics, such as *Red Rydler* (based on the comic book *Red Ryder*) with Frank O'Hara, in which he misdrew a dog's face and, instead of redoing it, simply made a scrabble of lines over it. Sometimes he even added arrows pointing to the messed-up spots.

It was during this same spring, I believe, that Joe did some large gouaches of chubby women in bright dresses, painted in delicious muted colors flowed onto paper with a loaded one- or two-inch brush. The influence was de Kooning, but the feeling was joyous and the sense of design was all Joe.

One evening Anne Kepler came by the First Avenue apartment with a friend of hers, an attractive young woman visiting from out of town, and since the weather was lovely, someone suggested that we go up on the roof to look at the lights of the city and the starry sky. Joe brought two blankets. I sat down on one with Anne. In the interval since high school, I had come to accept the fact that she would never reciprocate

my feelings. This, along with my attachment to Pat, enabled me to lie next to her on the roof and not get any "ideas" (and to feel quite grown-up about it all). Joe and the other girl were on another part of the roof. It was awfully quiet over there. Finally they reappeared and we all went back downstairs. After Anne and her friend left, Joe told me that the girl had suddenly started kissing him.

"Did anything happen?" I asked.

"Well, I got a hard-on, but that was as far as it went."

He had told her he had a headache!

Joe and I decided to make a radical change in our appearance by bleaching our hair blond. At a nearby pharmacy we bought a bottle of peroxide, took it back to his apartment, poured it on our hair, and waited. Every few minutes we checked, but our hair remained the same old brown. We added more peroxide and waited. Finally we gave up. A few years later I realized that we had bought not hair bleach but hydrogen peroxide, the antiseptic.

While I was staying at Joe's my lung collapsed, spontaneously, and after ten days in the hospital I rented a room in a building with an elevator, near Columbia. Pat took a room in the same building.

When my sophomore year concluded, at the end of May, my father and a cousin arrived, ready to drive me back to Tulsa. Joe and Pat joined us. Joe wrote a hilarious, manic account of the trip, called "Back in Tulsa Again." Here is an excerpt:

> Back in Tulsa again, by way of free ride from Ron's father: Ron being a Columbia University student, also poet, and Ron's father being a John Wayne with $80 cowboy boots. I wear desert boots. Pat usually wears very basic black flats, tho she looks better in high heels. They complement her legs. Very nice. Yes, Pat too made the big move back to Tulsa. The three stooges make the big move back to Tulsa. The three fuckado's make the big move back to Tulsa. The big move back to Tulsa was made by Pat, Ron, and myself.
>
> The trip back was as normal as possible considering John Wayne drove (in $80 cowboy boots) and we, the three "Tulsans in New York" were his passengers.
>
> "Lunch," Ron said again to his father with $80 cowboy boots driving like a madman directly aiming at Tulsa with

serious conviction of direction. Yes, Ron's father was anxious to get home, home to Tulsa. Home to space and lightness, white square gas stations and shining car lots. Ron's father is obviously from Oklahoma. We Marx Brothers minus one are obviously only flounderers. Floundering because we are neither New Yorkers nor Oklahomans.

It was my turn to be by the window: goody. It was open, with my arm and head stuck out, and the wind stinging my face making it even harder to breathe. I sang louder, but no one could hear me: the wind blew the volume back down vibratingly into my throat. I sang the worst songs in the world not knowing why; not knowing why I sang the worstest songs in the world: "The Tennessee Waltz," "Tell Me Why," "Dancing [sic] Matilda," and "The Thing," Others too, yes, many others. And more others. Many many etc.'s.

We slept. Ron's father drove. We smelled the dry grass: bad at first then heaven. We entered Tulsa. Ugh!

"Ugh! Ugh!" we sang, "Ugh! Ugh!" as we entered Tulsa. Ugh! John Wayne smiled and we three sang "Ugh! Ugh!"

An indescribable farce began, simply indescribable, quite simply unbelievable. A farce which could only possibly occur between a woman and two men, a girl and two boys, in a car driven by John Wayne wearing $80 cowboy boots driving from New York to Tulsa, Tulsa, Oklahoma.

We sang "Oklahoma."[14]

My dad was a big macho bootlegger who had always liked Joe for his good manners and gentleness, and he was very amused by Joe's childish penchant, on the trip, for pointing his finger at passing motorists and making a quiet little gunshot sound. Daddy called him, affectionately, "Joe-Joe the Dogfaced Boy."

There is another section of "Back in Tulsa" worth quoting here:

Pat was suddenly on top of me as Ron's father, John Wayne, swang [sic] off the road heading straight toward a small, very small, café. The sudden turning of the car at a very high speed, yes very high (like the sky in Tulsa) was quite spontaneous on Ron's father's part, and quite a surprise to us. Yes, it shook us up

a little. Resulting in Pat suddenly being thrown in my lap, which appeared physically impossible. As I said, Pat was in my lap, which felt very good. It felt good to have Pat in my lap. In fact, it felt too good, for I'm afraid I embarrassed her. Pat became a woman. The spell was broken.

This passage tends to get overlooked amidst the comic diction, Steinian repetitions, and Dostoyevskian fever pitch, but it suggests that Joe's sexual orientation was still ambiguous. In the piece, Joe—it's safe to assume here a virtual identification between author and narrator—is in close physical proximity to a beautiful girl whom he trusts and likes. He is attracted to her, but can make no overture, other than writing obliquely about it, because he would not want to betray his friendship with me and because his sexual attraction to her is not whole ("The spell was broken"). I think that the desirable Pat's unattainability partly accounts for the depth and longevity of their friendship. But only partly.

In any case, Joe, Pat, and I brought with us a goofy New York City gusto and found that in Tulsa there was no place for it. That summer I took a photograph of Joe emerging from a large cardboard box in the trunk of a car, and I made a home movie in which Joe and Pat dance and stagger around like happy lunatics. His relatively uninhibited hair style was not that of the well-groomed boy who had left town twenty-two months before. People looked at us.

But a few of them also looked at his art in a small one-man show that included a diptych self-portrait in jockey shorts. In it his skin is an undersea green—recalling his food-coloring episode—and his hair a deep Day-Glo scarlet. When an embarrassed gentleman discreetly asked if it would be possible to purchase only the lower half of the piece, Joe obliged.[15] In that same show, he also exhibited some of his delicate colored-pencil drawings and collages of Chesterfield and Alka-Seltzer packages, which he had done in late 1961 or early 1962. One small collage from 1962 showed a pack of Chesterfields and some individual cigarettes, all cut from a magazine advertisement and arranged on what appeared to be Victorian wallpaper. Priced at twenty dollars, it went unsold, so he gave it to Pat and me.

Dear Diary

JOE STAYED IN TULSA only briefly before returning to New York, where he wrote his "Diary Aug. 4–Aug. 15," a picaresque account of visits to the Metropolitan Museum and the Museum of Modern Art, followed by the death of Marilyn Monroe—an event that upset him. Ted and I loved "Diary Aug. 4–Aug. 15." We were surprised by its semi-ironic, naïve tone and the canny rhythms of its phrasing. As Joe later said:

> I had no intentions of being a writer. Everything was against me. I had no vocabulary. I can't spell. I'm inarticulate. I have sort of learned to use that. But this happened because all my friends were writers. I wrote a short story, the first thing I remember writing, and I showed it to Ted and he said, "It's very good." So I kept at it.[16]

Joe had already written "Back in Tulsa Again," but he didn't value it as highly as "Diary Aug. 4–Aug. 15."[17]

Joe was far more sure of himself as an artist. He wrote to Pat in Tulsa that he was

> painting lots and lots: purely abstractly. . . . I'm playing artist per usual and starving to death, tho I feel good anyway. . . . Spent today at the Bronx Zoo deciding which I'd rather be: a monkey or a peacock: no conclusions. Been painting so much that my apt. is in active chaos. . . . M. M.'s death shook me up, though I don't know why. I did a great collage homage to her.[18]

41

In late August, I returned for my junior year at Columbia and took a room in a residential hotel on West 112th Street, sharing it with a classmate. Pat took a small single room there. We did this to maintain an image of propriety for her parents' sake, but in fact my roommate stayed in *his* girlfriend's room and Pat and I were together.

A *Tulsa Sunday World* clipping pasted into Ted's journal reproduced an oil painting from a show that Joe had had in Tulsa in 1962 at the Bartholic Gallery:

> My collaborative American flag with Joe was a Tulsa scandal. Bartholic didn't hang it, but he showed it. Another gallery cancelled Joe's show, partly because of the flag.[19]

It may be hard to understand how the collaborative flag work could have offended gallery-goers, but Tulsa has always been a politically conservative city, quick to take offense at any suggestion of disrespect for the flag.

Over a period of months, Joe and Ted had done a number of other collaborations, as described in Ted's journal:

> Today Joe & I went to the Met—then tonight we did a series (5) of drawings & poems on rough paper in India ink (ruining this pen). We did one spontaneous one, one with him drawing first, and three with me writing first. They are all exciting. [August 30, 1962]

> Today Joe & I start some collaborative works. Last week we did two works in crayon & pencil & ink, a portrait of this room [possibly Ted's rented room near Columbia], and a portrait of Pat Mitchell, that are pretty good. [October 23]

> Yesterday Joe and I did 5 very successful collaborations—two writings by me on paintings of Sandy, & 3 spontaneous small works. We talked, worked alternately, drank Pepsis, took pills. [November 13][20]

But things between the two were not always easy. Joe still felt that Ted had mistreated Pat, and Ted suspected that Pat was driving a wedge between him and Joe. Ted's October 14 journal entry reads: "Joe is aloof a little to me lately. (Again.) It is because of Pat."

For Christmas break I flew to Tulsa. When I returned to New York and Pat opened her door, I saw that her small hotel room had been transformed. Joe had redecorated it entirely in black, with several shrinelike areas, deeply quiet and private in the muted glow of candlelight. Suddenly I felt as if I were in the presence of a great erotic force field. Maybe I was just horny. But many years later Pat told me that during the holiday she and Joe had spent a lot of time together, and that one night Joe had escorted her back to the hotel, pausing to say good-night at her door. He was pleasantly tipsy. There was an instant in which she saw something flicker in his eyes. He hesitated, as if he were about to say something, and then decided not to. She was certain that he had been on the verge of asking if he could stay the night, and she recalled not being sure what she would have said.

PART III

Breakthroughs

Boston

IN JANUARY OF 1963 Joe, feeling that his work had gotten stagnant and that a radical change in his life might provoke a fresh start, announced his decision to move to Boston. In New York he had succumbed to painting pictures for sale:

> Joe is mired in his current boom of selling sentimental paintings in a popular style to the Art Fair for twenty & thirty dollars. . . . "I would like a reason not to sell things to the Art Fair," he says. But he's pretty smart and the Gorky show upset him, too. [Ted Berrigan, journal entry, December 29, 1962]

I think the high seriousness of Gorky's work had served as a reminder to Joe. But his decision to move to Boston wasn't entirely artistic. He needed a break from Ted. As Joe's first mentor, Ted tended to hector him, the way an older brother might. I think that Joe felt, perhaps unconsciously, that I too had some "hold" on him, the kind that comes from having known someone from way back when. Pat feels that Joe had also become uncomfortable and confused about what she sees, in retrospect, as his attraction not only for her, but a suppressed one for me as well. Perhaps he had an unconscious fear that staying in New York would lead him to the conclusion that he was "queer." Or maybe he knew he was queer but felt he could come out only in a place where no one knew him.

The larger issue was that Joe thought that he couldn't become the person he should become if he continued to be surrounded by

friends who treated him as if he were still the Tulsa Joe. Except for Pat. Being very much herself, at that time she never had any heavy theories of how or who he should be.

On January 9, Joe left for Boston "with a cardboard box of clothes his only luggage," as well as seven Desbutols (a combination up and down pill, supplied by Ted).[21] I don't remember why he picked Boston, instead of, say, Providence, Philadelphia, or Baltimore. Any of these cities could have provided the anonymity and freedom he wanted. He knew no one in any of them. As he himself wrote, "I came [to Boston] from New York for a very good reason. Though I don't know what it is yet."[22]

In his first two months in Boston, Joe read forty-nine books and made very little art. By the first week of February he was running out of money. He was unemployed. And he was lonely. The volume and intensity of his letters to Pat and me show that he missed both of us, especially her.

It seems as though Joe stayed in Boston a long time, because so much drama was involved. Although he had intermittent jobs doing layout and mechanicals, there were stretches of poverty and even serious hunger. Budgeting was a mystery to him. In mid-January he sent a postcard to Pat saying that he had just spent all his money on art supplies. He also related an incident that is unique and totally atypical:

> Believe it or not (I don't believe it) I actually got in a fight with a man twice my age. I was so mad I was actually crying. [I] have never been so mad or exploded so violently in my entire life. Will explain when I have more room. By the way, I won, both physically and mentally.

He mentioned that "poverty is setting in, but I still feel calm and almost contented with everything." But the calm he felt was temporary. More persistent was his scavenging cigarette butts from the sand urns at the entrance of the Museum of Fine Arts or tearing out the same page from every book he borrowed from the public library—a socially destructive gesture quite out of character. His desperation came through forcefully in his letters, in which he made no attempt to disguise his economic

and emotional crises, not to mention his poor physical health, as in this one from early 1963:

> I'm writing again already. I feel rather strange. However, I don't have five cents to mail the letter with. . . . Today has been sorta strange, because the effects of not eating have hit. I spent the $2 extra ($8 for rent) you sent immediately, and have been living off a loaf of bread for the past three days. I'm not sorry, though. But today is Saturday late afternoon and I have left only two slices. And tomorrow is Sunday, so no mail. I put all my faith in Monday's mail: Don't know what exactly will happen if the mailman fails. . . . How absurd my present existence is. I mean really absurd, no reason whatsoever, etc. If I thought it'd be this way forever, I truthfully believe I'd have the desire and the guts to end it all. But as I said, I have tremendous faith in the mailman.

Things got worse the next day (Sunday):

> I'm absolutely delirious. If I don't get money in the mail tomorrow, I swear I'll go crazy. . . . It's not snowing but absolutely unbelievably cold. I've just been out to try and find some cigarette butts and my ears are still tingling from the bite of winter. Also there's still snow all over so all the butts are wet and frozen. I found one, though, but it tasted so bitter, like shit. Also I went out with the intention of asking some people in the street for money, but I couldn't. . . . If someone said no to me, it'd kill me.

Finally Monday arrived.

> Waited with horror until the mailman came at 11 or 12. No mail. Sick. Had no choice but to go begging in the street: out of four people I got fifteen cents. So I bought two candy bars and a five-cent stamp.

For reassurance, what did he do? He turned to the two books he had just borrowed from the library: *House of the Dead* and *The Possessed* by Dostoyevsky.

Pat was sending him what little money she had left each week

from her sixty-dollar paycheck, usually five to ten dollars, which bought a lot more in 1963 than it does now. For Joe it was a lifesaver. At one point he reported that not only had he not eaten for days, but also that drops of blood were appearing on his nose. Pat and I airmailed him a carton of vitamins and food.

Near the end of April, Ted brought out the first issue of *C*, a mimeographed journal of poetry, with four contributors: Dick, Joe, himself, and me—the group that John Ashbery later would dub "the soi-disant Tulsa School of Poetry." Joe's two pieces were "A Play" and "A Diary" (the "Diary Aug. 4–Aug. 15" mentioned before). Here is the entire play:

A Play

A Song: "Like a mighty army moves the Church of God!"
A Me: "What?"
A Song: "The Church of God!"
A Me: "A What?"
A Church: "A Me!"

Issue 2, which would appear on June 20, contained three pieces by Joe—two poems and a prose piece—along with an excerpt from a letter to Ted, dated May 20, 1963:

This has been the best weekend of my entire life. Honest. I worked like crazy. All that stored-up energy: two paintings all about women, a painting collage of childhood, I guess, but not really, of a boy in a chair with linoleum, giant white roses, an empty frame, and a rubber doll leg. . . . I swear to god I grew three inches. At any rate, most important of all is this really big grand collage I've been working on for several weeks. Perhaps Pat mentioned it to you. It's very 3-D all the way, divided basically into two parts. The upper half, the larger, is a ½ circular alcove with a plaster cast of Mary with dead full-grown Jesus in lap with a little plastic red cardinal on his head, and a wonderland spreads out at their feet of red roses, giant purple orchids, lilies, etc. etc. with lots of birds and butterflies, and behind all

this is a blue blue sky with clouds and mean black birds. And surrounding all this is a stained-glass window of all possible colors including two pieces of pearl inlay, with two angels singing to a centered LUCKY STRIKE big circle; at the edge rosaries are draped and a yellow bird flies on the top right-hand corner. And below this is a secret door upon which is an orange-to-yellow-with-pink sunset, with a black monster of a bird flying carrying a human baby of long ago in its beak; and there's also a black wooden cross, and part of the words "Season's Greetings" in fluorescent orange-red. This door opens up to a purple-lined box containing 12 bride-and-grooms. What I'm trying to say is I finished it this morning.

Somewhere about this time Joe wrote three poems, including "Gold and Silver and Purple Memories," which has passages that prefigure his *I Remember*, such as this one:

I remember Heinie the boy with glue on his fingers
The fake silk hat / Green
Sweetmeats, bonbons, Candy Kisses, and purple hearts
I remember when a black night is truly black
Her little girl madness
And where are you, Bronco Bill?
Where are you, Eddie Polo?
M. M. is dead
I remember healthy perspiration
The way it oozes
Always running into a fire to save a kid
Being left-handed as I am
The glorious future:
It ruins your digestion and does harm to your liver
I remember a banana man pushing a banana cart
"Banana!"
Of thee we sing
I remember the White Sox lost to Boston two to one
I remember the hush broken only by automobiles
The wind and the empty tree[23]

That spring (1963) Pat accepted my proposal of marriage, and around June 1 we borrowed a car and, with Ted and Sandy, drove up to see Joe, partly to give him the news in person and partly to check on him. We left New York around one in the morning and arrived around dawn. Joe was living in a room at 231 West Newton, which today is a renovated condominium building in a highly gentrified neighborhood, but in 1963 it was a single-room-occupancy dump. His floor had one toilet—which he shared with seven other tenants—down the hall. He lived in

> a small room with dirty no-color walls. The curtains are plastic. They contain on them a red and green floral design (large pattern) of a wild sort popular eight years ago when I was only twelve.... My bedspread is of pink chenille. It comes free along with weekly fresh white sheets which are yellow. Ivory actually. And I hope it is only from age. All for eight dollars a week. A bargain? No. I have a chair I don't sit on.[24]

His alcoholic next-door neighbor talked to himself, swore at the radio, and vomited frequently. Sometimes he gave Joe old magazines.

At night, prostitutes and other demimonde characters cruised the street outside. The railroad and subway tracks (now enclosed in a tunnel you'd never know is there) next to the building made it sound as if the trains were coming right through the room.

Joe had been doing a lot of art work, most of it hallucinatory. I recall collages of wild ducks in black silhouette flying past a bright Taj Mahal that was set against a deep blue sky, suggesting a mysterious obsession. But the ultimate attraction was Joe's sense of design, as if the images had locked into exactly the right places by themselves.

Joe was employed a few days a week for two dollars an hour by an advertising agency in Brookline, a brisk sixty-five-minute walk from his room. Other businesses had turned him down. One company

> thought I was some sort of nut or something upon seeing my collage.... At Filene's my fashion figures were too elongated and my faces not "pretty" enough. I'm not "practical" enough for Lloyd's.

Joe accepted the news of our engagement quite normally. The five of us drove to Cambridge, where we walked around, joking and clowning. We calmed down enough to visit the Busch-Reisinger and the Fogg Museums. But it was time to go: we had to get the car back to New York. Although we had been awake for far too many hours, and although it was strange seeing Joe in such an unfamiliar setting, the visit had been a lot of fun. Pat and I left feeling somewhat reassured about his health.

One spring day Joe opened his door and there stood Royla Cochran, the young woman who in Tulsa had gotten him at least partly into bed. It turned out that she had moved to Cambridge before he had moved to Boston, and she had just learned from his parents that he was only a few miles away. He was polite to her, but cool and distant, and she got the distinct impression that he didn't want to see her. She visited him perhaps one more time, but as he wrote to Pat and me in June:

> I've really treated Royla like shit so she's stopped coming around; which is O.K. with me. I think what finally did it was my saying sex was too personal. Which for me I'm afraid is too true.

According to Royla, he had also told her that he loved Pat and that he hoped to marry her. Although he did have a crush on Pat, he probably said this in order to make Royla abandon what he saw as her pursuit of him, though later she said that all she had wanted was friendship. In any event, he seems to have relinquished the notion of sleeping with a woman. It may have been around this time that he made his first forays into cruising—with no success, as he later wrote in *I Remember*. And although he hadn't quite announced to his friends in New York that he was gay, the same letter (as above) did describe one of his new works as looking "homosexual."

He also wrote, "I wanta save money and move home to New York." Notice his use of the word *home*. But Boston *had* provided the artistic breakthrough he had hoped for. Despite his miserable circumstances, his work was going well. In a letter mailed June 15, he wrote:

I wrote a really good new thing ["Purple"] but it's really strange.... I'm truly a genius.... I feel super-good. As of last weekend all I do anymore is dance around talking and laughing with myself. I'm so terribly happy and all over the work I did: 10 large (15 x 20) painting collages. You might laugh if I say it, but for once you'll be wrong in doing so, they are without a doubt *the greatest things ever seen.* And considerably different from my other new work you saw. They totally destroy all normal sense of perspective, logic, art, realism, etc. by way of contrast. (A giant black hand emerging illogically into a pool of color) (yellow nude men swimming in purple) (a little girl in pink swatting [sic] on top of a giant ink splash)....

A week later he described a new Marilyn Monroe painting-collage, which featured the pink and smiling face of Marilyn in the center, surrounded by hearts and draped with a crystal rosary. He was also doing a "box collage." "All my new collages have a '7' in them, which is good because I hate to sign paintings, and this takes the place [of a signature] very well."

In June, Pat and I returned to Tulsa, got married, and after a car trip to Mexico, rented an apartment for the rest of the typically hot summer in Tulsa. Without air conditioning, we slept during the day, though occasionally I got up early enough to earn some money doing yard work. From dusk till dawn she and I read, wrote, made collaborative artworks, and wrote to our friends in New York and to Joe in Boston.

In a letter written in late June, Joe surprised me:

The other day I was thinking to myself that all it'd really take for us to *really* be friends would be for me to say "Let's be friends!" ("Let's be friends!") And just saying this to myself made me feel more real about you than I have in a long time.

I hadn't been aware of even a slight distance between us, or that in his eyes I hadn't been quite "real." Maybe the marriage had released him from an unconscious frustration he felt toward Pat and me individually.

Joe's euphoria over his work continued into early July:

I am doing work now which surpasses me: I watch myself work
in total amazement. And the results are no less surprising. It is all
totally unexplainable. I'm not even myself anymore.

He talked about visiting Sandy Berrigan in the hospital in
Providence, Ted's hometown, only hours after the birth of their first
child, David, on July 9. He also mentioned the box collages he had
done prior to Boston, such as a small one starring the Infant Jesus of
Prague and some crows. But his new work was the big news:

> I've done my first piece of "sculpture." Assemblage or construc-
> tion would be a better word. And actually the primary difference
> is that it sits on my table. . . . It contains a large clock case, a doll
> head with lots of hair, a throne, the same boy-girl figure, 2 gold
> angels, 4 red cardinals, and an oval of sky.

The word *assemblage* had come into common use after an exhibi-
tion at the Museum of Modern Art called "The Art of Assemblage"
that Joe, Pat, and I had seen together in 1961.

It was sometime in June that I set about self-publishing a col-
lection of poems, translations, and mistranslations called *Quelques
Poèmes/Some Poems/Some Bombs*. From Boston, Joe responded to
my invitation to add his work to the booklet by sending me nine
black-and-white "collage drawings," as he called them, and told me
to choose what I wanted (though he did list his favorites). I chose
one for the portfolio cover and three as *hors-texte* images—one for
each of the booklet's sections—and had them printed on white
cardstock.

One image has always been my favorite: in the center is a large
black silhouette of a hand between whose thumb and forefinger a pill
is being held up, behind which is a white circle, behind which is the
word BOOM and to the right of which is a gray rectangle. At the bottom
left is Dick Tracy with both his arms raised, in three-quarter view from
the back. The hand of an unseen person has stuck a revolver in his back.
Joe also liked this image especially ("I am *positive* this is *totally* great!").

The poems and images were presented in portfolio format so
that they could be rearranged by the reader. The poems were

Joe's illustration for my booklet, *Some Bombs*, 1963.

mimeographed, the images were printed offset. Joe, who paid for part of the printing expense, liked the result: "I was enormously pleased with the capturing of the paint quality," he wrote in August.

The third issue of *C* magazine (July/August 1963) carried the first of Joe's many *C* cover designs.

His work was going well, but personally he was shaky. As Ted wrote in his journal, "Joe . . . is flipping his nut—feeling complete depressions & insecurity etc."[25]

By this time, virtually all of Joe's work consisted of an assembling of parts, whether in "collage-drawings," assemblages, or collages. In late July, Joe gave Pat some advice on making collages:

> Do not try to "arrange" your objects; let them help you formulate by building from one object to the next. . . . Fantastic things can happen. Also, at least in the beginning, do not contemplate where to put an object, just put it there, tho it may well be a mistake. To get "into" a work I find it important to begin by getting into the spirit of pasting. (The process, technique, etc.) Of course, all this is not true. But, of course, it is true too.

The willingness to risk making a "mistake" was something Joe admired not only in Ted but also in his abstract expressionist idols. Fourteen years later, Joe would put it this way:

> I think of Abstract Expressionism as high seriousness. It's spilling out your guts all over. You think, and you work from an area that has no boundaries, so it's very tough and you've got to be very serious about it, and dedicated to an ideal. *I like to start from nothing and just surprise myself* [emphasis mine]. . . . It doesn't come out of gut emotions or a high sense of color or something as a source. I may use it, but it's not the source.[26]

A parallel influence on Joe's way of working came from dada and surrealist chance techniques and collaborations.

Joe's descriptions of his recent work continued in late July:

> Two things somehow appear in all my new work: flowers and "7." And quite often brides and grooms. And the usual birds. Babies.

Words. Hands. Crosses. Etc. But often not. Muscle men and butterflies have disappeared.

The combination of images in his work had gotten wilder, and he himself seemed to be living at greater extremes, as shown in letters to us in July: "*8½* is the greatest movie I ever saw! . . . People just dance around and do things all the time." Then, writing to Pat, he described a heat wave, in which he felt "bugs" crawling over him as he tried to sleep. Flies were attracted to his sweat, so he went out and walked around most of the night. The devastating Boston weather and his continuing poverty made him confirm but adjust his plan to return to New York:

> I've come to realize that I won't possibly be able to move to N.Y. in Sept. in the fashion that I want to move to N.Y. in: with at least $100. . . . I want to be able to get an apartment and oil paints, canvas, and all. However, I shall definitely be there by Christmas [the word *definitely* has a column of repeated underlines that extend four inches down the page].

He suggested that if Pat and I find a large apartment when we get back to New York, maybe we could all share it, to economize.

One Friday in August, the postman left a notice of an attempted delivery of a registered letter, which Joe was sure must be from the draft board. He spent the weekend sweating out his decision, finally realizing that he would not willingly give up two years of his life to the military. Let them do what they wanted. The letter turned out to be from a book club, dunning him for payment.

In a letter dated August 9, 1963, he was quite excited:

> Andy Warhol says *C* cover is great. And he's to see me and some of my new work next weekend when I'll be in N.Y. Here's hoping he might pull a string for me. I continue doing great things. I can't believe it. Most of all I'm anxious for you all to see everything.

Ted had met Andy at a reading of Frank O'Hara's in late July and immediately sent him the first two issues of *C* magazine, along with a note saying that the imminent third issue would have a cover by

Joe. This was the cover Andy liked, the first artwork he saw by Joe (though perhaps he read Joe's writings in the first two issues of the magazine). At Ted's suggestion, I sent Andy a copy of the *Some Bombs* portfolio Joe and I had just published. Because Andy liked *C* and Joe's work, he offered to do the cover for the fourth issue, which was to be devoted to the work of Edwin Denby.

In mid-August, two months after our marriage, Pat and I returned to New York, where we sublet a small one-bedroom apartment at 210 West Eighty-eighth Street. In September I began my senior year. Pat found a job as a private secretary for a realtor near Washington Square. My mother was still sending me twenty-five dollars a week for living expenses.

Back in New York Again

IN OCTOBER, Ted borrowed his mother's car in Providence and moved Joe back from Boston and in with Pat and me on Eighty-eighth Street.

Joe slept on our living-room couch. Neither he nor I cooked, and Pat was sketchy in the kitchen herself. Breakfast was coffee and, on good days, a Pop-Tart. The dinner menu rotated through three or four main dishes. One standby was macaroni and cheese, the boxed variety from Kraft. We washed it down with Pepsi, and for dessert we had chocolate pudding (Royal), followed by coffee (Maxwell House). That dinner for three came to a little over one dollar. Our true basic fuel was coffee and cigarettes. Joe smoked Tareytons, whose pack, with its vertical red bars, continued to appear in many of his works.

While I was in class and Pat at work, Joe roamed the city, especially the art galleries, museums, and junk shops, usually alone, sometimes with Ted, and on weekends with Pat and me. There wasn't enough room in our apartment for him to set up a work space.

For entertainment the three of us talked, read, listened to records (folk music, classical music, and jazz), and went to galleries or to movies across the street at the New Yorker theater, where the price of admission was, if memory serves, sixty-five cents before 6:00 PM, $1.25 after. The wonderful programming there included a lot of film noir, Busby Berkeley musicals, Preston Sturges and W. C. Fields comedies, foreign classics, and an occasional oddball festival of, say, Hammer horror films. Occasionally we watched television on a portable black-and-white set.

It was on Eighty-eighth Street that Joe and I did a series of small works that we called *S*. The name came from a flat, metallic gold *s* that one of us glued onto the lid of a small pasteboard box, the kind that greeting cards come in, and into which we placed the finished works. These were on pieces of cardstock, typing paper, and tracing paper—drawings, words, and collaged material, much of it rather cryptic and hysterical, some of it erotic, some of it with images from *Dick Tracy*, *L'il Abner*, and *Nancy* comic strips. Our working method was highly collaborative; that is, Joe provided some of the words and I provided some of the images. Using the limited media and materials at hand, we worked spontaneously at a table in the living room, passing the pieces back and forth, drinking coffee, and smoking. Joe and I were twenty-one and goofy. Pat was a few years older and far more pragmatic, but she joined in on a few pieces. Over four or five such sessions, we ended up with around seventy works, some good, some puerile, some good *and* puerile.

That same autumn, Ted came uptown one evening with a box of new mimeograph stencils. He, Joe, and I did some collaborative poem-pictures on the spot, using ballpoint pens to incise our words and images into the stencils' thin layer of wax. The result, which we printed as a limited-edition portfolio under the title of *Some Things* (the title an intentionally moronic takeoff on John Ashbery's *Some Trees*), was exuberant, excessive, and sometimes funny. Joe never said anything about these pieces, but I suspect that later he didn't think all that highly of them. Anyway, trying a three-way collaboration had been a lark.

Around that same time Joe and Ted did another three-way collaboration—of sorts. Andy Warhol had designed the front and back covers to be silk-screened for *C* magazine, but he lent Ted the two screens, some black ink, and a squeegee; he himself could not do the printing because he had to go to Los Angeles for a show. Ted saved some of the prints that came out faint, and it was on one of these that he and Joe drew and wrote.[27]

Later that fall Joe did a mixed media *Portrait of Sandy* that included a Campbell's soup can medallion and a ribbon on which *Andy Warhol* was printed. He might have dropped the *S* and called it *Portrait of Andy*. His admiration of Warhol was in full swing.

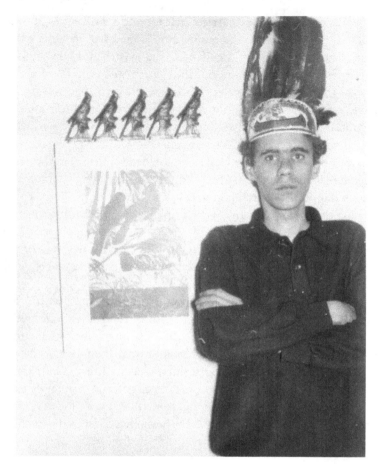

Joe with one of his assemblages. West Eighty-eighth Street, New York, probably 1964. Photo: Lorenz Gude.

That Joe had virtually no income meant nothing to Pat and me. He did make occasional forays into money-making. The deli owner around the corner on Broadway needed new hand-painted signs, for which he paid Joe twenty dollars in advance, but Joe could not bring himself to do the tedious work. The man, who bore a striking resemblance to Picasso, kept asking me when the signs would be done. I stalled and stalled, then I avoided his deli altogether. Later I teased Joe by telling him that "Picasso" was looking for him.

Pat recalls that it was during Joe's stay with us that the military caught up with him. As soon as he had dropped out of art school, he became eligible for the draft, but apparently the transferal of his records from Tulsa to New York had taken a while.

On the appointed day, Joe obeyed the order to appear at the induction center on Whitehall Street. He was standing in line there when an official walked by and told him to report immediately to the shrink.

The psychologist took one look at him and asked, "Do you like girls?"

Joe answered, "What do you mean?"

"Are you a homosexual?"

Joe said, "Yes."

"What homosexual experiences have you had?"

"I haven't had any."

The doctor scribbled some notes and told Joe to report to a certain window. He was 4-F—unfit for military duty.

Military duty was something most of our friends wanted to avoid at all costs. Even before the true horror of the war in Vietnam had kicked in, young men tried all sorts of things to be classified 4-F, such as pretending to be queer, a claim that would be bolstered by vivid accounts of sexual experiences. What made Joe so believable was his open admission of a *lack* of such experiences. What straight guy would think up such a strategy? Besides, Joe's timid demeanor suggested that he would not harm a fly, let alone kill a person.

Joe LeSueur and Frank O'Hara

By late november of 1963 Joe had moved in with Tony Towle at Tony's apartment at 441 East Ninth Street, near Tompkins Square Park. Tony was a young poet who had been a student in Kenneth Koch's and Frank O'Hara's poetry classes at the New School. He had been looking for someone to share the monthly rent of fifty-six dollars ever since his friend Frank Lima, also a poet, had moved out to live with his girlfriend. (The apartment had been Frank O'Hara and Joe LeSueur's before Tony and Frank Lima took it over.)

Since Joe didn't have a job, he had trouble coming up with his half of the rent. But soon it became less of a problem when Tony got a job at Tanya Grossman's Universal Art Editions, enabling him to buy some of Joe's new work each month, usually for a bit more than the twenty-eight-dollar half of the rent.[28]

It was right around the time of his move to Tony's that Joe met Frank O'Hara and Joe LeSueur. He already knew about O'Hara from Ted. In fact, one day Ted, Sandy, and Joe had seen O'Hara on the street and introduced themselves—actually, Ted sent Sandy over to speak with his hero first—whereupon Frank invited the three of them to a party at Larry Rivers's loft in the Chelsea Hotel, where Joe met Joe LeSueur,

> who I thought was absolutely a dreamboat. He sort of reminded me of football players in high school, the sort of short, blond football players—sort of short and chunky. I couldn't believe he was Frank O'Hara's lover, he looked so straight to me.[29]

Joe Brainard and Joe LeSueur at the Gotham Book Mart, probably
late 1960s. Photo: Bill Yoscary.

When Joe B. learned that Joe L. and Frank were just roommates, he decided to go after Joe L. He didn't know that Joe L. had already asked Tony, "Do you think I have a chance with your roommate?" Unsure whether Joe B. was gay or not, Tony had shrugged.

It turned out that the two Joes fell for each other, and Joe B. glided easily into the gay life. In fact, Joe B. eventually found himself in secret trysts with Frank.[30] He couldn't have had a better sexual introduction, since both Frank and Joe L. were perfectly comfortable with being gay. Also, both loved literature, art, music, theater, ballet, people, and gossip, and both saw in Joe the artistic genius that it was becoming clear that he was. As for Joe himself, his indecisiveness about his sexuality seemed to evaporate. He was gay. As one of his collaborations with Kenward Elmslie would say, a year or so later, "So what? The light is here, where my body is."[31]

On February 17, 1964, Joe, Ted, Dick, and I had given a reading at artist Robert Dash's loft on Elizabeth Street. To an audience of about fifty people, including Edwin Denby, John Giorno, David Ignatow, Gerard Malanga, Andy Warhol, and a reporter from *Life* magazine, we read, among other things, my "Two Stories for Andy Warhol," which was a single page of prose narrative repeated ten times, each of us taking turns reading the page(s). Later that fall, Joe's prose piece "Andy Warhol's Sleep Movie" appeared in *Film Kulchur* magazine. By this time Joe and Andy had become friends, and not too long afterward Andy did "pull a string" for Joe by getting him a commission as guest designer of the window displays at Tiffany's.[32]

Also in February was a poetry reading that Joe, Ted, Dick, Lorenzo Thomas, Peter Orlovsky, Gerard Malanga, and I—billed as "The New Decadents"—gave at Wagner College on Staten Island. It was arranged by Gerard, who was a student there. The night of the reading a blizzard swept over the metropolitan area, and by the time we Manhattanites reached the campus the blinding snow was horizontal in a fierce wind. We managed to reach the venue, to find that only two seats were occupied in an auditorium built for 500. Peter Orlovsky grabbed my arm and said, "Let's go get some people!" We staggered outside and headed for the first building we saw, which turned out to be the library. Inside, Peter boomed out, "Hey, everybody, c'mon,

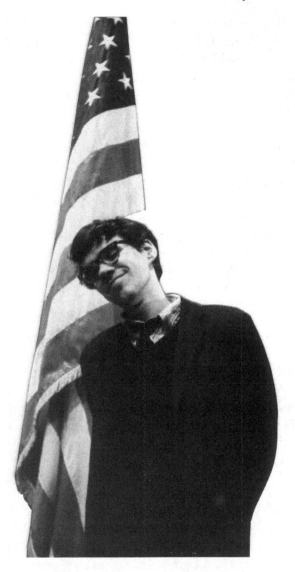

Joe at Wagner College, Staten Island, February 1964.
Photo: Lorenz Gude.

big poetry reading! Great poets!" One trembling student actually got up and followed us. He joined our "entourage"—Pat, Sandy, and friends Lorenz and Ellen Gude—so that the readers barely outnumbered the audience. The funny thing is that we had a great time, with everyone giving top-notch readings. Lorenz took photographs, one a shot of a bashful Joe in front of the American flag.

In the 1960s the New York art and poetry worlds were more socially accessible than they seem to be now. For example, to a small but ardent group of young admirers, Frank O'Hara was a big hero, but he was unpretentious and friendly to young poets. He chatted with us at readings and openings and parties and he invited some to drop by his office at MoMA anytime. In the poetry writing course he taught at the New School, some of his students accompanied him to a bar after class. It wasn't just that he wanted to go to bed with them. He was sociable and welcoming, whatever one's sexuality. At times Frank did have a sharp tongue, but to me he was congenial and generous.

Also he was open. One evening Joe B. was playing bridge with Frank and two others. Frank's bridge games involved more talking than playing cards, which was the reason Joe had learned the game anyway. At one point he worked up his courage and asked Frank a question he was truly curious about: why didn't Frank like Andy Warhol's work? Frank proceeded to give a long, cogent list of reasons, at the end of which Joe said, "Everything you said might be true, but I still love his work." Frank replied, "Well, you're the painter here, not me, so maybe I had better take another look." Apparently he did, because some months later, in an article, he made a complimentary reference—his first—to Andy's work.[33]

Joe B. was greatly encouraged when Joe L. and Frank bought his new work. One piece Frank especially liked was a small assemblage consisting of a light blue, eight-keyed, legless toy piano with a life-size, gloved wrist and hand rising from its top and clutching a plastic ice-cream cone, and a miniature Viking warrior at the bottom of the cone poised to stab a big black rubber snake beginning to wind its way up the wrist; a second Viking, scaling the thumb, has almost reached the cone. The effect is nightmarish but funny.

From the same period (1963–1964) Joe L. bought a small, beautiful construction made of a crucifix, a plastic woman, a pencil, a Cat's Paw sign, and the numbers 6 and 9. Joe L. also bought (for fourteen dollars) an energetic work on canvas of the 7-Up logo (which Joe did in 1962 before he saw a similar piece that Oldenburg had done a year or two previous). But *fourteen* dollars? That was the price Joe B. proposed. When Joe L. asked him why fourteen, Joe B. replied, "Because that's how much money I need at the moment."

Joe's work at the time was mostly assemblages and collages, involving, as he put it in an unpublished interview I did with him:

ice cream cones and spiders and nails and feathers and cigarette butts and roses and orchids and flamingo birds and cardinal birds and blue birds and blue ferns and dancing girls and skeletons and fringe and tassels and lace and linoleum and ribbon and Dristan and toothpaste and the Infant Jesus of Prague and bottles and bottle caps and bottle openers and beer cans and cookies and babies and chocolates and rosaries and Christ and necklaces and jewels and sparkles and doilies and dollars and rubber stamps and plastic eggs and hard rolls and glasses and "Peace" buttons and cameras and satin slippers and elephants and screws and price tags and words and squares and mooses and Indians and sea shells and bird skulls and chicken bones and swans and legs and feet and hands and pianos and boxes and Mary and towels and wash rags and mirrors and building blocks and Tinker Toys and poodles and Christmas balls and "Happy Birthday" and the American flag and Saint Teresa and Saint Anthony and teeth and sequins and butterflies and crucifixes and vases and angels and glitter and circles and muscle men and "7-Up" and spaghetti and bow ties and wallpaper and bingo and confetti and nylons and altars and bird cages and kitchen tables and kitchen chairs and airplanes and police stars and brides and grooms and mailboxes and underwear and silverware and cherries and full moons and pencils and lots of things.

With his uncanny eye, Joe spotted some of these items in the street. Also he cannibalized comic books, movie magazines, and other pop sources for images and themes for both his visual art and

his writings. Joe's work gradually filled his bedroom/studio, then took over the kitchen, and by late summer of 1964 threatened a serious encroachment on the living room. Tony was on the verge of having a talk with Joe about it, when Joe announced that he needed to find an apartment with more space.

Bob Dash gave Joe his loft for July and August of 1964, by far the largest and most pleasant workspace Joe had ever had. By early July the Moos International Gallery in Toronto had taken nineteen of his pieces on consignment. He was moving "up." As he phrased it, "I think some people suspect me of 'trying to get ahead.' Funny thing is, I am."[34]

At some point, probably back in the winter or spring of 1964, Joe, Pat, and I went to hear Barbara Guest and Kenward Elmslie read their poems at the Smolin Gallery on the Upper East Side. After the reading, the three of us followed Kenward, at a discreet distance, out onto the street and down Madison Avenue. I was enthralled by Kenward's poems, which I knew from his collection *Pavilions,* and by his reading style. I think Joe was enthralled by *him.* And why not? Kenward was young (barely thirty-two), handsome, talented, and witty.*

Joe had been designing the sets and costumes for Frank's play *The General Returns from One Place to Another* and LeRoi Jones's *The Baptism,* a double-bill production of the Present Stages theater company that premiered on March 23 at the Writers Stage Theater on East Fourth Street.

The next month Frank wrote to Larry Rivers that he was "making some cartoons with Joe Brainard, a 21-year-old assemblagist genius you will like a lot."** Noting that Joe was doing cartoons with other poets too, Frank added that "it is a cartoon revival because Joe Brainard is so astonishingly right in the drawing etc."[35]

That spring Joe was still with Joe LeSueur, but around late summer of 1964 he wrote to Jimmy Schuyler: "Joe and I are not working out too well. Once together there seems nothing to *do.* This does not seem to bother Joe but it does yes bother me. He's really quite nice, tho."

* We didn't know that he was also the grandson of Joseph Pulitzer.
** Apparently Frank didn't recall that Joe had been at the December 1963 party at Larry's studio.

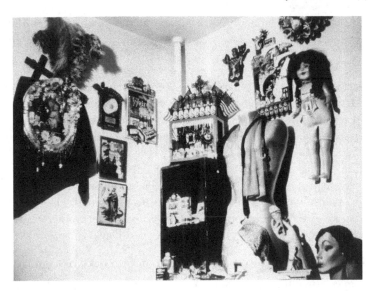

Joe's apartment/studio, 441 East Ninth Street, New York, 1964.
Photo: Lorenz Gude.

A few months later, on November 1, Joe wrote an account of his day:

> Let's see, I got up feeling about par for Sunday 10:00 AM Joe LeSueur made a big breakfast: cold cereal, scrambled eggs, bacon, orange juice, toast, and coffee. The night just before I had had a terrible sore throat. So swollen I could hardly breathe. Then I went home. I picked up two Pepsis on the way. And a chocolate bar. I worked very hard all day on a new construction. I won't go into details. It's coming along very good. Lovely weather. Fine day. At 3:30 PM I went uptown to see Pat and Ron. Pat and Ron had already eaten, so I ate something Ron had made the night before. Around eight, people came over for a get-together-reading. (Ted, Dick, Allan _____ [Kaplan], and David Shapiro.) We all read stuff. Pat shut the door with the TV and her inside and ate sunflower seeds, slept, and read something. We read for a long time. When the reading was over we went to the Esquire [coffee shop], except Pat, who was asleep. I had cold cereal, two scrambled eggs, toast, and a Coke.
>
> Now we are back at Pat and Ron's apartment. Ron and me are, everyone else went to the Dom [a bar on Saint Mark's Place]. Except David Shapiro, who had to study for a midterm. Pat is still asleep. Ron is typing on some forms. I, of course, am writing. Soon we too are going to the Dom. Except Pat, who will still be asleep I imagine. She has to go to work in the morning.[36]

It may have been around this time that one of Joe's new collages, which we called *Bingo,* was hanging on the wall that faced my writing table, and because of which I wrote this poem:

Joe Brainard's Painting Bingo

I suffer when I sit next to Joe Brainard's painting *Bingo*

I could have made that line into a whole stanza

I suffer
When I sit
Next to Joe

Brainard's painting
Bingo

Or I could change the line arrangement

I suffer when I sit

That sounds like hemorrhoids
I don't know anything about hemorrhoids
Such as if it hurts to sit when you have them
If so I must not have them
Because it doesn't hurt me to sit
I probably sit about $8/15$ of my life

Also I don't suffer
When I sit next to Joe Brainard

Actually I don't even suffer
When I sit next to his painting *Bingo*
Or for that matter any of his paintings

In fact I didn't originally say
I suffer when I sit next to Joe Brainard's painting *Bingo*
My wife said it
In response to something I had said
About another painting of his
She had misunderstood what I had said[37]

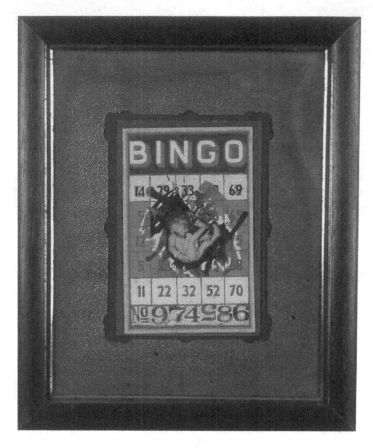

Joe's collage *Bingo*, ca. 1964. Private collection. Courtesy of Tibor de Nagy Gallery.

The theme of suffering may have come from the collage's central image of a newborn or perhaps prenatal baby in what appears to be a state of distress, but the remark the poem attributes to Pat is erroneous. She had said something else, which I had misheard.

According to Aram Saroyan, he and Joe appeared together on a Sunday morning arts magazine TV show (probably a half-hour show called *Camera 3*) in New York City in the fall of 1964. Aram read his poems and in another segment Joe showed his collages and spoke with an interviewer.

In December Joe took part in his first New York group exhibition, entitled "Poets Show," at the Smolin Gallery. A *New York Times* critic commented: "The idea is they show some paintings by day and read their poems by night. . . . In the art department, most of them are nonstarters. But Barbara Guest is very good, and Brainard is good." What the critic didn't know, of course, was that Joe was primarily an artist.

Kenward

ONE VERSION HAS IT that by early October of 1964 Joe had been introduced to Kenward Elmslie by Ted on the Staten Island ferry. Kenward was taking part in an antiwar reading, in which four poets read their work to bemused passengers. That is Kenward's memory of meeting Joe. However, Ted's journal entry for November 13, 1962— approximately two years earlier—reads: "Met Kenward Elmslie at the South Ferry/Battery Park Poets for Peace reading." It's possible that there were two different readings.

In Ted's December 2, 1963, journal entry, he describes going to the party for Frank O'Hara at Larry Rivers's studio in the Chelsea Hotel, among whose guests were Kenneth Koch, Edwin Denby, Barbara Guest, Barnet Newman, and Joe. It is possible that Kenward was invited but did not attend.

In any case, Joe recalled first meeting Kenward at the latter's birthday party in April of 1964, and then seeing him during a visit with Jimmy Schuyler at Anne and Fairfield Porters' house in Southampton.* Apparently it was at the Porter house that Kenward, wanting to get to know Joe better, asked him if he played tennis. Joe told him that yes he did, but when they went onto the court it was clear that he didn't even know how to grip the racquet, let alone hit the ball. Kenward found this quite endearing. By mid-November they had become lovers, and by Christmas Kenward felt that he had found not only a lover but a friend.

* Jimmy's birthday poem "Dear Joe" mentions first meeting him, Ted, and Tony at a party at Kenward's.

Kenward was to become Joe's primary collaborator. Joe's first collaborations were with Ted and me, the earliest being a work that Joe and I did in 1959 or 1960, our senior year in high school: a woodcut of a wistful girl above a short poem—basically a picture and a caption.* Joe and Ted did a number of collaborative paintings and collages in 1962, and by 1963 Joe was doing collaborative comic strips with Ted and me. When Joe suggested to Kenward that they do some comics, Kenward was skeptical. He had collaborated on theater pieces and even an opera, but never so déclassé a form as the comic strip, but he agreed because he was in love with Joe, and soon he was in love with the form too.

In late 1964 Joe brought out the first issue of *C Comics*, a mimeographed collection of the comic strips he had done with Bill Berkson, Robert Dash, Edwin Denby, Kenward, Barbara Guest, Kenneth Koch, Frank Lima, Frank O'Hara, Peter Schjeldahl, James Schuyler, Tony Towle, Ted, and me.

Larry Rivers took notice, and by July he had picked Joe for a group exhibition called "Artists Select" at the Finch College Museum of Art, October 15–December 15, 1964. Art critic John Gruen, who knew both Frank and Larry, alerted Charles Alan, whose eclectic Madison Avenue art gallery represented David Hockney, Jacob Lawrence, Bruce Conner, and Jack Levine, and in mid-October Alan offered Joe a solo exhibition, his first in New York.

At some point, certainly by October 9, 1964, Joe had moved from East Ninth Street to a small, funky loft at 21 Bleecker Street, just west of Bowery. Artist Michael Steiner had told Frank O'Hara he needed someone to share the space, and Frank had relayed the information to Joe. The total rent was $100 a month; Joe's half of the space had four windows and a skylight. Apparently there was a shower but no kitchen. The landlord promised to install some heaters. Steiner was a hard-edge abstract painter, so there was no formal competition between his work and Joe's. As Joe put it, "He is quite good really: 'hard-edge' with light bulbs. Bright colors and stripes that *do* a lot."[38]

* Its format was similar to that of an original work that hung in the Brainard home, a painting of a rustic cabin by Joe's father, done at age eighteen or nineteen, above a poem by *his* father.

The fall 1964 issue of *Gallery Guide* listed a two-person show of paintings by Michael Steiner and Joseph Branard [sic] for the month of October at the Washington Square Gallery, 530 West Broadway (now LaGuardia Place). Those were the days: the hours were noon to midnight! The gallery, where John Ashbery had given an influential reading of "The Skaters" the previous summer, was operated by Ruth Kligman and her husband, the artist Carlos Sansegundo. It's possible that Joe pulled out at the last minute so he could show at Charles Alan instead.

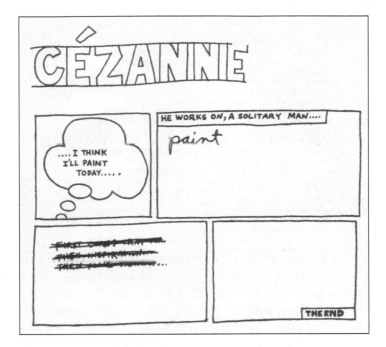

Cézanne by Joe and me, ca. 1964.

The Alan Gallery

JOE'S FIRST NEW YORK SOLO SHOW opened on January 4, 1965. Its announcement carried a commentary by John Ashbery that described Joe's work as "a glittering microcosm, ordered, very formal, very dramatic, and beautiful, and he proves that beauty is really interesting after all." Apparently the word was out, for the *Village Voice* described Joe as a "much discussed and very highly praised young artist," while placing a photo of him, seated in front of five of his assemblages, on the front page of its January 7 issue.

The show occupied the entire Alan Gallery, which was located at 766 Madison Avenue: approximately seventeen glittering, outrageous assemblages of bright pink rubber snakes, plastic flowers, crucifixes, lobster claws, Lucky Strike packages, a moose statuette, rosaries, costume jewels, bowties covered with glitter, ostrich feathers, 7-Up bottle caps, black dime-store dolls, nineteenth-century illustrations of babies' faces, daguerreotypes, a white bird's wing, purple plastic grapes, a rubber fried egg, cigarette butts, a bas-relief of an American Indian's head (including his headdress), bits of colored glass, extravagant gushings of necklaces, fringe, angel figurines, the Virgin Mary, and so on, all eye-poppingly dense and arranged with perfect architecture.

The critical response was mainly favorable. In the *New York Times* Stuart Preston described the show as "fantastic . . . the best of them have a mysterious, quasi-magical power, while the others are tours de force of magpie humor." Charlotte Willard, of the *New*

York Post, didn't care for them ("all too obvious self-consciousness"), but John Gruen, in the January 9 *New York Herald Tribune*, raved: "This debut by a young assemblagist must be considered something of an event." Of course it had been Gruen who had helped secure the exhibition.[39]

Shortly after the show closed, Joe wrote to Jimmy Schuyler that it hadn't resulted in

> any money, but lots of talk, and tons of people came to see it. Good reviews. To be included in several books because of it. And possibly to be a guest teacher at Cornell (arg!), I don't know, if I wish. So I am really not disappointed even tho I do enjoy money terribly. In fact I feel quite good having it all over with. Now I can concentrate more fully on painting.

Eventually a number of the pieces did sell, enough to encourage Alan to offer another show. One work that didn't was *Beige Lace*. Joe added a few new touches to it and gave it to Pat and me. Once a piece left his studio he didn't want it back.

There was a period in which Joe, Kenward, Pat, and I went to the movies ("It seemed like every night," Kenward later said), especially to the New Yorker. Joe and Kenward came up to our Eighty-eighth Street apartment for a traditional Thanksgiving dinner (1964), which Pat was unaccustomed to making, especially for a gourmet such as Kenward. Her trepidation was unfounded: he was an easy guest and Joe loved the Tulsaness of the cuisine. Other hometown favorites of ours were chipped beef on toast with mashed potatoes and peas, and meatloaf with mashed potatoes and string beans. (Jimmy once quoted Joe as saying, "You can't beat meat, potatoes, and a green vegetable.")

Not long after the Alan Gallery show, Joe received a frightening telegram. It was, he told Pat and me, from a U.S. Army sergeant in Washington, DC, asking him to call as soon as possible. Joe feared that the army might be wanting to rescind his 4-F classification. The whole thing sounded odd, so I asked to see the telegram, which Joe fished out of the wastebasket. The message was as he had described,

but it was signed not by an army sergeant, but by Sargent Shriver, who was not only President Kennedy's brother-in-law but also the director of the newly formed Peace Corps (and later the Democratic vice-presidential nominee, along with "dove" presidential candidate George McGovern). It turned out that Shriver wanted Joe to come down to Washington to paint a portrait of his daughter, all expenses paid, money no object, a studio right in the home, etc. Wary of finding himself "trapped" in such an environment and uninterested in doing society portraiture, Joe politely begged off. Maybe too he associated the invitation with another Sargent—John Singer Sargent, whose talented portraiture, according to Joe, descended slowly into a comfortable rut.

The Umbrellas of Cherbourg Apartment

IN FEBRUARY OF 1965, Joe rented a sixty-five dollar, three-room apartment at 240 East Second Street (Apt. 3D), which we called his *Umbrellas of Cherbourg* apartment because he, Pat, and I painted it the pale pastel colors of that film: "lavender and mint green and sunset yellow walls; all in the same room."[40] Unlike his other places, this one felt like a stage setting, with no sense of his actually living there. He was seeing a lot of Kenward, collaborating with him on *The Baby Book*, a parody of the traditional baby book. Their relationship was good, but not perfect. In a postcard depicting Guatemalan Indian dancers in ritual masks, Kenward wrote to Joe: "Let's let off some steam sometime soon, and take off our masks. Because, actually, I *really* love the *real* you."

Westhampton Beach

IT WAS PROBABLY in the late spring of 1965 that Kenward invited Pat and me to Westhampton Beach for the first time. We hitched a ride out from Manhattan with another guest, Ruth Yorck, his closest friend. In 1937 Ruth had fled to America from Nazi Germany, where she had appeared in the first vampire movie,[41] published several novels, married a count, and teamed up with the young Marlene Dietrich in a duo cabaret act. On the wall of Ruth's New York apartment hung a publicity photo of her and Dietrich, their beauty tinged with naughtiness. Oskar Kokoshka was so infatuated with Ruth that he once climbed in her window and told her that if she did not sit for her portrait right then and there, he would shoot himself with the revolver in his pocket. In America Ruth was a writer and translator, but on the Long Island Expressway with us she was a motorway critic in her Volkswagen, glaring from beneath the bill of her baseball cap and referring to a large number of other drivers as dummkopfs. She didn't mind that Pat and I found this funny.

Kenward's house sat right on the ocean, with miles and miles of the beautiful white sand that stretches along the shoreline of eastern Long Island's South Fork. During that visit, Kenward bought a new board game called The Game of Life. The object of the game was to get a good education, great job, spouse, house, car, investment portfolio, etc. Kenward and I modified the rules, the game board, and the pack of cards, and, to inaugurate this new version, Kenward invited Fairfield Porter and Jimmy Schuyler to join him, Joe, Ruth, Pat, and me. We all sat around the board, rolled the dice, advanced our counters, picked

up cards, and so forth. But instead of going to college, Ruth found herself in the Bastille in the eighteenth century. Jimmy was briefly turned into a Chihuahua. Fairfield lost a turn when he landed on a square that made his shoes explode. When the silliness finally became too much for Ruth, she stormed into her bedroom, declaiming in her harsh German accent, "This game is stupid!" A silent Fairfield continued to play seriously. Jimmy joked. After picking up a card that said he was now lost in a swamp, he said, quoting an old advertisement for a bug spray, "Quick, Henry, the Flit!" Pat and Joe, knowing what to expect of the modified game, played along. Kenward and I giggled like children. Finally Jimmy got to the penultimate square, poised for victory, but—oops! It turned out that because we had overlooked a flaw in our rules, the game was unwinnable. Fairfield stood up and left the house, followed by Jimmy smiling and saying, "That was *wonderful!*" I looked anxiously at Kenward and Joe and said, "I think we offended Fairfield."

Joe said, "Don't worry. That's just the way he leaves places."

During the day Joe sunbathed and combed the beach for pieces of glass—particularly those from blue Milk of Magnesia bottles—that had been frosted by the action of the waves. He used these fragments, along with small pieces of sea-worn wood, in what he called "beach constructions."

Throughout this period, collaborative pieces by Joe and Kenward were appearing in the *East Village Other*, a funky, energetic response to the *Village Voice*. Ted knew some of the editors (in fact he had named the paper). Joe and Kenward would do a new piece, and voilà, a week later it would appear in print.

Tulsa Again

In early June of 1965 Pat, Joe, and I drove to Tulsa, using what was called a "drive-a-car" agency. That is, someone had left his or her car in New York with an agency, who then found a driver going to that person's destination. For us the nearest drop-off available was outside Chanute, Kansas. Pat recalls that we ran out of food money somewhere in Illinois, and that in the later stages of the twenty-eight-hour nonstop trip we tortured each other with vivid descriptions of milkshakes and cheeseburgers. The trip couldn't have done much for Joe's plan to gain weight. In a piece written in 1964 or 1965, he described himself as standing five-eleven and as having put on five pounds recently, all the way up to 135.

After spending the night in Tulsa, Joe and I continued on to Chanute. We delivered the car to a farmhouse and then got a ride back into town, where we caught a late bus for Tulsa. On the ride back, I drafted some lines that made their way into a long poem:

> The wind shows off
> The cows fall again
>
> The bus goes pitching over Kansas
> Joe is reading
> I am asleep
>
> I wired the violets[42]

At one point I snuck a glance at Joe. The overhead reading light threw his face into dramatic shadow, and he was so absorbed in his book that he didn't notice my gaze. Although exhausted, I felt elated and even privileged to be sitting next to him and to have him as my friend, and for a moment I sensed an aura around the two of us as our bus careened through the Kansas night.

A few days later, in my parent's garage, Joe attempted to repeat the good luck he had had a few months earlier in cutting Pat's hair, but this time the more he cut the worse it looked, until finally he confessed that it was a disaster and that if he cut any more she would be bald.

Joe stayed for perhaps another week, then flew back to New York, using a ticket from Kenward. It was his first time in an airplane. He sent me a flying saucer postcard with this message: "Flying is the greatest thing I ever did! The clouds are quite unbelievable. I am afraid that I do not understand them at all. And I am not sure I want to."

The evidence is sketchy, but it is likely that he did not visit Tulsa for the next fifteen years, or if he did, it was only once.

Europe

IN LATE JUNE OF 1965, Joe and Kenward sailed to Europe. It was Joe's first time on an ocean liner and his first trip to Europe. Expecting the crossing to be like the one in *Gentlemen Prefer Blondes,* he was disappointed to find not glamourous people like Marilyn Monroe but anonymous middle-class vacationers getting drunker and drunker.

After putting in at Genoa, the ship continued on to Ostia, the port of Rome. From there Joe and Kenward took a taxi to Spoleto, where Kenward was to read at Gian-Carlo Menotti's Festival of Two Worlds. Joe wrote to us that "on the road from Rome to Spoleto there are millions of red poppies growing wild. It is not as bad as one would think seeing something so rare become so common."

At the festival he and Kenward joined John Ashbery, Bill Berkson, Barbara Guest, Charles Olson, Jane Wilson, Yevgeny Yevtushenko, John Wieners, Pablo Neruda, Stephen Spender, Ingeborg Bachman, Allen Tate, Pier Paolo Pasolini, and Ezra Pound.[43] Joe was introduced to Pound at an outdoor café. The venerable poet extended a bony hand. "When you meet him he does not say a single word: he rolls his eyeballs around. He does not look real. He looks like he belongs on a coin," Joe wrote to us. Pound said nothing then or during the subsequent conversation around the table. Joe, of course, did not dare an icebreaker, particularly "I enjoyed your reading yesterday" since, as Joe confessed, "I could not understand a single word he said."[44] Pound had read in such a quiet voice that virtually no one could hear his translations of ancient Egyptian poems and Marianne Moore's translations of La Fontaine.

At one point Menotti took Kenward aside and, referring to Joe, advised him that the Festival did not look kindly upon the presence of "teenage hustlers." Surprised, delighted, and miffed, Kenward assured the composer/organizer that Joe was neither a teenager nor a hustler, but an artist and a genius.

Joe and Kenward visited nearby Assisi, where they viewed the mummy of Saint Clare, Saint Francis's friend and counterpart: "We went to her church and saw her, her clothes, her hair, etc. It was the spookiest thing I've ever seen."[45] A few days later, before catching an evening train to Rome, they visited Perugia and Gubbio with John Ashbery:

> Perugia because of the museum and Gubbio because John read about Gubbio in Marianne Moore and has never been contented since. Now he is contented. We rented a car. Kenward drove. As I have told you before: the Italian countryside is beyond believing. It is as tho it was exactly planned to be exactly the way it is. The grape vines are sprayed with a sea-blue bug killer of the most beautiful color. In the mountains we saw a patch of yellow: they were yellow flowers. John said, "It's as pretty as a picture of a lost glass of ice water." The museum in Perugia is too much to say. Gubbio turned out to be somewhat of a ghost town. Somewhat of a Bruce Conner![46]

Joe also mentioned having "met a beautiful blond boy. Beautiful for one night, but ..."

After the festival, Kenward and Joe flew to Barcelona, then went on to Madrid and Granada, spending much of their time searching for postcards. Joe bombarded Pat and me with funny ones depicting the smooth and smiling face of Rock Hudson, who must have been hugely popular in Spain at that time. What left a far deeper impression on Joe were the Goyas and Velázquezes in the Prado. Joe wrote to us from Granada: "The room after room of Goyas at the Prado are not to be forgotten. Goya was never Goya before. He is now my new favorite painter."

Joe and Kenward then took a seven-hour taxi trip from Granada back to Madrid, during which Joe noted a village called Banana. The European tour was rounded out by a stop in Biarritz and, in

late July, one in Paris, where Joe sent us a postcard that depicted a handshake, saying, "See you August the 5th!" At the end of July, Joe and Kenward sailed back to New York on the *Rotterdam*. The rather dull crossing culminated in a gala, for which the passengers were invited to make paper party hats. Joe and Kenward hid in their cabin.

For Pat, Joe brought back a seventeenth-century Sicilian scapular, an inlaid box from Barcelona, a beautiful pendant from Paris, a Chanel chain necklace, postcards, and holy cards. Pat wrote to her parents: "I tried to find out from him about the cost of various things there, but Joe being Joe I could learn absolutely nothing. He had no idea how much anything cost, foreign money to him is just not money."[47]

Actually Joe was vague about American currency as well, as he once said: "I don't know what I do with money."[48]

40 Avenue B

THE NOVEL COLOR SCHEME of the Second Street apartment became tiresome, and in mid-August Joe moved again, this time to 40 Avenue B (Apt. 3B), near the corner of Third Street. This was the nicest apartment he had ever rented. The five-story building, which had only two units per floor, was quiet and clean. The neighborhood, however, was dodgy. Every night at the corner of Third and B the drug dealers would assemble and deal, and there was nothing glamourous about the people they attracted. By this time Joe was occasionally using Desoxyn, a diet-pill form of amphetamine, to help him work. He was supplied by Ted and other friends, not by the street dealers.

Maybe it was around this time that Joe met Montgomery Clift, probably through Los Angeles friends Don Bachardy and Jack Larson. Whoever it was, they all had dinner out, then went back to Clift's Manhattan townhouse for nightcaps. Clift was completely soused but highly mellow. When someone suggested that it was getting late, Clift offered to see them downstairs to the door. Fearing that he would fall down the stairs, the group assured him that they could see themselves out. Clift waved them off, staggered over to the staircase, sat down, and flowed downstairs on his back. At the door, he insisted that Joe accept his tie, as a gift. Joe found himself outside in the street, holding Montgomery Clift's tie.

Vermont

NEAR THE END OF AUGUST, Joe, Kenward, Pat, and I, along with Kenward's whippet Whippoorwill, left for Calais, Vermont, in Kenward's old Mercedes-Benz convertible. At that time Vermont's interstate highways were not yet completed, so we followed winding two-lane roads edged by mountain forests and rushing streams up through Rutland, Warren, and Montpelier, to Calais, an eleven-hour trip. As it got darker, the roads seemed to get smaller, the houses fewer and fewer, until finally we found ourselves creeping along a dirt path whose trees bent down and brushed against the windshield, as if we had strayed into a forest. Suddenly we emerged into a clearing in the middle of nowhere, and there was Kenward's place, a two-story farmhouse surrounded by the crisp, clean smell of pine.

During that stay Kenward took us to tea at the home of a handsome *grande dame*, Louise Andrews Kent, who wrote children's books under her own name and New England cookbooks under the name of Mrs. Appleyard. She lived in Boston but spent her summers in an imposing and historic three-story house near a rural crossroads named Kent's Corners. Mrs. Kent immediately became my image of the ideal New England aristocrat.

Kenward also took us to dinner at the home of Helvetia Perkins, who had been a close friend of Jane Bowles. Bowles had used Helvetia as the model for one of the "ladies" in her novel *Two Serious Ladies*. In the late 1940s Helvetia, in search of a work retreat from the exhausting, alcoholic round of her sophisticated New York circle, had bought a farmhouse in East Montpelier. Bowles visited

her there, as did their mutual friend John Latouche, the talented young author of the opera *The Ballad of Baby Doe* and the Broadway musicals *Cabin in the Sky* and *The Golden Apple*. Latouche ended up buying his own country retreat in nearby Calais, later sharing ownership of it with his young lover, Kenward. Then, at the age of forty, Latouche had died suddenly of a heart attack.

One afternoon we drove through scenic vistas and the small towns of Plainfield and Marshfield up to Saint Johnsbury and back down through Hardwick, stopping at shops, homes, and barns where antiques were sold, and where Joe's eye invariably went straight to the best item in the place.

After about a week Pat and I returned to New York in time for our trip to Europe.

Between Paris and Avenue B

THE *FRANCE* SAILED on September 21, 1965. Pat and I were headed for France, where I was to do graduate work for a year. With the help of Kenneth Koch and F. W. Dupee, I had gotten a Fulbright to study twentieth-century French literature.

From Paris Pat and I wrote long, illustrated letters to Joe, and he reciprocated. In October he was working on a series of "sky" works, as well as two constructions,

> both of which are driving me crazy. I do insane things to them every day in hopes that something unbelievable will happen. And every day what I do cancels out what I did the day before. And every day what I end up with is a giant mess. But I refuse to give up on them.

He also mentioned having had a "fatherly" dream about Pat: "I have never loved you more. It is sort of funny, though, because I am about as fatherly as a hole in the head. Actually, it was fun being that way."

But his relationship with Ted was cooler:

> Tomorrow I help Ted run off *C.* We see practically nothing of each other and that of course is too bad, but there is not much one can do about it. When we are together nothing clicks. There is a little obligation left, but that is all. I suppose this is depressing, but normal. I am glad that you are away for a year because we will all be sort of different then and it will be a little like starting over and of course that is a good thing.

He reported that *Lines,* edited by Aram Saroyan, and *Fuck You,* edited by Ed Sanders, had accepted some of his writing, and that he was working on *C Comics* 2 and a small book of collaborations with Kenward. He also remarked:

> I find myself with a certain talent that Frank O'Hara has, and that is to say something quite simple so absolutely that one, without even thinking, assumes that you are of course right. This is rather silly since no one is ever right, but I suppose one has to impose oneself somehow. And actually, when one thinks about it, it is quite fun.

Less fun was learning that not a single piece in his show in Toronto the past spring had sold.

Joe's letters to us in Paris showed how his night life and social life had blossomed with Kenward. There were performances by Paul Taylor and Martha Graham, poetry readings by Tony Towle, Ted, Aram—Joe himself read with Kenward and Barbara Guest. In a single week he went to opening parties for Alex Katz and Jane Freilicher, a book party for Edwin Denby, a Thanksgiving dinner given by Kenward and Ruth Yorck, a Jean Tinguely opening at the Jewish Museum, and the Danish Ballet. This was immediately after a dinner and birthday party for Ted.[49]

Lest one start to think of Joe as an art-world gadfly, note his lack of art-world shrewdness: "I sold a construction the other day, which is nice. I forgot who I sold it to, but he is supposed to be a very important collector...."* About this same time, Joe was doing cover designs for two of Kenward's opera librettos, *The Sweet Bye and Bye* and *Lizzie Borden.*

In a letter written in the fall, he announced,

> I am taking pills to get normal: "Trophite" (vitamin B1 and B12). What they do is make you hungry so you eat a lot and then you gain weight. Also I am drinking milk. Did you know that Zachary Scott died?

The run-on is coincidental. That is, Joe was not on a new health regime because Zachary Scott had died.** Sometimes he simply didn't

* Possibly Richard Brown Baker.
** Zachary Scott was not only a film star, he was the husband of Kenward's friend Ruth Ford, the actress known for her starring roles in the plays of Tennessee Williams.

use paragraphs. Anyway, throughout Joe's adult life he periodically established a regime for improving his health and appearance. His use of the word *normal* is without irony. He still wanted to look more like the socialite kids in our high school, and he felt that his skinniness was sexually unattractive.

In the same letter he mentioned having gone with Kenward to the Russian Tea Room, where they bumped into a producer friend of Kenward's and Anthony Perkins, who at that time, because of his starring role in *Psycho,* was a celebrity. "I *really* did shake hands with him." The four sat together and chatted.

> Tony was eating a vanilla ice cream sundae with blueberry sauce. When it had melted he said it looked like a Paul Jenkins. At any rate, he was nice, tho a bit dumb. I got his autograph, and he said he was going by the Alan Gallery to see my work.

Then he reported that Lita Hornick had accepted six of our collaborative works (words about and drawings of roses) for *Kulchur,* and that he had sold the originals to her—for a total of sixty dollars. "I didn't want to ask her for lots of money just because she is rich."

I fired off a heated response. How could he sell our work for practically nothing? We were worth more than that! Apparently I went overboard and accused Lita of having taken advantage of him. His response—the only time he ever showed anger toward me—was a terse note saying that if Lita was as bad as I said, "then you are a shit for having anything to do with her. If you want the six rose things back you will have to write her and ask for them because I will not. Love, Joe." As a postscript he drew a skull and crossbones. Then: "P.P.S. Write a nice letter soon so I will not stay mad." Which I did.

In the midst of his busy social life, Joe reserved time for solitude:

> Tonight will be my usual "night out alone." I go to Times Square and I have a Bloody Mary and ham and sweets at Toffenetti's [a 1,000-seat restaurant at Forty-third and Broadway that he had discovered a few years before] and then I go to the movies. I do this at least once a week these days. There is something very

comforting in doing the same thing over and over. It must be a bit like being married. I mean, the security of it all.[50]

Although Joe was selling some pieces, his cash flow was, as usual, highly irregular. He sent us three Christmas packages by surface mail because he couldn't afford the twenty-five-dollar airmail postage. Also, his large new construction, *Japanese City,*

> is costing me a mint. . . . It is certainly sensational and will be a big hit I am sure. Personally, I think it's a bit of a monster and I never want to see it again after it leaves my apartment. Nevertheless it is very beautiful.

He signed the letter, "Beautifully yours, Joe."

Japanese City was the largest work he had ever done—approximately eight feet long by seven feet high—and he worked madly on it in December for a group show at Alan (January 4-22, 1966).[51]

At the same time, he did what he called "slurp" drawings for *The Platonic Blow,* a homoerotic poem by W. H. Auden that Ed Sanders was ready to print in a bootleg edition. Joe also created a comic strip piece called "People of the World, Relax!" that was in effect a collaboration with himself, and he wrote a short Pop art piece called "Colgate Dental Cream No. 2" and drafted a diary piece called "Saturday, December the 11th, 1965" that was in response to my request for new writing from him for an issue of *C* magazine that I was guest-editing.

In a letter postmarked December 7, he had reported that his teeth were "all finished at last after three hours this morning in the chair." Over the coming years he would return for a great deal of cosmetic dentistry, all in the hope of becoming more attractive.

The dental work was finished in time for him to play a part in Kenneth Koch's *Tinguely Machine Mystery or The Love Suicides at Kaluka,* which was written to be performed among Jean Tinguely's kinetic sculptures at the Jewish Museum on December 22. Kenneth wrote a part for Joe after the announcement card had been printed, so his name was missing from the cast list: John Ashbery, Kenward Elmslie, Jane Freilicher, Kiki Kogelnik, Clarice Rivers, Larry Rivers,

Niki de Saint-Phalle, Jean Tinguely, and Arnold Weinstein. The play—and Joe's part in it—went well, and in a letter the next day he was feeling spunky: "Howdy! Lots of news, and as usual, lots of not news too. I have been doing lots of dirty drawings, and I feel wonderful! . . . Tomorrow is Christmas Eve. Kenward is having a big party and I do wish you were here."

A few days later he reported that he had a wonderful Christmas: "I didn't give you a single thought the entire day. I would feel like a terrible person except that I know that there is no one in the whole world that I love more than you two. . . ."

At the time, Joe was drafting four art reviews—of shows by Roy Lichtenstein, Alex Katz, Robert Mangold, and Jane Freilicher—for *Kulchur*. He had contributed to Lita Hornick's magazine before, a cover design for the summer 1964 issue and a rambunctious, semi-fictional diary called "Sunday, July the 30th, 1964."[52]

Since for Pat and me it was our first Christmas away from America, Joe had sent us two boxes and three large envelopes that contained a trove of gifts, and when they did not arrive on time he was distraught. Added to this was a New York City transit strike and a spell of arctic weather that made it extremely difficult for anyone—including reviewers—to get to the gallery to see *Japanese City*. *C Comics* 2 was at the printers, but even there he felt hesitant: "Do me a favor and do not be surprised if not all of the issue is up to par." As usual, Joe's grasp of money was unrealistic: the estimate for the 600 copies was $950, so even if it sold out (at the list price of $1 per copy) it would lose $350. Along with his letter came a new story, "Brunswick Stew." About this piece, he said:

> I die laughing every time I read it. And it is a good thing that I do because nobody else thinks it is funny at all. It is so difficult being a real artist. The hours are long and the rewards are few. Everybody hates you because you are "different." And then there is the rent to be paid, and the children to be fed. The little wife needs a new dress but there is nothing you can do about it.[53]

The Christmas packages did finally arrive, filled with wonderful things. I remember especially three small boxed assemblages (visible

through the glass front of each box, and resting on a white cotton background, were, respectively, a fragment of a doll's face, a plastic saltine cracker with a drop of blood issuing from it, and a thick band of rhinestones with a lock of brown hair), a portfolio of ink drawings for me to write on (they were so beautiful that I couldn't bring myself to "deface" them), and antique jewelry. He had gone to considerable trouble to assemble, wrap, and ship these things to us. Because of him, Pat and I felt a lot less homesick.

It was perhaps in January that *C Comics* 2, this issue printed offset, came out. His collaborators—in addition to those in *C Comics* 1— were John Ashbery, Dick Gallup, and James Schuyler.

In February he made us feel even better:

> You know, all the things that you keep sending are really great and I am afraid that I do not get around to thanking you all for even half of them. The [handmade] little books are absolutely beautiful! As I said before: you all have really just gotten too good; I just don't know what to do. I'm jealous. And I am jealous of you all being in Paris and all the fun and excitement of it all. I have a picture in my mind of you two in Paris and I see you two running around and everyone thinking you are wonderful and happy and the most exciting people in the world. It is almost like history.

He had just returned from an eight-day stay at Kenward's in Vermont, which was "totally blizzards." At one point Ralph Weeks, Kenward's handyman, had driven up in the deep snow and found Joe and Kenward shoveling a path to their car, using frying pans! Another episode involved an electrical fire in the kitchen ceiling. Lacking a fire extinguisher, Joe came up with the idea of shaking bottles of Pepsi to make them fizz and then spraying the smoldering ceiling with them. This episode was followed by frozen pipes and more snow. Despite all that, he felt the trip had been good:

I would paint Kenward all morning and then draw or something in the afternoon and then we would play Pounce (for stakes) at night. I won some really great things: a Vermont rug (the one with the house and two trees) and that great little cabinet with all the little drawers and the letter box. . . . Kenward won a painting that I did of myself and those (sob!) photographs of you two (please send more) and two nude ladies and a velvet piano throw I had picked up on the way.

Pounce, by the way, is a card game for two or more players, in which each person plays solitaire with his or her own deck of cards, with all players sharing the "heaven" area. The question is how quickly one can play one's hand, especially the cards going into heaven. You have to pounce. We four had played it the summer before, to all hours of the night, with such ferocity that sometimes we ended up with scratches on our hands.

Painting had its challenges as well: "Kenward is very hard to paint. When one *really* looks at his features they disappear. The only hope is to glance at them and pray the hand will follow."

It had been wonderful to wake up to the snow on a sunny morning ("It sparkles and reflects a wonderfully white light") and he was excited by our new project, *Cherry,* for which I had cut up a European photoroman, rearranged the pieces, and supplied new words.[54] Joe was to redraw the images in any style he chose.

The February letter continued:

Through my letters I am sure that you imagine that work-wise all is very well with me and that I am doing and have done tons. This is not true. So much of everything that I have done since you left has not held up one bit. . . . I have reached a funny sort of point somewhere where things are a little different. There are two things that I lack: patience and [two] feet on the ground. I might mean "focus" but I don't like that word. There are really so many different ways that one can go about being an artist, and perhaps one does not have total choice, but one does I know have a considerable say in the matter. I am curious as to would I be better off if I were to concentrate on something (say painting flowers) and really make myself be able to do it so well that that would be where I and the pleasure was [*sic*] . . . I guess that is one reason I

PORTRAIT OF KENWARD

Ink portrait of Kenward Elmslie by Joe, 1965. "Kenward is very hard to paint. When one *really* looks at his features they disappear."

like Alex Katz so much. When I think about him I sometimes think I am just making a bunch of art, which is fine, but . . .

With the letter he enclosed his prose piece "Smoke More" and an artwork consisting only of star-shaped holes in a piece of white watercolor paper: "The starry night is to hang in the window at night if it is not starry and you want a starry night."

In February he asked Pat and me to save our cigarette butts and mail them to him for use in the small assemblages he was making, usually a solid group of butts around a central object. The previous month he had asked us to be on the lookout for hands—from mannequins, on postcards, or in any other form—for his new collection of hands. His collections, which had started in childhood—stamps, salt and pepper shakers, ceramic monkeys, movie stars, seashells, pinups, travel brochures, etc.—were transient. Eventually he gave them away or used them in his assemblages and collages. When cash was short, he sold them.

Late winter in New York continued with a swirl of activity: "There is so much every day that it seems very silly to even try [to describe it]."[55] In addition to a cocktail party for portrait specialist Don Bachardy, a birthday party for Kenneth Koch, a book party for John Ashbery, openings, films, and Joe's own new artworks and writings, he mentioned that Alex Katz was trying to get him a job teaching at Cooper Union. "I think it would really be fun, and very hard. I can't believe that when they see me and talk to me they will still want me." And, for the first time in his correspondence, he sounded a political note: "I hope that the war will stop. The thought of you being drafted scares me to death." Of course this is as much personal as political, but in the ensuing months his letters showed more and more political concern.

In late February Joe gave a progress report on our new project, a collaborative book to be called *100,000 Fleeing Hilda*, based on a series of very short poems I had sent him:

I have been working for a week now trying to *really* <u>do</u> something with *100,000 Fleeing Hilda*. And I almost have. It is not quite finished. What I have been working with (for) is a sort of boring

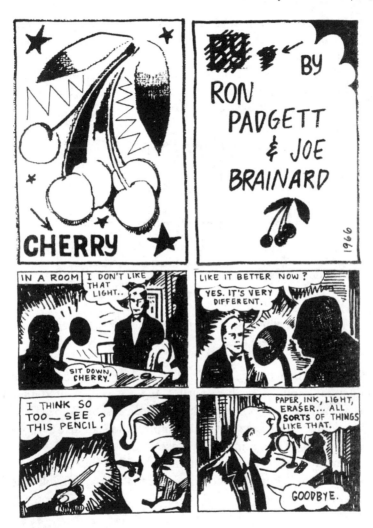

The first page of *Cherry,* 1966, by Joe and me.

detachment between words and pictures: eliminating both con-
trast and any possible relationship. That is to say that the pictures
neither belong nor not belong to the words. Also I have been
working with a certain "offness": an almost boring offness. That is
to say that a shopping bag is not where it ought to be, but it is not
where it ought not to be either. Example:

1. This dot seems properly on the paper.
2. This dot is too obviously (or dramatically) not where it ought
to be. This is modern.
3. There is not much to say about where this dot is. It doesn't make
one even care where it is.[56]

In the same letter he described Fairfield Porter's new show at
Tibor de Nagy as "really beautiful and so well painted that it
hurts. . . . It is as tho brass tacks had been reached." Joe felt that
Fairfield, like Alex Katz but unlike himself, was an artist who had
concentrated on one thing and learned to do it well.

Sometimes Joe even felt uncomfortable about the things he sup-
posedly did well. John Ashbery suggested that they do a book-length
cartoon collaboration,

which, so far, I am forcing myself to do. (12 pages) (so far). It is
really terribly hard because he just writes and then I have to make
up the drawings. . . . I am not really a real cartoonist, and suddenly
that is the position I have put myself in.

When Alex asked Joe to pose for him, he was flattered. In addi-
tion to that, he said, "I have a vision of my tragic death in a couple of
years, and the exhibition of paintings by various painters and poets
of *me* me me me me Me Me ME ME ME!!!!!"

As for his own work, it was

going well, but as I never take pills anymore, a bit slower than usual. I'm not against pills or anything, but they are not available very often, and then on and off is no good. Big constructions are few and far between, but I do tons of drawing. I just draw all the time. I've just become a regular little drawer, that me. I just draw all the time. (Help!)

On March 11, Kenward gave a birthday dinner for Joe, which was followed by a surprise party. Joe was so delighted by the gifts that he sent us a long list of them.

Later in the month he was posing again for Alex: "I love just standing there. At home I always have to be doing something, so it is nice just to stand there for a while." He enjoyed letting his mind wander, until, in a subsequent session, he had a peculiar experience:

All I could think about was you [Ron]. I had to face looking out the window at the Flat Iron Building which said in big letters "Flat Iron Building." All I could think of was crossing out the I in Iron and leaving it as "Flat Ron Building." At first it was funny, then it was sort of infuriating because I could think of nothing else.

In the same letter, dated March 24, he made a first mention of the work that would become what many people feel is his most powerful assemblage, *Prell:*

As more or less of a farewell to constructions I am doing an all-green construction, sort of compiling the best things I have done, but all green. My plan from then on is to paint objects. I don't know why, or where it will get me. . . .

No doubt the examples of Alex and Fairfield figured in this decision.

Then he reported that New York had changed a little: the Batman craze had hit, memorabilia and antique stores with items from the 1920s and 1930s were springing up, pin-on buttons were suddenly the rage, and the underground cinema had surfaced. Even

the Fugs, the satirical-political rock group formed by Ed Sanders and Tuli Kupferberg, now had their own theater (two shows per night). "The policemen are putting people in jail like crazy. There is a giant new crackdown going on. It's really spooky."

A week later Joe mentioned the resistance to the proposed demolition of the Metropolitan Opera House, a big antiwar march, and demonstrations for the legalization of marijuana. Allen Ginsberg was facing a possible twenty-year prison sentence and Ed Sanders was being prosecuted for publishing "obscene" literature in his magazine *Fuck You: A Magazine of the Arts*.

On the nonpolitical front, Joe's account of a visit to Ellsworth Kelly's house shows how balanced his opinions could be:

> He [Kelly] has an absolutely great apartment and studio, and he is very nice, but a bit stupid in that same way that so many painters are stupid. "I never read poetry" (said with a certain amount of pride). All he wanted to talk about was what is valid and what is not valid in art, as tho anything is or is not valid in art. . . . At any rate, he is a very good painter, and accomplishes a lot.

Joe mentioned another artist whose work he liked: "I wrote Ernie Bushmiller and asked him for his autograph, and if one of his drawings of Nancy could be bought." Joe was disappointed that the great cartoonist did not reply—until somewhat later, when Bushmiller got wind of Joe's Nancy works and threatened to sue him. Oh well.

Joe had a somewhat Taoist equanimity in dealing with the "serious" side of life. When he heard that Pat might be pregnant, he wrote to her, "Are you really pregnant? . . . I'll be glad if you aren't. But then, I'll be glad if you are, too. So let me know so I'll know what to be glad about."

In early April he and Jimmy Schuyler went to the Brooklyn Museum, the first time for Joe: "They seem to specialize in the very worst paintings by the very best artists."[57] That evening he had dinner with Jimmy, Kenward, and John Ashbery, and the four of them went on to a party at the Katz's. Two days later, on Sunday the 10th, Kenward gave a huge Easter party:

Frank O'Hara was so drunk he was making no sense at all. Kept wanting me to go into the closet with him so we could "straighten everything out." What he wouldn't say. He did say, tho, that I was "King of the Mountain," but that I ought to be meaner. He also had a long list of compliments and insults for everyone else. The incredible thing is that everyone puts up with it all, including me. One minute he was telling someone they were a shit, and then the next minute he was crying and hugging them. It certainly is a different way to live than the way I know. Somehow, tho, he avoids making himself appear like a fool. It takes talent. And I guess you have to "give in" a lot.

On Easter afternoon, Joe finished *Prell*. Three days later he was working on the third version of his collaborative booklet with Ted, *Living with Chris*, as well as a large circular work using cigarette butts. For the first time he went, with Ted and Sandy Berrigan, to see Warhol's multimedia rock group, The Velvet Underground: "The Velvet Underground was genius! I feel I have tons to tell you. . . . Right now so much is going on I can't tell you all of it and part of it is not enough. . . ." To compensate, he appended a letter from the Timothy Leary Defense Fund that listed his name among its "Literary and Arts Supporters," along with Ted Berrigan, Robert Creeley, Jason Epstein, Peter Fonda, Allen Ginsberg, Nat Hentoff, Kenneth Koch, Robert Lowell, Norman Mailer, Anaïs Nin, Charles Olson, Norman Podhoretz, Ad Reinhardt, Ed Sanders, Robert Silvers, Susan Sontag, Alan Watts, and other luminaries. Artists and writers in New York were growing more and more political—even Joe, to some degree, though as he later said:

> I'm not "anti" anything, really. If I don't like something I just tend to ignore it. I don't claim at all that that's good, but I've never really felt strongly about a cause. It's always been different from reality for me, I think. I can get much more . . . you know . . . over a person, an individual. That's real. I've given paintings and things, but that was generally because I was asked, and I thought it would be a nice thing to do, rather than the fact that it would help a cause. I wasn't very political.[58]

On April 27 he wrote to us, "Today is Kenward's birthday. I am giving him a beatnik party. I die laughing when I think about it, but everyone else seems to be taking it quite seriously." He himself, though, was in a bit of a quandary about our new project, a commercial children's book to be called *Jenny Jump*. Remembering the stylized drawings of skip-roping girls he had done in Mexico, I had sent him a text to work with. He had doubts about the ending ("It's a nice-clean-empty ending, but I'm afraid it's not what people want") and he didn't want to spend a lot of time working on a project that would never be published.

Joe's usual flurry of activity continued into May, when he mentioned spending weekends at Kenward's beach house in Westhampton and reminded us of our invitation to Vermont that summer.

By June 10 he and Kenward had decided to stay in Westhampton for the rest of the month, with an occasional foray into the city. He thanked us for the gifts we had been sending him, including a volume called *Egyptian Ornament*. It was an art book, printed in Czechoslovakia, that had gorgeous color reproductions of decorative patterns. It was "exactly what I needed. It appears in three of my new collages. It was such a beautiful book that it hurt a bit to tear it up." He was planning to take LSD the next day: "Actually, I'm a bit afraid of it. I am taking it out of some sort of obligation. I really don't want to."

When our ship docked in New York on July 13, 1966, Pat and I went to Joe's apartment on Avenue B. Like all his previous places, this one had no phone and the general look was spare, and as usual he slept in the back room and painted in the living room. The amazing feature was the kitchen, whose cabinets, open shelves, countertops, drawers, and under-the-sink storage areas, as well as the refrigerator and the floor itself, were totally thronged with empty Coke and Pepsi bottles, maybe 300 of them, all neatly rinsed. It was like a 3-D Warhol multiple, but it was not an installation piece. Joe was simply loathe to return the bottles for the two-cent refund.

We also found a long note from him: "Happy Coming Home! I am in Maine visiting the Porters and the Katzes, and then to Vermont. Write and tell us when you want to come up." He then

listed the idiosyncrasies of his apartment. The drain in the bathroom sink was stopped up. The pull chain on the light over the sink didn't work: you had to screw the bulb in and out. The windows were all nailed shut. The door was odd: sometimes it took one key to open it, sometimes two. The light in the icebox didn't work. There was something wrong with the hall light. He told us where to find his various jars of coins: we could use them, or, if we need more money, we could sell some of his art books.[59] Also, he asked me to give the originals of *Living with Chris* (the collaboration with Ted) to Peter Schjeldahl, to see if Peter wanted to publish it in *Mother* magazine. He signed off, "Hurry, hurry to Vermont! Tons of love! Love, Joe."

The Death of Frank O'Hara

ON JULY 24, about the time that Joe and Kenward were to arrive in Vermont, Pat and I got the news that Frank O'Hara had been critically injured. I remember standing in Joe's shower as the water hit me, thinking *Frank O'Hara might die at any moment.* I looked down at the line of six Prell shampoo bottles lined up on the bathtub's rim, leftovers from Joe's recent assemblage, glistening their deep emerald green, suddenly evil.

The next day Frank did die, and shortly afterward Pat and I took a train to Vermont. Despite—or perhaps because of—the aura of Frank's unreal death hanging over everything, it was wonderful and comforting to be back in Vermont. We just didn't know what to say. There had been little question of Joe and Kenward's rushing back for the funeral—Joe had a pronounced aversion to funerals.

In the "music" room of the house, Kenward and composer Claibe Richardson spent the days working on their musical, *The Grass Harp*. The songs were witty, melodic, and very singable, and the good-natured Claibe was a delight to be around. Joe was doing tempera paintings, roughly 11 x 14 inches, of small flowers in a Pepsi bottle, but his other works that summer were taking a new tack. In these pieces, the iconography of Madonna and Child was familiar, but, with Pat's help, he was surrounding them with embroidered and appliquéd materials, influenced, no doubt, by Vermont patchwork quilts.[60] Joe was also working on *The 1967 Game Calendar*, a collaborative piece with Kenward, and trying to write an article about

Fairfield, which was, as he wrote to Jimmy, "driving me nuts trying to say something half-intelligent."[61]

On August 11, Joe, Pat, and I drove down to Weston, Vermont, to see our friend Tom Veitch, the author of innovative and irreverent pieces of fiction inspired by Henry Miller, William Burroughs, and Carl Jung. But now, as Brother Robert, he had entered a Benedictine monastery! I found the place quite pleasant—Tom was expansive and relaxed—but Joe thought it was eerie.

In August, Kenward was called away for the launching of *The Grass Harp*. Pat (now six months pregnant), Joe, Whippoorwill, and I were to hold down the fort. I use this seige expression because all of us had been made edgy by the recent news that a deranged young man in Austin, Texas, had climbed up in a tower on the university campus and started shooting people below.[62] Around ten o'clock the night Kenward left, I thought I heard the faint strains of distant music, but when I approached the back screen door I realized that it was coming from a radio in the nearby bushes. When I called out "Hey!" the sound of running footsteps streaked around the house toward the road in front. I told Pat and Joe to turn off the lights and lock the doors. We peered out and waited, but there was not a sound. Isolated in the woods, we had neither phone nor firearm. The idea of staying there all night with a lunatic or other type of mental defective lurking about—for who else would listen to a radio while window-peeping?—caused us to rush out to the car and speed off toward Montpelier, leaving Whippoorwill (some watchdog!) behind. Later, whenever the subject of the prowler came up, Joe would make big eyes and say, "Spooky!" But it was fun spending the night unexpectedly in the big hotel in town.

Kenward had bought a home photostat machine, something like a photocopier. I don't think photocopiers for private use were available at that time; the home photostat machine itself was a novelty. With it Kenward, Joe, and I produced very limited editions of booklets of poems and drawings, mostly for each other.

Joe, Calais, September, 1966. Photo: Ron Padgett.

It's possible that Joe and I intended to use it to print a few copies of *Little Jeanne,* a children's book that, in late August and early September, I wrote and Joe illustrated. *Little Jeanne* was part of my grandiose scheme to write a series of works that played off traditional genres. That summer I attempted two: a pornographic children's book and a pornographic cowboy novel. The latter got no further than the first chapter, when I realized that I had only the feeblest sense of how to write *any* kind of cowboy novel. The children's book, which was for adults, was not erotic (though Joe described it to Jimmy as "dirty"); it was a deadpan parody of an oneiric story about a little French girl who becomes a child fashion model after World War I. Joe did black-and-white illustrations and I typed the text, leaving spaces for the pictures. The camera-ready copy even had a cover design and a colophon page. The project halted because of my last-minute doubts about the text, not its sexual content but its structure and narrative flow. Given the current public outrage against child pornography, it may be hard to see the innocence of our project—perhaps *naïveté* is a better word for it. Or *tunnel vision.* My interest was in taking on a new and difficult aesthetic challenge, that of writing a pornographic children's book that would succeed as art. I didn't care that such a book would be an affront to conventional values. Joe liked to push the boundaries too, but his drawings were quite chaste. We dedicated the book to Pat.

In September, she and I returned to New York and stayed a week or so with Ted and Sandy. Joe came back too. Using Pat as his assistant, he continued to work on the "tapestry" pieces he had started in Vermont. He and Pat quickly fell into a routine of eating at a particular diner at Avenue A and Third Street, where, with her pregnancy showing abundantly, she became known as "The Little Mother." After Pat and I left town, the waitress and cashier asked Joe, "Where is The Little Mother?" but, as he later wrote us, "I have neither the desire nor the heart to confess that I am not the daddy." So he avoided the place.

By now Pat was seven months pregnant and we had no jobs and almost no money, but in Tulsa we would have a roof over our heads, at my parents' house, which had been mostly unoccupied since their

divorce. Given the circumstances, Tulsa would be a more manageable place to have a first baby than New York. In early October the two of us signed on for a drive-a-car and headed toward Oklahoma.

Joe's first letter to us in Tulsa continued in the vein of his letters to us in Paris: he had just seen some Noh plays with John Ashbery and Kenneth Koch, Grove Press was to republish Ted's book *The Sonnets*, he was doing a cover for Dick's play *The Bingo*, John was giving readings, Bill Berkson was editing an artists' book on Frank O'Hara for MoMA, Kenward's *Power Plant Poems* was ready to be printed, etc.

Since I was in Tulsa and not Paris, my responses were somewhat less excited and breathless, and with the birth of my son Wayne, on November 29, my world shrank, for a while, to the size of our house. Joe and I did correspond a lot about *100,000 Fleeing Hilda,* its production and eventual distribution.

I don't recall our having said much about his participation in *Bean Spasms,* a book of collaborative works that Ted and I were putting together for Kulchur Press. For Ted and me it was a given that Joe would take part, and since I was far off in Tulsa, I let them decide on the visuals, though I did send Joe a postcard of two chimpanzees at a typewriter, which I suggested he redraw and use as a frontispiece. On this project Joe was our slave, as he wrote to Jimmy: "I have almost finished Ted and Ron's book. It has been very hard because I have been trying to do what they want me to do."[63] By the way, in *Bean Spasms* there is a drawing of a coffee cup, signed and dated 1965 by Ted, but I'm pretty sure that Joe did it, basing it on a drawing of Ted's. On another page are the words BE BIG in large bold letters. The creator of this work has never been identified—in fact Ted and I wanted to blur and blend our identities throughout the book—but I'm fairly certain that this page is entirely Joe's, an updated and semi-ironic expression of the ideas that originally had catapulted him into serious art.

PART IV

Up

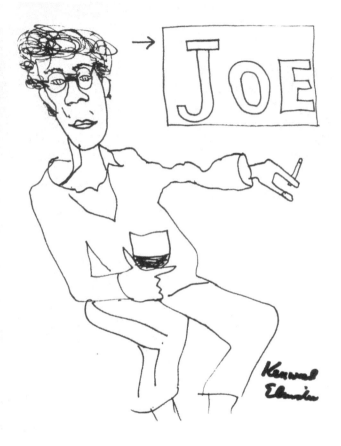

Kenward Elmslie's portrait of Joe, Calais, ca. 1968.

Starting Over

EARLY IN NOVEMBER OF 1966, Joe had written to us that he had gone on another of his start-over binges:

> Yesterday I spent the day cleaning up and clearing out my work room. You would not believe it. There is nothing there anymore. Today I am going to paint over the paint splashes on the walls. The floor is mopped and the closet is packed. The windows are nailed over with white boards so as to keep dirt out. I can hardly wait to start painting. I don't know if it makes sense to you or not: painting the way things look. But for me, now, it is wonderful. It leaves you wide open. Also, it is like "beginning again," which has always appealed to me. Also it is very hard, and also allows me to be surprised at myself now and then. I have not been surprised at my collage ability for quite some time now.

Some nice news was that "Fairfield Porter gave me a beautiful painting of wildflowers (yellow). I say 'gave' because it is quite large and good in comparison to his tiny tempera Brainard. (Blush.)" Then he quoted Thomas B. Hess's commentary on *Japanese City:*

> Joe Brainard's *Japanese City* rejoices in similar polyphilo-progenitive energies. The gimcrack parts (artificial flowers that would make an undertaker weep, beads that Sadie Thomson would consider outré), as they are repeated and multiplied, take on a severe Gothic radiance.[64]

Joe added: "It doesn't mean much, but there are four words I like: energies, repeated, multiplied, and radiance."

By mid-November he was having no luck painting flowers, though one day he reported: "Work going a bit better. Poppy-like flowers (the winter flower shop kind), large, in layer upon layer of colored inks." He also described an enjoyable birthday party for Ted on the 15th and said that he and Ted might become art critics for the *Village Voice*. For Pat, to make up for forgetting her birthday, he enclosed "an original Max Ernst," an unsettling collage depicting the lower half of a muscle man's body in front of a collection of bizarre undersea life, and at the bottom a set of false teeth. For many years the Ernst collage stayed in a steamer trunk under our bed, along with other artworks. After Joe's death, Pat and I looked at it with new eyes and wondered if it really is an Ernst. Or a Brainard.

By November 21, Kenward was in Providence, rewriting *The Grass Harp* for its opening there, and Joe was feeling listless. A series of bad work days, an Ad Reinhardt opening, some plays at the Judson Church he didn't feel like going to, halfhearted interest even in a dinner with Alex and Ada . . . One bright spot for him was some progress on a short piece he was writing and illustrating, *The Ron Padgett Story*.

The *Village Voice* needed convincing that Joe was worthy of being their art critic: "There seems to be some doubt about my abilities, and I don't feel like proving myself. So—either they take a chance, or 'no soap,' as Mr. Tide would say." But Jack Larson, the actor who played Jimmy Olson in the Superman movies and TV series and who had gotten to know Joe, was in town, and Joe had had a nice lunch with Harry Mathews. Jimmy Schuyler had given Joe an oak leaf from de Kooning's lawn, which Joe enclosed in his letter. He had just had his recurring dream about finding jewels. This time, in a bombed-out apartment house, he found a chest, in one of whose drawers were "quite a few necklaces, pins, etc.: all of dark red garnets." He felt that things were going to pick up soon.

In early December Joe learned that Rudy Burckhardt wanted to use a prose piece of his in a new film and that Rudy wanted *him* to do the voice-over because nobody else quite knew how to read the

text aloud. On the down side, the new issue of *Tzarad-New York* had just appeared, with a piece by Joe in the form of a letter to his houseplant: "I am very embarrassed by that letter to a plant. I must have been out of my mind. I'm going to hide in the closet for a few days." He then confessed to having been depressed lately, "but as I tend to take advantage of most situations, it is not all that bad." Because he had spent all his money on Christmas presents, he was broke, but he knew that he could sell some of his collections, and that he could get an advance from Mr. Alan, and that the dividends from his stocks would be coming fairly soon. Apparently Kenward had given him these stocks.

As a Christmas gift, Joe sent us a self-portrait in the form of five small glass bottles with photomaton pictures of himself inside them.

Denmark in Providence

IN PROVIDENCE, work on *The Grass Harp* was continuing up to the last moment. Because it was Kenward's first full-scale Broadway musical, he was under enormous stress. His hands had begun to shake, a recurrence of a symptom of his teenage anxiety. He even rushed down to New York to see a doctor. Realizing that Kenward needed emotional support, Joe abandoned his own schedule and went to Providence on December 19. He didn't want Kenward to be alone at Christmas, especially under the circumstances.

Joe rated the musical's opening night a hit. He loved it and the three Broadway stars—Barbara Baxley, Carol Bruce, and Elaine Stritch—who played leading roles. The audience loved it too. However, the local critics weren't enthusiastic, and Kenward and Claibe continued to rewrite, with the dwindling hope that a trimmer version of the show would move to Broadway.

During his stay in Providence, Joe described a recent experience:

I was reading this ad in the *New Yorker* for Denmark which is unbelievably hideous. I don't think I'll ever be able to forget it. One thing for sure, I am never going to Denmark. The slogan was: "Denmark—little land of good living. . . ." Can't you imagine the "Little Ol' Winemaker, Me" (from TV) living there? What I saw was a kind of nightmare Walt Disney place: terribly crystal clear and colorful. So much so that one could not possibly walk out of doors. Also cottages with bright green ivy, peasants with white aprons, and lots of cheese and grapes. I wish I could tell you how

hideous this place I imagined really was. It was so bright that it made me spin. (Dizzy.)

Although his work—small tempera paintings of flowers—was going quite well, he wrote on January 13 that he would be "ultra-glad" to be back in his apartment in a few days.

Shortly after his return, he wrote to us that Don Bachardy had sent him a "real Marilyn Monroe autograph which he got from her personally at the world premiere of *How to Marry a Millionaire*!!!!!!!"

By January 27 he was working on what he called a garden:

Every day I paint all these flowers and then as soon as I get enough I'm going to cut them all out and make a garden out of them. It's sheer torture, but I keep telling myself how beautiful and big it will be. I hope. I hope. . . . It's only 3:30 and already my head is too heavy to keep working. It does something to me, painting those hundreds of flowers. It's going to be very hard to keep it from evaporating into wallpaper.

Throughout this period, his cartoons continued to appear in the *East Village Other*.

Finally, in February of 1967, *100,000 Fleeing Hilda* came out, and, despite our doubts along the way, both Joe and I were pleased with it.[65]

On February 20 Joe reported that he was working on "the garden and the big Mary" (perhaps the piece later known as the *Madonna of the Daffodils*), and that the Valentine's Day party he and Kenward threw was "the best party I've ever been to."

More about Parties

ON MARCH 10, 1967, I returned to New York to look for an apartment, just in time for Joe's birthday party the next day in the small three-story garden house Kenward was renting at 28½ Cornelia Street, a few doors down from the Phoenix Bookshop, where Ted, Joe, and I had sold our poetry books and magazines when we needed cash.

The parties at Cornelia Street were crowded and convivial. Among the guests were Kenneth Koch, Ruth Yorck, Ruth Kligman (Jackson Pollock's girlfriend who was in the car wreck that killed him), Leo Lerman (the editor of *Mademoiselle*), Bill Berkson, D. D. Ryan (a photographer and café society figure in the fashion and theatrical worlds, and later Halston's right-hand person), Morris Golde, Tony and Irma Towle, Gerard Malanga, and Andy Warhol. (A year or so later Andy gave Joe a birthday party.)

Bill Berkson and his date Bianca Perez de Macias (later Bianca Jagger) were among the guests at one dinner party in which everything served was white: vichyssoise, fish, mashed potatoes with cream gravy, endive and white radish salad, blancmange, white chocolate, Pouilly-Fuissé.*

When Kenward moved to a larger place on Greenwich Avenue a year later, the parties grew and the people were always interesting, talented, various, and witty—people such as Edwin Denby, Rudy Burckhardt, Yvonne Jacquette, Marisol, John Ashbery, Barbara Guest, Ned Rorem, Alex and Ada Katz, Ted and Sandy Berrigan,

* It was a coincidence that someone named Bianca was at a "white" dinner.

in addition to those named above—and great food, drink, and marijuana were abundant. Poets, artists, composers, actors, and socialites all commingled easily, erasing the lines between economic levels and social classes—between "uptown" and "downtown." Those evenings were so upbeat and filled with urbane conviviality that they still sparkle in my memory.

Joe loved them. Back in late 1964 he wrote to Jimmy:

> Several parties are happening and I am glad. I always have a feeling something really great is going to happen at a party. Tho it rarely does I like them anyway, altho I don't know exactly why because I am a horrible bore at parties. But I look tremendously forward to them anyway.

Early on, Joe's stutter had made him more of a listener than a talker, but now he was amid highly sociable and verbal people who were delighted to have such a good listener. Besides, everyone admired Joe's work and liked him, perhaps even more for his shyness (an unusual characteristic in *this* crowd). These parties provided a social occasion in which he felt successful, popular, and at ease, all three probably for the first time in his life.

But it was more than that. Joe also liked most of the people, finding them interesting or entertaining in one way or another. And it was as if he couldn't help but notice things about them—their dress, their speech patterns, their way of looking around the room. His knack for social analysis had started to surface. Over the years that followed, Joe might be misinformed, but his direct perceptions and gut instincts about people were unerring. And his way of stating his observations was so concise and simple that you wondered why you hadn't noticed the same things yourself.

For a small dinner party at Kenward's in honor of Stella Adler, Joe created a one-time work that was taped to the wall behind her chair: a huge sheet of white paper on which he drew a large valentine heart filled with several hundred lipstick kisses, below which was a banderole with her name, all in the style of an old tattoo. Floating around the big valentine were smaller all-red ones. The guests included Red Grooms, Alex and Ada Katz, and John Ashbery.

For one Christmas party at Greenwich Avenue, Joe painstakingly taped Christmas tree ornaments to the entire ceiling, creating a glittering overhead wonderland.

At the larger parties Joe indulged his unalloyed pleasure in dancing, especially swing dancing. Dance crazes came and went but he remained true to the classic moves of traditional swing, which he had mastered in junior high school. For many of his women friends he was their favorite partner. For him, dancing was a way of letting go, but in a very organized way, like making assemblages and collages.

Pat and I, now brave young parents with our baby Wayne, moved back to New York around April 1, 1967. On April 2 Joe sent us a letter—neither of us had telephones—to welcome us back and give us the latest news, adding that he was feeling "very good these days. But what I would really like is some pills." The word *really* was underlined twelve times and the pills he refers to were any form of amphetamine. In any case, we had returned in time to see Joe's second solo show (April 1967) at the Landau-Alan Gallery—Charles Alan had taken on a partner, Felix Landau, the owner of one of Los Angeles's best galleries—a show of dazzling Madonnas and gardens, along with *Prell*, the apotheosis of his constructions. The April issue of *ARTnews* carried a "garden" cover by Joe and a long article about him by Jimmy Schuyler.

Southampton and Vermont

FOR JUNE AND PART OF JULY OF 1967, Kenward rented Fairfield and Anne Porter's place in Southampton, a large two-story rambling white frame house built in 1800 by a whaling captain. Situated on a capacious lot, with tall hedges, forsythia and lilac bushes, stately elms, horse chestnuts, and sycamores, the Porter house had a highly attractive air of threadbare gentility. Behind the house was a grape arbor, a two-car garage, a tool shed, and a barn, the large hayloft of which served as Fairfield's studio. The property doglegged into a field that went all the way down to Agawam Pond, around fifty yards away.

Joe and Kenward arrived on the evening of June 4. They were sharing the house with Jimmy Schuyler, who lived there with the Porters. The next morning, according to Jimmy,

> Joe went into the studio and hasn't been seen since, not much anyway. He's painting in oil which he says is impossible, but I thought a couple of them already were very pretty. Last evening we were looking at all the swelling buds and he said, "I hope I get good in time!" I rather think he will.[66]

At the Porter house Joe also did a series of lush gouache and tempera still lifes of flowers, inspired partly by Fairfield's paintings of objects on the dining room table. Joe worked during the day, with an occasional afternoon at the nearby beach. The evening social life was urbane: Jane Freilicher and Joe Hazan, Jane Wilson and John Gruen, Barbara Guest and Trumbull Higgins, Arthur Gold and Robert Fizdale, Larry and

Clarice Rivers, and others were nearby. John Ashbery, Kenneth Koch, and J. J. Mitchell came out from the city for visits.

After the success of his Landau-Alan show, Joe had set a new goal for himself: oil painting.

> I'm beginning, at last, to feel a little bit comfortable with oils. It's very weird. Like starting all over from the beginning. Here I am, I'm supposed to be a pretty good artist, and suddenly I'm not. So it's rough on the morale. Also it's nice. I mean good. To work rather than make art.*

Joe added that Southampton was beautiful, and if we had a chance to come visit, and we saw Ted first, would we try to get some pills from him? Pat and I and baby Wayne did go out for a weekend in late June. I can't recall if we took him any pills, but the chances are that we did.

Around July 10 Pat, Wayne, and I went to Kenward's in Vermont. Joe and Kenward arrived from Southampton on the 21st, immediately followed by poet and *Paris Review* editor Tom Clark. A routine quickly developed. Joe, Kenward, Tom, and I worked during the day and then we had wonderful dinners, burnished with wine and marijuana. Late in the summer we gathered some of our new work into a seventeen-page, 14 x 22 inch portfolio, printed in hand-set type by a shop that produced local auction posters. I tried to imagine the bewildered face of the small-town typesetter as he scrutinized our manuscript, which we called *Wild Oats*.

Then Tom left and Jimmy arrived. We had a lovely time driving around the area with him. Jimmy had a knack for saying things that sounded as though they were from unwritten poems of his (and which I secretly wrote down). For example, at a corner in Saint Johnsbury, he noted, "We're at the intersection of Spring and Winter," which happened to be true. Others included: "Half the housewives of America reeling around," "Pyramids of milk," "It makes a nice cloud rack," "Hotpoint used to make a toaster called El

* Jimmy wrote to Pat and me that Joe "has mastered the oil." Letter of June 12, 1967. He wrote to the Porters: "Joe is in the vast studio painting small pictures of roses and trees—very beautiful. It didn't take him long to master the oils." Letter of June 13, 1967.

Toasto," "The tree that hill is starring," "It's like the moon—it doesn't mean much until you've seen it," and "If your edges aren't completely covered, do you get droned out of the society?"

I must have been tuned into what people were saying, as Jimmy wrote to the Porters:

> Ron is very funny with Joe & seems to collect things Joe says. . . . After a drive into Calais [Jimmy must have meant Maple Corner or Montpelier] he said Joe kept saying, "There's a touch of autumn. There's another touch of autumn!" And he just came in and said, "Joe's outside getting a tan on what he calls his 'front.'"[67]

Jimmy also reported that Joe had us doing decoupage:

> Joe has got everyone (including me) cutting pictures out of 1925 *McCall's* and pasting them on boxes and pieces of wood and things. That's what we do in the evenings, besides hearts or chess.

Actually, we carefully cut hundreds of images from advertisements in old magazines and glued them onto small wooden boxes, cigar boxes, breadboards, and small tabletops, finishing them with a preservative coat of polymer or Elmer's glue.

Around September 10, Jimmy, Pat, Wayne, and I motored to Great Spruce Head Island, Maine, for a visit of six days at the vacant Porters' summer house, before continuing on to Southampton, where we dropped Jimmy off and then went on to New York City.

For the rest of the month and into October, Joe and Kenward bounced between Vermont and New York. Joe wrote that "out of desperation I am making gardens again. Somehow I've got to make some sort of contact (get into that position) again, even if I have to repeat myself to do it."

Alex Katz's efforts had proved successful in getting Joe a teaching position at Cooper Union. "I don't really want to [teach], but I figured it'd be good for me."[68] Joe later told me that he was a terrible teacher, since all he did was sit at the front of the room reading until a student asked for help. He couldn't bring himself to say anything negative about the young students' work, even when he suspected that it might prove beneficial. After a year or two at Cooper, he decided not to return.

74 Jane Street

By early november of 1967 Joe had moved to a second-floor studio apartment at 74 Jane Street in Greenwich Village. The apartment's one room was of decent size, and its two front windows looked out onto the quiet and lovely street. It was Joe's first apartment in a nice neighborhood.

In early December I received a postcard from Teeny Duchamp saying that William Copley had decided to give Joe a $2000 grant. The two had never met. All Joe had to do was send Copley a résumé. Joe, who knew of Copley as part of the American artistic circle that included Marcel Duchamp and Man Ray, was bowled over.

The illustrious names flew thick and fast. On February 29, 1968, Morris Golde, a congenial patron and great appreciator of the arts, gave a party for Kenward and Joe that was thronged with Joe's artist and writer friends, as well as classical music luminaries such as Virgil Thomson and Leonard Bernstein.

Jamaica

In march of 1968 Joe and Kenward flew to Jamaica with Jane Freilicher and Joe Hazan and their young daughter, Elizabeth. The five of them shared a house not far from Montego Bay. In a card postmarked March 8, Joe wrote:

> This is a part of Jamaica I have not yet seen. And probably won't. "In town" Jamaica gives me the creeps. Out here on the hill we have wild peacocks and poinsettias. Also orchids and geese. Buzzards are very big and swoop very low. A pool. And two maids.

The part of Jamaica Joe had "not yet seen" was depicted on the other side of the postcard: a group of highly crazed Jamaicans on a dark beach enacting what looked like a ritual execution. (The card's printed text described it as a "dramatic native show.")

A similar note of unease, though without any humor, permeates the diary Joe kept on this trip, beginning with the first entry (March 2): "What I feel right now is that perhaps I shouldn't be here. That perhaps I have no right to be here. That perhaps I don't deserve to be here." Was he out of place because he himself couldn't afford this lifestyle, or because he felt like a comfortable white intruder in a poor black country, or both?

In the next day's entry he sounded a similar note: "I don't like having two maids. I can't ignore them. It seems that I am continually saying 'hello' to them." Of course, someone accustomed to hired

help would have no such problem, but as someone from a family that couldn't afford even a used car until he was fourteen or fifteen, Joe never did feel comfortable watching people work for him. One time, at a Sunoco station in Montpelier, Joe told me, as the attendant cleaned the windshield, that just sitting there doing nothing while someone else worked had always made him anxious. In the diary's March 9 entry, Joe returned briefly to the wealth leitmotif when he mentioned trying to write a script for a new movie by Rudy, starring Edwin Denby as "a nice rich man." The script, unsurprisingly, was proving problematic, even though the rich man was to be nice. Incidentally, Joe's continuing inability to come to grips with money was reflected in the question that is repeated throughout the script he finally did complete: "What is money?"

The Jamaica trip had probably been planned as a birthday present for him, but in the diary's final entry (March 11), Joe dismissed the occasion in one bald sentence: "Today is my birthday." Then he thought about New York, where most of his friends were, and his feeling for friendship rose at the end: "If you are one of my friends let me tell you right now that you are absolutely terrific. I know how lucky I am."[69]

The publication party and exhibition for *The Champ,* a collaborative book by Joe and Kenward, took place at the Gotham Book Mart on May 25. For this book Joe had read Kenward's manuscript and then done a number of drawings, more or less in the spirit of the text. At first he did drawings all in the same register, but found the overall result boring. So, as he wrote to Jimmy, "I'm just going to draw and not worry about what I'm doing. I'll worry about it when I start making my selection."[70] Actually both he and Kenward made the choices, by putting the manuscript pages and drawings on the floor and sequencing them fairly spontaneously, without much thought as to connections between text and image. As usual, Joe had avoided illustrating the words, to keep the whole thing open. Kenward's noun-dense text automatically suggested connections to the images, but imposed none.

Joe, in the hayloft doorway of Fairfield Porter's studio, Southampton, 1968. Photo: © D. D. Ryan.

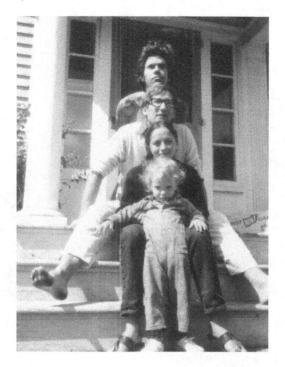

Joe, Kenward, Pat, and Wayne, Calais, summer 1968. Photo: Ron Padgett.

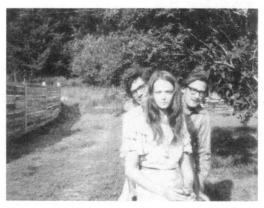

Joe, Anne Waldman, and Kenward, Calais, 1969. Photo: Lewis Warsh.

Joe and Kenward spent May in Vermont and June in Westhampton Beach, and then again rented the Porter house in Southampton for July and August. In July I wrote to Joe, inviting him to design the cover of my forthcoming book of poems, *Great Balls of Fire*. He wrote back: "Yes, I certainly would like to do your book. In fact, I'd *love* to. I will do my best ever on it." He went on to talk about his recent work: "I am doing my best work right now. It is a garden but of a different sort (more abstract). It is the best thing I've done in years it seems that I am really nuts about." Life in Southampton had been good, so good that he saw himself "in a few years as not a New Yorker," though he didn't specify where else he might live. Perhaps the Hamptons? They looked even better after Bill Berkson took him to visit de Kooning in East Hampton on July 8.

After a two-week trip to Tulsa, Pat, Wayne, and I made our way to Southampton, where we stayed with Joe and Kenward for a few days, until around August 10, when we went to Provincetown, where for about a week I worked with Jim Dine on a collaborative book.[71]

Joined by Pat's sister Tessie, we Padgetts then drove to Kenward's in Vermont. Joe and Kenward arrived a week later, the evening before I went to the hospital emergency room: my lung had collapsed again. Then Bill Berkson arrived. When Joe, Kenward, and Bill saw that my situation was not so serious as it sounded, they clowned around at my bedside and helped raise me slowly out of the murky depression that had descended on me. I don't think my medical condition caused anyone to stop working, especially Joe.

In any case, he and Kenward drove down to New York for one day so that Joe could teach, on September 10, then drove back to Vermont that night, for one more week there.

Around Thanksgiving 1968, Joe visited his parents in Tulsa, but reluctantly.* It wasn't that he disliked his parents or bore them a grudge, even though they felt that once children leave home they should support themselves entirely. In fact Joe was fond of his parents, writing them regular (if cosmetic) letters and sending them

* At least I *think* he visited them then. In July he was planning to, and in a letter to Jimmy in 1969 he mentioned having gotten a scrapbook in Tulsa. Otherwise I have no evidence of such a visit. His brother John and sister Becky do not recall one.

choice birthday and Christmas gifts. His reluctance to return to Tulsa was due partly to its distance from New York City and due partly to the fact that he couldn't make art while in Tulsa—making art virtually every day had become an integral part of his life. It was also due to his distaste for Tulsa's increasing political and religious conservatism, the latter epitomized by Christian evangelist and faith healer Oral Roberts. But the main reason was that Joe didn't know how to revert to being the boy his parents had known, they did not know how to get to know the person he had become, and neither he nor they were willing or able to break out of their old roles. In the Brainard family, direct or probing personal communication was not a strong suit.

For Joe the most glaring though unacknowledged issue was his sexual orientation. Thus in Tulsa he feared even the possibility of unasked questions such as "Have you met any nice girls? Have you thought about getting married?" Having to conceal or temporarily "forget" his homosexuality made Joe uncomfortable. He was happy with who he was, but it seemed unlikely to him that his parents would be, and he saw no point in upsetting them. But in general, as Joe put it, "I hate being in any situation that is over with."[72] "Tulsa" was over with.

The Unfinished Clause

JOE'S THIRD SOLO EXHIBITION in New York ran from March 22 to April 17, 1969, at Landau-Alan. This visually luxurious show was reviewed by Peter Schjeldahl in *Art International:*

> Joe Brainard's show of flower paintings and collages at the Landau-Alan Gallery, though modest in scope and scale, further confirmed the presence in our midst of a prodigiously talented and original young artist. . . . Like Watteau, Francis Picabia, and Andy Warhol, he engages subject matter in a personal, anti-conventional way so pervasive as to render sterile any strictly formal analysis of his work. What makes an artist of this kind so difficult is precisely what makes him so interesting—he insults or evades every habitual approach to art. He will be unique or nothing. . . . In line with Yeats' dictum about poetry, these works have been labored to remove all trace of the artist's exertion. Their real identity comes as something of a shock, like a snowball with a rock inside it. It *is* rather unsettling to confront a perfect little watercolor of some pansies with the consciousness that no "appropriate response" is possible. Like Nature herself, it challenges us to account for its complete, unambiguous beauty, and of course we can't.[73]

Peter, who had been a friend and astute admirer of Joe's work before becoming an art critic, was perhaps the first to bring up an important issue: most of us look at Joe's work and can't think of

135

anything to say except "That's beautiful." Back in 1966 I myself had tried to write an essay on his work, but it never amounted to more than a mass of jottings. Joe's work didn't give commentators an easy "handle."

However, John Ashbery, ever the graceful stylist, wrote in *ARTnews:*

> Joe Brainard reminds one of Proust's gallant remark to the painter Madeleine Lemaire that she had created more roses than anyone after God. Brainard gives both a run for their money, if not with roses then with pansies, and with tulips and poppies tied for second place, row upon row of garden-variety flowers painted with meticulous deftness. . . . The effect is always of profusion and of strangeness beyond that. What is a flower, one begins to wonder? A beautiful, living thing that at first seems to promise meaning . . . but remains meaningless. . . . Here they merely continue, each as beautiful as the others, but only beautiful, with nothing behind it, and yet. . . . The unfinished clause secretly binds the work together and raises it above a high level of provocation.[74]

John's description of "row upon row of garden-variety flowers" brings to mind Joe's view in church on Easter Sunday when he was a child: "From up in the balcony, a whole congregation full of flowery pastel hats that made the sermon go a whole lot faster."[75]

About five days after the show's opening, Joe asked me about the cover he was to design for my *Great Balls of Fire:*

> When I saw Jimmy's book with Alex's cover [for *Freely Espousing*] and saw that [the publisher] had converted his lettering to type I realized, again, how much I hate type on a cover. . . . I know you want type on the cover because you made a point of saying so. The one thing I want most for the cover for your book to do is to please you. So—what should I do? . . . Would you be happy if I hand lettered the jacket but hand lettered it to look like the type in the book?

I thought this was a great solution.

Joe had been in bed since his show's opening: stiff neck, depression, and intestinal flu. He was feeling much better, but the letdown was lingering. In a May 21 diary piece, he hoped that the reading he was going to give that very evening (with Bill Berkson) would be good

> just because I do, and because I feel a little bit bad about my show, and this reading, I hope, will help make up for that. (For it.) Not that I think my show was bad. I don't. I gave it everything I had. But it was rushed, and, basically, a bit false. I'm not really that interested in gardens anymore.[76]

Part of his motivation for doing more gardens was simply to please his friends and admirers, who liked those works enormously.

When I began writing this book, I had a certain concept of the trajectory of Joe's life, but as I got deeper into the details and discovered new information, my concept began to look thinner and thinner. It had been tinted rose by my perennial optimism (or knee-jerk denial). I had seen Joe as someone who had his ups and downs, but I had minimized the seriousness of the downs. When, in his letters, he spoke of being depressed or lethargic, I ascribed it partly to his tendency to dramatize, alone in his studio—a tendency he himself often admitted and laughed about. Besides, most everyone I knew was subject to the occasional funk. Gradually, though, the evidence mounted, until I was finally struck by the gravity of some of Joe's bouts of insecurity, uncertainty, and despondency. For example, in May of 1969 Ned Rorem asked Joe to design a cover for the forthcoming edition of his *Four Dialogues for Two Voices and Two Pianos,* which had words by Frank O'Hara. Joe replied, "Yes, I would love to do the cover." He promised to get right on it. But it wasn't until six months later—a long delay for Joe—that he came through with the design:

> I want you to know that I am sorry for my neglect of the sheet music cover. My excuse?
> Well, I don't believe very much in excuses, but—
> The truth of the matter is that I am very much up in the air

these days. And I find myself, too often, just not giving a damn. (You do understand that, don't you?)

I am very mixed up art-wise, and personal-wise too. And I just cannot, from time to time, make myself cope with complications.

In December, when the edition appeared, Joe wrote to Rorem that he was very happy with the way it had turned out (as was Ned). What the public saw was a nicely designed and witty cover that gave no hint of the emotional background of its creation.

To backtrack to mid-May: Kenward's house guests in Vermont were John Ashbery and Jimmy Schuyler, but by June 1 Joe and Kenward were in Westhampton Beach, where Joe was trying to work on an "old" construction:

> Working on my Spanish construction again this morning it occurred to me how much I rely on "the work" itself to tell me what to do. So often when I work I just "do a lot of stuff" all over what I am doing (a painting, a collage, a construction, etc.) until something I do tells me what to do. That is to say, I just work off the top of my head until one flower, or one line, or one gesture gives me a clue as to what I want to do. Or as to what I am doing. My work never turns out like I think it is going to. I start something. It turns into a big mess. And then I clear up the mess. . . . It is a construction I've been working on for several years. I don't really do constructions anymore, but this one I cannot give up on. It is made up of many beautiful things I got when I was in Spain. I only work on it when I am in Westhampton. That is not very often.[77]

And the next day:

> After breakfast I tried to work on the Spanish construction, but no dice. It needs the sun. Or I need the sun. Today it looked very black. (The construction.) And it is. But not morbid. Today it looks morbid. I don't know what I am going to do with the rest of the day. Probably read some. And roam around a bit. (Outside.) Smoke a lot. And be nervous. . . . I have been thinking a lot about what I want to do this summer. I'm going to make a list:

1. Oil paint
2. Gain weight
3. Exercise
4. Get a good tan
5. Do another issue of *C Comics*
6. Get together a manuscript for Lita Hornick[78]
7. Try to let myself get closer to people
8. Keep this diary

His diary continued on June 25 in Vermont, a few days after his and Kenward's arrival there. He was planning on doing a third issue of *C Comics* partly because so many poets were going to be visiting Kenward's that summer and partly because he was inspired by the new California underground comics, especially those by R. Crumb:

Not always so good, perhaps, but inspiring. Especially sex. There is a new freedom. And I plan (slurp) to take advantage of it.

But for some reason he had abandoned the first item ("oil paint") on his summer list of things to do:

As for painting, right now, I'm going to cool it. For once in my life, I'm just going to sit around and wait for inspiration. I'm not going to "make" any paintings. Painting is not going to be what I "do every day."[79]

On June 27 Joe wrote Pat and me a chatty letter that began: "You guessed it. I am outside sunbathing." Getting a very deep tan was, until dermatologists told us it could prove fatal, one of Joe's perennial summer projects. He had been keeping a summer diary, but with little luck:

You just can't keep saying the same things over and over again, unless you don't like yourself, or unless you're a painter ([that's] a joke) or unless you are willing to give in more each time (*not so easy*).

But he was working on his manuscript for Kulchur.

Another of Joe's summer projects—to gain weight—was part of his perennial drive for self-improvement:

> I've been eating like a fiend. This is what I had for breakfast this morning:
> One glass cranberry juice
> One vitamin B12 pill
> Two pieces oatmeal toast with honey
> One poached egg
> One bowl of wheat germ with fresh peaches and cream
> Two cups coffee
> My poor stomach can't believe it. I think I know what it must be like to be pregnant. I even walk a bit differently.

But he was doing his daily push-ups, which he hoped would help "spread" the food out. He ended the letter by assuring Pat and me that he was sunning his back. In previous summers we had pointed out that although his tan was impressive from the front view, the combination of it and the back view—a highly contrasting white—looked odd.

Around the same time, he was wondering what he would do with his ten weeks in Vermont. He wanted to paint, complete his book manuscript, and do work for a third issue of *C Comics:*

> This is too much to do in ten weeks but I imagine that I will try. If I had any sense in my head I would just paint and forget everything else. But I enjoy "everything else" so much that I find this hard to do. So—as usual—I am torn. Between this or that or both. And—also as usual—I imagine that I will pick both.[80]

Around the Fourth of July holiday, Anne Waldman and Lewis Warsh came for a stay. Joe had known this charming young couple for three years, and they had all become fast friends. Anne's openness, dynamism, and beauty formed a particularly irresistible combination. During this visit she named Kenward's pond Veronica Lake. "I die laughing every time I think about it," Joe wrote.[81]

Judging from the entry for July 15, it doesn't appear that he did sit around waiting for inspiration to strike:

My painting is not going so well. Oils. So, that is why I am sunning today. Instead of painting. I need a break. What I have been painting are wild flowers. In cream jars. The kind you don't see anymore. Except in Vermont. And places, perhaps, that I have never been. What I am trying for, I think, is accuracy. That is to say, "The way things look." To me. This is really very hard to do. And, I imagine, impossible. What I really hope for, I guess, is that, by just painting things the way they look, something will "happen."

The entry rambles on for a bit, eventually into the subject of aging:

Old age is not to be believed. Can you imagine yourself 60 or 70 years old? [Joe was 27.] I can't. I imagine, rather, that I will die young: 40 or 50. Not because I want to die young. But because I can't imagine being old. So there is nothing else to imagine. Except dying young.[82]

When young people are asked how they imagine themselves in, say, twenty years, they often respond by saying things like "I'll be married, have two kids, a good job, and a nice house." That is, they imagine the situation around them, but not who they will be, which is, admittedly, an extremely hard thing to do. Joe said he couldn't imagine being old, but my guess is that he didn't want even to try. Why fantasize one's future of physical and mental degeneration, illness and disease, the death of family and friends, and one's own extinction? Better to stay in the present, especially in the moment.

Later in July the shining Bill Berkson came for a stay:

I haven't been oil painting since Bill arrived. But we have been collaborating on some cartoons. A dream cartoon. And a de Kooning cartoon. Also an advertisement for Vanish (cleans toilets). Collaborating on the spot is hard. Like pulling teeth. There are sacrifices to be made. And really "getting together" only happens for a moment or so. If one is lucky. There is a lot of push and pull. Perhaps what is interesting about collaborating is simply the act of *trying* to collaborate. The tension. The tension of trying.[83]

Two days later, Ted Berrigan and Donna Dennis suddenly appeared. With Kenward, Bill, and Joe they smoked pot and stayed up late playing charades. The next day Joe, noticing a bag on the front porch and thinking that perhaps Ted and Donna were leaving, wrote:

> I hope they are not going to stay very long, but I hope they will stay longer than this. Ted is terrific. Also he is exhausting. Often he is a bore. But I *feel* very close to him. I don't think I *am* very close to him anymore, but still I feel that I am. . . . Actually Ted and I have seen so little of each other the past few years that we haven't even had the opportunity to *be* close. . . . I like Donna. Tho I find her hard to talk to, and almost impossible to look at. This I don't understand as I love looking at people. And she is, I think, very beautiful.

As for himself:

> You would think that by now I would know myself pretty well. Well, I don't. Or, if I do I don't admit it. I think I think that most of me is just temporary. So I don't bother to figure it (me) out much. Or worry about the way I am much. This is not true. I think about myself a lot. But I think about myself as I am now, not really believing for a minute that this is the way I will always be, and to be realistic, I am probably wrong. I am probably very much the way I will always be. From now on out it is probably just a matter of putting things (me) in order. Throwing out a bit. (I hope.) And pulling out into the open the best of me. I'm getting depressed.[84]

Kenward, Donna, and Ted had gone down to the pond for a swim, but Ted soon returned, saying, "I'm an indoor man." And the mood lifted.

The next day a collaborating session with Bill didn't go particularly well:

> The words are good but I have never been able to accept "words on a drawing" unless there is somehow a reason for them being there. Like with Larry Rivers, for example, words on his paintings are a part of his paintings. Visually. I mean, it is all one thing, first, and then you can read the words, if you want to. But with my

work this doesn't work. My work, I think, is solid. And complete. Tight. All space is taken, empty or not. That is why I like the cartoon form. A cartoon *is* a cartoon. A cartoon is made up of words and pictures.

He added that he also liked drawing "for" words, as in Kenward's book *The Champ* and John's *Vermont Notebook*.

That day, before Ted and Donna left, all five posed outdoors for "naked photos." Perhaps *posed* isn't quite the right word; several show Bill joyously leaping and flying into the air.

Writing "I Remember"

THAT SAME SUMMER, perhaps in late June, Joe wrote to Jimmy Schuyler: "I wrote a bit on a new thing I am writing called *I Remember*. It is just a collection of things I remember." Joe had started it one day while sunbathing:

> I remember the first time I got a letter that said, "After Five Days Return To" on the envelope, and I thought that after I had kept the letter for five days I was supposed to return it to the sender.

> I remember the kick I used to get going through my parents' drawers looking for rubbers. (Peacock.)

> I remember when polio was the worst thing in the world.

> I remember pink dress shirts. And bola ties.

> I remember when a kid told me that those sour clover-like leaves we used to eat (with little yellow flowers) tasted so sour because dogs peed on them. I remember that didn't stop me from eating them.

> I remember the first drawing I remember doing. It was of a bride with a very long train.

I remember my first cigarette. It was a Kent. Up on a hill. In Tulsa, Oklahoma. With Ron Padgett.

I remember my first erections. I thought I had some terrible disease or something.

I remember the only time I ever saw my mother cry. I was eating apricot pie.

I remember how much I cried seeing *South Pacific* (the movie) three times.

I remember how good a glass of water can taste after a dish of ice cream.

I remember when I got a five-year pin for not missing a single morning of Sunday School for five years. (Methodist.)

I remember when I went to a "come as your favorite person" party as Marilyn Monroe.

I remember one of the first things I remember. An ice box. (As opposed to a refrigerator.)

And so on.

Joe's method was simple: he closed his eyes and wrote down whatever memories came to him. He hadn't thought of writing an entire book:

> I loved it, but I still thought it would be one piece, one big piece. Then I showed it to Jimmy Schuyler [who had come to visit Kenward's in late August]. . . . And he flipped over it and said I'd better keep going. So I kept going. He was an instant audience; I would do it all day and show it to him, and he would tell me how terrific it was, which was all I needed for the next day. After a few days . . . I started finding out all kinds of different things about one's head.[85]

He found it interesting how one memory would trigger another: "There kept being more and different layers of things that were hidden." This peeling away of layers to get to hidden things reappears throughout Joe's life and writings, often in the form of a desire to be honest and open.

Joe wrote to Anne Waldman, one of the people he was most open with:

> I am still reading [Gertrude Stein] on the toilet and I still find her very difficult and I was thinking how great it would be to hear Gertrude Stein out loud. . . . I am way, way up these days over a piece I am still writing called *I Remember*. I feel very much like God writing the Bible. I mean, I feel like I am not really writing it but that it is because of me that it is being written. I also feel that it is about everybody else as much as it is about me. And that pleases me. I mean, I feel like I am everybody. And it's a nice feeling. It won't last. But I am enjoying it while I can.

I Remember was influenced by Stein's repetitions and by Warhol's repeated-image paintings from the early 1960s. In fact, in 1964 Joe wrote several appreciations of Warhol that also made heavy use of repetition. But whereas the repetition in Stein's works was often about language itself and in Warhol's paintings it emphasized the predominance of "image" (as opposed to the "real"), the repetition in *I Remember* worked as a springboard for Joe to leap backward and forward in time and to follow one chain of associations for a while, then jump to another, the way one's mind does. Coupled with his impulse toward openness, the "I Remember" form provided a way for him to lay his soul bare in a collaged "autobiography" that is personable, moving, perceptive, and often funny, with a mysterious cumulative power. About a month after seeing those first drafts, Jimmy wrote to Joe: "I think about *I Remember* all the time. . . . It's a great work that will last and last—in other words, it is literature."[86]

Pat, Wayne, and I had gone to Tulsa in early July, and then Pat and I went on toward California. Stuck for two days in a dusty, small-town motel in New Mexico while the service station next door awaited a

part for our car, we listened to the radio account of Neal Armstrong's stepping down onto the moon.

After California we returned to New York and continued on to Vermont, where we spent much of August. A few days before we arrived, Joe wrote to Jimmy, confessing that he was very much up in the air about his work, his feelings about being an artist, and what he should do with himself. He added:

> What I would really like right now is a big bottle of pills [speed]. Not that I believe in them. But I believe in them after I take one. It's a bad habit, but you know how liberal I am in the bad habit area. At the same time, however, I believe in self-control. In all of my years of off-and-on pill taking, I have never taken in one day more than one. And never over a long period of time. Knowing what they did to Ted cured me of any temptation in *that* (over-doing it) area.

Maybe Joe wanted some pills because he wasn't focused on work, as his diary piece of August 3 made clear:

> Right now I don't give a fuck about work. Right now I care about me. And what I am going to *do*. I feel (and have felt for some time now) the need to do something drastic. Not destructive. Just something (anything) to shake things up a bit. Like a good vomit. It occurs to me that if I don't do something to change my life now, it will be too late. I can just see myself exactly as I am now, only sixty years old. That's pretty scary.[87]

Neither Pat nor I noticed any special anxiety.

Sometimes Kenward and I would drive into town to play tennis. Other Vermont pursuits included working, scouting for antiques, sunbathing, swimming, and walking in the woods, with card and board games at night. Kenward, Pat, and I let out a howl of protest each night as Joe, to prepare for our highly competitive game of Pounce, went to his private supply of Visine eyedrops. For Pat and me, these summer visits were idyllic. After dinner we would often walk up into Kenward's high meadow in the woods, sometimes with a bottle of champagne and some marijuana, to look at the sunset.

Kenward was generous and friendly (and patient—we Padgetts were like the man who came to dinner) and Joe was his own sweet self. The final bonus was that we could let Wayne play on the lawn, all of us safe in the middle of nowhere.[88]

On September 7 Joe took the bus from Montpelier to New York. Pat, Wayne, and I had gone to house-sit the Porters' house in Southampton while they were in Amherst, where Fairfield was to be a visiting professor for the academic year. In late September Joe wrote, asking about what he called our "new life" and saying that the draft of *I Remember* was "150 pages long! I'm impressed." He was writing to us from his Jane Street apartment, which was now virtually empty because he had decided to move, apparently following up on his determination the past summer to "shake things up a bit" (and get a "new life" for himself). But he had "no place to move to yet. I refuse, this time around, to compromise. I know what I want and I'm not moving until I get it."

He had seen Ted the night before: "For the first time in some time I could actually *talk* to him. I mean, he wasn't just feeding me words. . . . It was good to see him." One of the letter's four postscripts added: "I'm off pills, liquor (except beer and wine), and I'm down to two packs of cigarettes a day. And I eat *three* meals a day. And I never smoke before breakfast." In the next postscript: "Also, no more cheap sex novels. And I do push-ups every day. You won't know me. (You will.)"

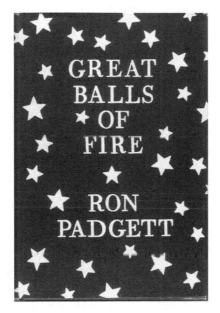

Dust jacket of *Great Balls of Fire*,
1969, by Joe.

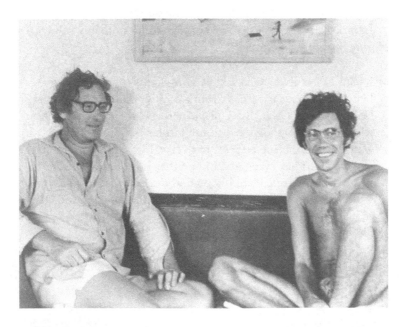

Kenward and Joe, Calais, late 1960s or early 1970s.

Waiting

IN OCTOBER JOE FOUND A LOFT TO RENT, but since he couldn't move in until November 1, he had to stay "two more dreary weeks" on Jane Street. Apparently Kenward had driven back to New York in mid-September, but returned to Vermont, where, joined by Jimmy and Trevor Winkfield, he spent most of October. Kenward had asked Joe to move into the top floor of his Greenwich Avenue townhouse, an invitation Joe declined. Perhaps for this and for Joe's unwillingness to be monogamous—or as a result of his desire to "shake things up"—the two were on the outs.

In a piece called "A Special Diary," written probably in October of 1969, Joe said:

> I want to live a very wild and exciting life. Why don't I? I guess I must be a chicken. I can't think of any other reason for not living the way I want to. Unless, perhaps, to protect myself. I wish that nothing mattered to me but having fun. I wish that I wasn't afraid of being a fool. I wish that I was a stud. I wish the days wouldn't just evaporate. I hope that I don't grow old before I realize how terrific I am. I hope that tomorrow won't make this sound too corny. Tho I know that it will. That it is. And that, actually, I don't care.[89]

Joe had cut his hair very short and was shaving every fourth or fifth day:

I fancy myself as looking somewhat like a gypsy. . . . At the book party for John and Alex last night two people I know well didn't know who I was (at first glance). For some perverse reason I find that exciting.

He was still eating a big breakfast and doing push-ups, and he was planning on taking part in an antiwar march. Also:

I have a new thing I do which is getting drunk (alone) in queer bars. Getting drunk (on purpose) is new to me. And queer bars are new to me too. There is nothing masochistic in this. You know that if anybody is not masochistic it is me. It is just the doing of something to the extreme that I find exciting. And good for me. I'm tired of feeling like a bore.

His last letter to us from Jane Street was written after Pat, Wayne, and I had been in town briefly: "It was really good to see you. I wish we could have been together more. But that, I admit, was my fault (party boy)." He noticed that because all his art supplies were packed up for the move, he had been writing more:

I finally finished my piece about Frank O'Hara. It's good, but of course it's not good enough. It makes me want to write pieces about all my friends *before* they die. It's so awful to have to say that someone *was* this or *was* that. As opposed to *is*. Because *was* is so final. I mean, it carries too much authority.

In a happier paragraph, he complimented me on my new book, whose covers and endpapers he had designed so spectacularly:

Great Balls of Fire is great. It really does make me proud to know you. Your poems cut through the air in such an even way. . . . The lightness of your poems really isn't so light. And it has something to do with how even they are. I mean, how even each poem is in itself. Like a box. Or like a circle.

About the same time, he wrote to Ted, who was teaching in Iowa City:

You are *the only* poet that I really identify with. Sometimes I feel that *I* could have written your poems, if only I could. So often I know exactly how you feel when you were writing a certain poem. Or at least, I think (feel) I know. The time of day. The moment. What you had (or didn't have) for breakfast.

Ted noted in his journal:

This is the greatest thing, that is, Joe, saying this, that has ever come to me this way, this life. & how I wanted it! needed it! from Joe (it wouldn't be the same from *anyone* else).[90]

Joe's relationship with Kenward had improved, too: "Kenward and I are on pretty good terms now. We only see each other four nights a week. Why Kenward puts up with me is beyond me." Pat wrote to Joe that she was glad the two were getting along better, and that she had noticed that every time he moved to a new place something significant happened.

664 Sixth Avenue

ON NOVEMBER I, 1969, Joe turned the Jane Street apartment over to Pat's sister Tessie and moved into the top floor loft at 664 Sixth Avenue, near Twenty-second Street in Chelsea. 664 was the same address as that of the Kennedys back in Tulsa, but I don't think he noticed; Joe wasn't numerological. The new place turned out not to be precisely what he was holding out for, but its skylight sold him. Kenward wanted to buy him an old-fashioned barber's chair as a housewarming gift, but the only furniture Joe wanted in the place was a table, a chair, and a bed.

In mid-November Christopher Cerf (the Random House editor of *An Anthology of New York Poets*, a book that David Shapiro and I had put together) sent Joe a telegram asking him to call. Cerf explained that the Random House design department wanted to change the type and rearrange the drawings of objects on the cover that Joe had designed. Could Joe come uptown to approve it?

> I said "yes." However, I had a bad night and I don't feel very good (in the head) today. And I just don't feel like having to get mad today. So I'm not going up. I'll just write him a note and say forget it. I mean, aside from the principle of the thing, I know that the objects *can't* be rearranged.[91]

I phoned the congenial Cerf and exploded at him. In turn, he made the design department restore Joe's original design.

In the new loft Joe began a new project: oil portraits. As he said in

a letter to Ned Rorem, "It is hard. This, however, is not a complaint. If it wasn't hard I probably wouldn't be doing it."

Also there was a major change in his professional life: the Landau-Alan Gallery decided to have mainly group shows.* Joe wrote to us, "I am now 'out.' I am glad in some ways (no temptations). But you know how I enjoy money." He was grateful that Kenward had a basement where unsold inventory could be stored. The other news—amid that of the usual flurry of readings and openings—was that he had at last gotten a telephone. It was the first time since high school—nine years—that he and I were both living in residences with telephones.

I had been driving into New York all that autumn to teach one day a week, and from time to time I saw him before driving back to Southampton. On November 26, I wrote to him about a personal issue:

> Here's a letter to keep our correspondence rolling. Plenty of subject matter.... The other night Tessie let fall a remark, in an unguarded moment, as to how Bill Berkson had told her that you had told him that I make you nervous. (This is getting good.) I've been thinking about it off and on ever since ... because it struck me as quite true, and it reminded me that I have been realizing this for several years, wondering why I do make you nervous, and wondering how I could stop.... At first it seemed that I might be treating you like the Joe I used to know, the way one's parents tend to do, for want of recent contact. But no, I've actually tried to "treat" you in no special way. In fact I've tried to put as little personal pressure on you as possible, because I've noticed how you are uncomfortable around me—eventually I began to think it easier simply not to see you— for your sake! not mine. Because I have missed you. Being out here [in Southampton] has made me realize how much so.... Another thing I regret is how, without wanting or meaning to, I have come between you and Patty ... as if our marriage had erected a wall between you and her, and I was forced to be the wall, something I never wanted, and do not want now.

Was I aware that I was giving Joe the meat and potatoes he enjoyed so much? His reply was immediate:

* And did so until the gallery closed on September 30, 1970.

Your letter was good to receive. And to read. I'm glad you care that much. As I do.

But, actually, any problems we may have had I feel are now in the past.

Your letter somehow rang true altho what it was based on is totally false. I never did tell Bill that you made me nervous.

All people make me a little bit nervous, but you perhaps least of all. What I may have told Bill is that, with you I felt like there was no room for me to change. I did feel for a while (the past few years) that you felt you had me too much figured out and in your pocket. And I admit that I probably had you sewed up too.

However—I really don't feel this way anymore. . . .

All of this has a lot to do with "room": it's so important with people to give them room. And I feel very roomy with you now, and that's a comfortable feeling.

. . . Remember when I was living with you both on 88th St.? I felt very close to Pat then. Actually, there is no wall. It's just that we don't see each other anymore (Pat and I). *If* there is a wall it is probably Wayne. (Sorry, Wayne.) I mean, I think it's hard for Pat to indulge herself with someone when Wayne is around to take care of. (?) But that is such a temporary thing. Wayne will be in school and totally in his own head before we know it. Not, I'm sure you understand, that I resent Wayne at all. He's great. . . . I wish I could have eaten with you [after a recent group reading] but I had a date to dinner and to see home-made "dirty" movies which, if anything could turn me off sex, they would have. The movies made it all seem like such hard work. . . .

I went to the post office the other day, the one on East 10th St., and a little Chinese Man behind the counter was wearing a name tag with his name on it: J. B. Him. If my book ever works out I am thinking of titling it that instead of *Self-Portrait*. I love the way it sounds. (J. B. Him.)

Then he plunged back into a discussion of how sometimes I was perceived as aloof by other people and added, "It's so silly that life is really this complicated but I suppose that it is. (Intricate.) It's almost funny. (Is.)" This was followed by a pretty description of the onset

of night and the heavy snow falling outside his window. With no transition, he continued:

> People wonder these days about Kenward and me (which I admit I rather enjoy). At any rate, I don't think I have really told you how we stand. "The problem" is not Kenward's, it's mine. Life with Kenward got into a bit of a rut. (Boring.) And we started taking each other for granted. Kenward doesn't mind this but I do. I like for people to be special and I like to be special to other people. Also sex. I really enjoy sleeping with lots of people and these, so they say, are my best years. I mean, let's face it, folks, youth is a commodity. And I wouldn't want to have to hold it against Kenward that I didn't have all the fun I wanted. (He understands this.) And, to tell you the truth, altho I love Kenward, I'm not madly in love with him. What I really want is to be madly in love. (I do believe in it.) So—as it stands right now I see Kenward four nights a week. Kenward is great and life with him is easy and enjoyable. Sex is good. And we never even fight. . . .
>
> So—these (now) are hard times for me. Not much satisfaction. I don't like the way I am with other people (too nervous and inhibited and tight). Painting is hard. Life with Kenward not too exciting. And sex and love with other people is not so easy as jumping into bed. I am beginning to feel pretty lucky, tho, as I discover all the hang-ups other people have (about "getting together"). It's incredible.
>
> I hope this letter doesn't sound like I am terribly depressed. Because I'm not. I'm deliberately upsetting my life and I know it. Sometimes I can almost watch myself doing it.
>
> And, as you no doubt know, I am still pretty much in control. (Damn it.) But trying not to be.

The letter ended, as usual, with a postscript: "Actually, I am not *deliberately* upsetting my life. It more or less just happened. But I am, perhaps, taking advantage of this moment. (Might as well go all the way.)"

It was a sweet, generous letter, but it wasn't enough for Joe, because he hadn't said anything to Pat. On December 4 he went about remedying that:

Actually—it occurred to me this morning that I still do feel very close to you. But the past year or so has just been like some sort of a vacation. And so obviously, to me, temporary....

Got up early this morning and re-read for the hundredth time *Hawthorne on Painting*. (In preparation for Anne [Waldman] who is sitting for me around noon.) It's a silly book in some ways (a bit delightful in an old man way) but always to me inspiring. (Clears the head.) Jane and Fairfield were very inspired by it. I don't think I take it *that* seriously tho. To me, now, it is more of a step.

A week later we saw Joe at the book party for *Great Balls of Fire* at the Gotham Book Mart, but the small, warm room was tightly packed with people and I became so congratulated that I had a momentary dizzy spell. Joe was being congratulated too. For us, having an extended conversation with anyone was out of the question.

I didn't know that he was entertaining even more serious doubts about his drive to be a painter, which he felt was more than being just an artist, as he says in a December 18th diary piece:

> Alex Katz makes me want to be a painter. . . . I *do* consider myself very much of an artist. But a real painter, no, not yet. I'm too spread out. And I'm just not that dedicated. That moral. But maybe I'm wrong. Or maybe I don't care that much anymore. (True). True, at least, for today.[92]

For Christmas Joe sent us a variety of wonderful gifts, including two collages. On Christmas Day, in writing to thank him, I gushed over one of the collages: "I remember this work very well, but—GASP—I didn't remember how utterly strong and stunning it is . . . a masterpiece! I'm so knocked out by it and by having it too!" I added, "You got so little from us. Well, you're in the 'Impossible to Buy For' category, you know."

In a letter to Pat a few weeks later, Joe commented again on his attempts to paint portraits:

> Portraits continue to be hard and frustrating and, let's face it, folks, a bit perverse. . . . Alex says that I am crazy. To do the hardest thing there is to do. Full face with no direct lighting from either side. And he's right.

Joe's sitters for these portraits were friends such as Bill Berkson and Joan Fagin. In early January, Ned Rorem was to sit for him, but Joe postponed it: "How terrific! (That you will sit for me.) It would be best if I wait about a month tho. Because by then I will know more what I am doing. (I hope.)" But on March 28, Joe wrote Ned again:

> I want to tell you that I am just not good enough yet to paint you. To be realistic—I should be by fall. (Good enough.) So I hope you won't lose interest by then. I would like very much to do a great portrait of you.

When *An Anthology of New York Poets* came out, the paperback edition looked wonderful, but the Random House design department had changed the colors of the hardcover edition from Joe's beautiful pure red on white to a gaudy metallic blue, red, and green on black. I apologized abjectly to him, but he took it in stride, well aware that design departments sometimes make last-minute unilateral changes. He let me off the hook by saying that the book is "terrific. And you did a great job getting what you got. So—as you can see, I decided not to feel bad about it. Which means, I hope, that you won't either."[93]

He then described giving a reading: "Read at Yale. (They are so young.) Reading *I Remember* to them was a horrifying experience for me. Hard to explain why. . . . I am not very good at reading to a strange audience. I don't even get nervous." These remarks point up the personal nature of Joe's writing. That is, he wrote for an audience of friends, not the public.

In a poem written after Joe's death, I said, referring to his public reading style, "What made him great was not that he was a great reader (he wasn't)."[94] My fear now is that people might assume that I didn't care for his reading style, which in fact I loved. What I meant was that he wasn't a *perfect* reader: occasionally he stumbled or misread words. Maybe I should have said "perfect" instead of "great."

Because actually he *was* a great reader, and for the reason my poem says: he was himself. Audiences—at least those with any

sense—were seduced by the modesty and honesty of his delivery. He never tried to disguise or eliminate his Tulsa accent, he never postured or overdramatized or acted cute or ingratiating. When the text presented certain angular grammatical constructions or unexpected words, he had a way of tilting his head to one side, the way a charming adolescent might. Add to this the humor of his work and his discretion in never going on for too long, and you will see why most audiences, especially those at venues such as New York's Poetry Project, adored his readings. Audiences that were stuffier or unaccustomed to his type of work tended to hold back, uncertain and unable to laugh or smile or silently emote, and when Joe got nothing back from the audience his heart sank. In such situations, why read?

Joe's new paintings were of "tumbled, tossed, and scattered cigarette butts. What becomes most important is not the butts but the air/space/or what-have-you around them."[95] Felix Landau had decided to give him a show in California the following fall, though Joe didn't really want one:

> I find having a show in California about as exciting as giving a reading at Yale. . . . But—I find myself with no income and I find myself not wanting to live off Kenward. Not from the moral standpoint but from the standpoint of I don't want that obligation.

He had heard that I was going to London in the summer to work with Jim Dine: "I'm just a little bit jealous of Jim Dine but that, of course, is as it should be," and he suggested that we do a new project together.

In May Joe came out to stay a week with us at the Porter house, where he did a beautiful portfolio of drawings and photographs called *49 South Main St.*, which later he gave me for my birthday. During this visit Joe, not wanting to miss a solo reading by Kenward at the Poetry Project, took Pat in a taxi all the way to Manhattan and back, a 200-mile round trip that night.

Two days later, Joe LeSueur called early one afternoon to ask if he could drop by the Porter house with some friends, casually mentioning Clarice Rivers and "Bill" de Kooning. Joe L. knew that Joe B. admired de Kooning more than any other living artist.

A few years before, when Joe was in Southampton for the summer, he had phoned Bill Berkson and said, straight out, that he wanted Bill to take him to meet de Kooning. Bill recalls:

> At first I was a little stunned, uncertain if I could really just call up the Great Man and propose such a visit. But I made the call and it was a snap, something like "Come right over." So Joe and I did. The reason I think it may have been pre-1970 is that the routine described in "I Love You, de Kooning" definitely happened that day—"You look great, Bill!" "You look great too, Bill!" and the three of us sat down in the little sitting area away from the painting walls, thought about it, and then chatted. At one point I think Bill asked Joe about his painting or whether he was a painter—I had said something on the phone to the effect that he was a terrific young artist—but mostly I recall its being a quiet affair, though not nervous-quiet, if you know what I mean. We sat around for a while, and then we left.[96]

So I told Joe L. that I thought we could fit Bill de Kooning into our busy schedule. When the group spilled into the Porter house an hour or so later, Joe L.'s eyes flashed with delight as he watched Joe greet de Kooning. With his customary shyness, Joe simply said hello and smiled widely. Pat suggested that we all sit at the big dining room table. She had tea and wine and a few edibles ready.

Joe LeSueur and Clarice were in top form, bubbly and witty, and from time to time I piped up. Joe and Pat remained typically silent. Although de Kooning said little, he enjoyed all the friendly animation, and I got the impression that he appreciated our not lionizing him. He sat back and smoked and laughed at the high-spirited banter, which went on for well over an hour.

As soon as the visitors departed, Joe rushed to de Kooning's ashtray and rescued a butt, which he later glued to a piece of mat board, titling it "Cigarette Smoked by Willem de Kooning" and dating it May 15, 1970. Later he gave this *objet trouvé* to Joe LeSueur. Over the years the butt's nicotinic acid has gently suffused itself into the area around it, as if creating a halo around a relic.

Cigarette Smoked by Willem de Kooning, May 15, 1970, 1970, by Joe.
Collection: The Estate of Joe LeSueur. Courtesy of Tibor de Nagy
Gallery.

Joe was popping up everywhere. He had just had an interview (which he hoped no one would see) in Les Levine's magazine *Culture Hero* and had finished cover designs for Tom Clark's book *Air* and Anne Waldman's *Giant Night,* as well as some new paintings of cigarette butts "very much like small explosions (in slow motion)."

But Joe was growing less and less impressed with himself and his work:

> I don't think I have to work as much as I used to feel I did. I think I have just about decided that I am no genius and that the world doesn't really "need" anything I might do, so———so what's the hassle?
>
> I only feel this way sometimes tho. But when I do, it seems very much for real.
>
> But you probably know how much I love to impress people. And please them. And as long as "art" helps me to do that I'm safe. (Safe from "Why" etc.)....
>
> And I think maybe I am really beginning to *know* what I've been telling myself for years: not to be so serious (not to take myself so) (so *much* so).[97]

In his better moods, Joe saw this attitude as an improvement:

> I may be actually "growing up" because more and more these days I feel less important to myself. (Less serious about myself.)[98]

In late July he wrote to us from Vermont, where Anne Waldman and Michael Brownstein were visiting. Using Kenward's grape arbor as a stage, the four of them put on a private show of Kenward's short play *Furtive Edna,* with Joe's sets—cardboard boxes with drawings on them and an arrangement of quilts. He was "working some and reading a lot. (Making myself get into science a bit and it really is interesting.)* Favorite novel of the summer so far is *Anna Karenina.* I really loved it." Amazingly, he had given up smoking and "gained

*Joe once told me that he had no idea how he passed chemistry in high school.

fifteen pounds, tho I find it hard to 'see.'" He enclosed some *Nancy* strips from the newspaper and an announcement for his show at the Elaine Benson Gallery in Bridgehampton, August 9–25. The announcement shows him sitting on a flower-patterned daybed, flanked by his gardens and still lifes of flowers. "Pretty ugly, isn't it? Well—maybe I'll make some money."

A few days after Anne and Michael left, Harry Mathews arrived, and a week after that, Maxine Groffsky. I believe that during this visit they, along with Kenward and Joe, took LSD. Maxine had a bad "trip," but was undaunted. (Once the indomitable Maxine told me, "I'll try anything *twice*.")

That summer in Vermont Joe and I did our collaborative comic *Sufferin' Succotash.*[99] Knowing that Joe preferred not to do the kind of messy, spontaneous, simultaneous collaborations that we had done in the early and mid-1960s, I wrote a text—a pseudo-professorial statement—that I thought could be adapted to the comic strip form. Then Joe and I set about looking through his and Kenward's postcard collections, selecting images that jumped out at us. We quickly put them in a sequence, sometimes matching image and text, sometimes going against an overt connection. In light of the images, I made a few final revisions of the text. Joe then redrew everything in black and white, and I lettered in the words.

A few days later we did another comic strip called *The Origins and History of Consciousness,* a title I borrowed from a book by the psychoanalyst Eric Neumann. Choosing whatever images he wanted, Joe did all the drawing and then I filled in the words. In both strips we tried to push beyond what we had done together before. I liked the results, and Joe did too, as he wrote to Bill Berkson: "Ron and I worked on a cartoon in pencil in the sun this afternoon. Will be good I think. And we have done one other that is very strange, and I like it."[100]

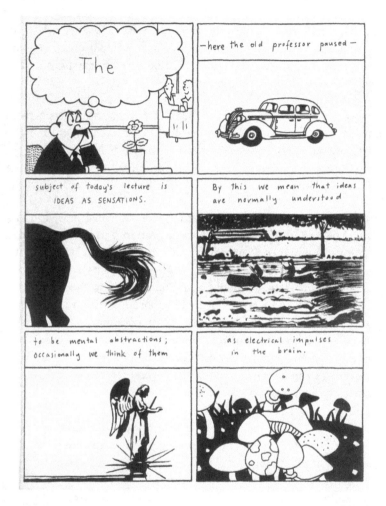

A page from *Sufferin' Succotash*, 1970, by Joe and me.

The Cut-Outs

DURING THAT SUMMER (1970) in Vermont, Joe made a number
of what he called cut-outs; that is, complex images of weeds and
grass, with an occasional wildflower, seen as if one had gotten down
in a field and stuck one's face into the vegetation, all intricately cut
with an X-acto knife from hand-colored paper and then arranged
between multiple layers of Plexiglas. Actually he had started this
type of work the previous summer:

> After oil painting all morning (I got up at 5:30!) I picked some
> green grass and did lots of green ink and brush drawings of it.
> Now I am cutting the grass out (with an X-acto knife) and then I
> am going to put it all together, in layers, to make a solid patch of
> grass (11" x 14"). So far I have cut out two layers. It is quite delicate
> cutting and I have a big blister to prove it. (Delicate but hard.) It
> will be very pretty, I know. It can't miss. And it's a good thing to
> do (cutting out grass) when your head is tired but you are still sort
> of wound up. Just before a drink.[101]

Perhaps he was able to get further into doing cut-outs in 1970 simply
because there were fewer visitors that summer. In any case, the visual
complexity of the work turned out to be even greater than that of the
garden works, and the colors were muted, the tone quieter, almost
somber. If the gardens were summer odes to joy, most of the cut-outs
were early autumn elegies.

Joe returned to New York, probably in early September, with Kenward, who was so appalled by the city that he went straight back to Vermont.

Joe continued the physically demanding work on the cut-outs. The results were handsome, but something was missing:

> The days *do* go so fast. And yet I *do* get so much done. And yet there seems to be no end to it all. I think maybe I am a bit crazy. (To work so hard to do so much.) Especially as it doesn't give me that much satisfaction. . . .
>
> I don't ever want to get "on" pills again but I would give my left arm for some to help me cut out some of my big cut-outs.[102]

Something was missing from his love life as well:

> I've been sleeping around a lot but not getting much satisfaction from it. I find myself just wanting to be in bed with people more than I really want to "do" anything. (Sometimes.)[103]

What Joe seems to have been missing was affection and closeness, and so it is not surprising that he had been seeing Pat, Wayne, and me and feeling "closer to all three than I have in years, and that's good."[104]

In early October Kenward came back to town, but Westhampton was never far away, as Joe wrote to Bill Berkson:

> Kenward and I went out to Westhampton this weekend where I did two big cut-outs. (Tho still to be cut-out.) One of beach grass in four layers and one of dried grass and weeds etc. in three layers.
>
> This week I plan to devote myself to cutting out a three-layer one of buttercups I did in Vermont.
>
> I remember once showing you several small cut-outs and you said a big one would really be fantastic and I said yes, but that it would be boring for me. Well—it is, but I'm doing one anyway. For the show. Not that they are *so* big, but big for what they are.

It *is* a good feeling, tho, to finish one. And, they *are* fantastic. (The big ones.)[105]

It was probably in October that *I Remember* was celebrated at a publication party. No one seems to recall anything about this fête. My guess is that because Angel Hair, the publisher, had no budget for renting party space, it took place at Anne Waldman's apartment on Saint Mark's Place or at the Saint Mark's Church, the home of the Poetry Project, whose director (Anne) was codirector of Angel Hair. The church would have been a more than suitable venue, since Joe had given numerous readings there, and by the late 1960s it had become a hotbed for a group of New York poets who admired his work.

On October 29, Joe and Kenward went back up to Vermont for a week. It is usually nice to be there around Halloween, but Joe's stated reason for going was to "work from real grass."[106] But surely there was real grass nearer than Vermont. Maybe the trip had something to do with Kenward.

Joe's love life with Kenward had been having its ups and downs, but it was far steadier than with anyone else. Joe loved Kenward, certainly, but not to the nth degree that he dreamed of. By December, the situation had grown more complicated:

> I refuse to let something nice become a hassle.
> Which is probably why Kenward and I are splitting up. (So as not to let something good go sour.)
> But then maybe we are not splitting up so much as we are finding new ways to be together.[107]

In December 1970 Joe visited Chicago for the opening of his solo exhibition of flower collages and Madonnas at the Phyllis Kind Gallery. He thought the show looked "pretty good," but it sold poorly, only slightly better than the show in Toronto.[108] These financial flops were an indication to him that his work didn't play well outside of New York.

At some point in 1970 Joe wrote the following poem:

1970

1970
is a good year
if for no other reason
than just because
I'm tired of complaining.[109]

This poem is a good example of Joe's knack for saying things that were simultaneously simple and complex, funny and serious.

Looking at Pictures

ONE OF THE GREAT PLEASURES IN LIFE was going to galleries and museums with Joe. In the early and mid-1960s he, Pat, and I went almost every Saturday. After seeing a show with them I was impressed by her ability to recall the exact locations of individual paintings—which wall of which room they were in—and by his ability to recall colors, lines, and brushstrokes. The three of us liked the same artists—Vermeer, Duchamp, Gris, Manet, Schwitters, Fra Angelico, Henri Rousseau, and so on—sometimes for different reasons.

I learned from Joe that the first thing to do when looking at a work of art was to do just that—look. Let your eyes take in what is in front of them. Look at a picture from different distances. Look away and then look back, but, since each picture suggests a visual starting point in it, choose a different point each time you look. At this stage, try not to have any thoughts about the work, such as where it fits in the artist's oeuvre or in art history or social history. You can do that later. If you allow such thoughts at this point, they will distance you from your seeing. And so Joe's comments at an exhibition would be of the "Look at that red" variety, when the very thing I had overlooked was the fact that red was the star—perhaps the raison d'être—of the picture in question. (Joe once said, in his own profoundly simple way, "No color exists except in the particular way it exists.")[110] For me Joe's visual perceptions were literally eye-opening.

His assessments were succinct and impartial. Looking at an over-the-top baroque or modern painting, he might smile slightly and,

mimicking our high school art teacher, Opel Thorpe, say, "That one is *in-teresting,*" which, translated loosely, for us meant "Yikes!" Joe was gentle with the art he didn't like. Mostly he ignored it and went on to look at something else. Sometimes he would surprise me, such as the time he said that Raeburn was his new favorite painter. I had never paid any attention to Raeburn. The same with Stubbs. Until Joe alerted me to them, my mild aversion to "society" painting had prevented my seeing it first as *painting.* Joe had no such categories blocking his view. Ultimately he looked at art as an artist; that is, he scanned it for what he could use or compete with or be inspired by in his own work.

I felt lucky to look at art with him, and I trusted his taste all the way. If he liked an artist I didn't like, I knew it was time for me to take another look, the way Frank O'Hara had done with Warhol's work.

In late 1970 Joe was interviewed at his loft by a reporter from the *Tulsa World.*[III] The article said that Joe was looking forward to his next show, in April, of cut-outs, at the Fischbach Gallery. After the Landau-Alan Gallery had folded, Fischbach's director, Aladar Marburger, who knew Joe and his work, had grabbed him for the Fischbach "stable." It was a special delight for Joe to be showing in the same gallery as one of his favorite painters, Alex Katz.

The *World* article ranged far and wide: "I'm planning to do about 75 of these [Nancy images] for a show and a book called *If Nancy Was a Painting by de Kooning.*" Joe then ascribed his mid-1960s assemblages to his childhood hobby of collecting stamps, shells, salt and pepper shakers, coins, rocks, Christmas cards, monkeys, and photos of movie stars. "I usually work all day, from whenever I get up, around 8 or so, to 4 or 5. Then, at night, I go out . . . to parties and films mostly. I guess Warhol's *Trash* was my choice for best film of last year. I also like Godard's stuff." The article concluded: "While we visit he chain-drinks Dr. Peppers and smokes. A sign on one wall reads: breakfast, vitamins, exercises—a reminder of his own disciplined routine and gentle but determined pursuits."

Near the end of 1970 Joe secured a new supply of pills, hoping to maintain his daunting work load and to keep himself from sinking into depression and inactivity. And so he was

Working *very* hard. (Fast.) (Continuously.) (Etc.) On many many things now:

1. Cutting out
2. Final work on new "I Remember"
3. Major book on Nancy called "If." (Pictures and words) (20 pages so far)
4. Drawing people two or three days a week (Anne tomorrow)
5. Lots of sloppy poems when drunk at night

The reason I am able to do all this is that I got some pills. (But only enough to last two more weeks, alas.) One a day. (Never more.) . . .

Tomorrow I draw Ron.[112]

Ted and poet Alice Notley had rented a house for the winter in Southampton, partly because he felt that New York was too expensive and, for someone prone to drugs, too tempting. In late February, when Ted passed through New York City on his way to Providence, he stopped to see Joe and to sit for a pencil portrait. On the train to Rhode Island he wrote his terrific book-length poem, *Train Ride*, dedicating it to Joe because it had been inspired by Joe's account of a train ride to the Hamptons.[113]

All through February and March Joe continued to work on cutouts and pencil portraits of friends. By the middle of March he knew that the show would be good. He was even planning on doing a series of prints, using poems by Anne, Ted, Kenward, Bill, Peter Schjeldahl, and me. But his supply of pills was running low, and they weren't easy for him to find.

The Fischbach Gallery

JOE'S FIRST SHOW (APRIL 1971) AT HIS NEW GALLERY was of the cut-outs he had been doing for the past two summers. These works showed two new developments. First, their colors were subdued, mostly faded browns and muted greens. Second, most of them were layered, with sheets of painted weeds and grass (and a few pale flowers) alternating with sheets of Plexiglas. The accumulation of objects imbedded in plastic may have been suggested by the work of Arman, the French New Realist whose work Joe had seen at the Sidney Janis Gallery in the early 1960s. But Joe's cut-outs were a natural development for him. Like the gardens, they were dense and complex, created as much by the cutting blade as by the paintbrush.

The cut-outs show was a commercial and critical success. Carter Ratcliff, always a smart and serious commentator on Joe's work, made an interesting point:

> In his most recent show he painted objects, then cut the paintings to make them more object-like. This interplay between the natural and the artificial, between what is displayed (an object) and what displays (also an object, the same one) breaks down the ordinary notions of composition and coherence in favor of an illuminated concentration. Nature and décor, nature and civilization, the timeless and that which bears precise indications of its origin in time, the a priori and the ephemeral—all these in their specificity stand for each other. Brainard is willing to make the point

(usually shied away from so desperately) that for consciousness the world *is* décor.[114]

A less cerebral review in *New York* magazine said:

Those rare combinations: innocence and virtuosity, charm and substance, predictability and originality, all mesh and wondrously succeed in this exquisite Mozartian exhibition.[115]

Joe himself had a somewhat philosophical view of the show:

A clearer show I may never have.
I wonder if maybe I will never again need to impress people so much.
And it *does* (?) show in the show. Which I consider both good and not good. (Neither really.) Just what it is.[116]

Doing the cut-outs had put such a terrible strain on his eyes, hand, and neck that he never attempted a large group of them again, though his X-acto technique came in handy later.

The Fischbach show was followed in the fall by one at the Gotham Book Mart Gallery, one flight above the famous Forty-seventh Street bookstore. Joe had already had one Gotham show, back in 1968, of his drawings for Kenward's book-length poem *The Champ*. In the late 1960s and throughout the 1970s, The Gotham, redolent with literary history, was *the* place for book parties and literary art exhibitions. It was small and pleasantly hip. This new show of Joe's, entitled "Work with Poets," consisted of collaborations, cartoons, posters, cover designs, and drawings that he had done for and with Kenward, John Ashbery, Anne Waldman, Ted Berrigan, Bill Berkson, Frank O'Hara, Lewis Warsh, me, and a host of others. The show demonstrated how Joe had tailored his work for each project and yet remained true to himself. The cover designs never looked commercial. They were art.

Joe's Hand

IN MAY OF 1971 Joe wrote me that he and Jimmy were going to see a show of Ingres drawings. It was around this time that Joe was doing the pencil portraits that invite comparison with those of Ingres, whose line and finesse never seemed to falter.

One time I was looking at one of Joe's drawings, which he pointed out was marred by a slight irregularity in one of its curved lines. I couldn't see any irregularity until he took out a measuring device for drafting and laid it down next to the line. There was a variation, but it was minuscule. A "normal" person would never have noticed.

One of Ted's poems refers to "Joe's throbbing hands." I don't recall any throbbing, but Ted's description does remind me how long Joe's fingers were, and strong, and how his hands, when he worked, moved with precision and absolute certainty. Often he would become so absorbed in his work that he would hum or whistle quietly, usually an old popular song or a nondescript tune, unaware that he was doing it.

His draftsmanship had a magical effect on me. Watching him draw always elicited a pleasant tingling in the back of my head and down my neck, as if someone were gently tickling me, and I would start to feel drowsy, like a child drifting off into an afternoon nap. Since childhood Joe had worked at drawing, but practice is not enough to produce such draftsmanship. He was born with a gift. I don't know what to call it: eye-hand coordination? Visual knowledge? Genetic blessing? Whatever it was, Joe had it.

He also had an active imagination, so I was surprised when he told me, one day when we were working on our collaboration

Sufferin' Succotash, that he couldn't do a good drawing of something unless he could actually see it. Of course, if I had asked him to draw a house, he could have, but it would have been generic. We had to abandon an idea for one of the piece's panels because we couldn't find an image of the old car I wanted him to draw.

But having the subject before him wasn't always enough either, for sometimes the real and actual appearance of a thing is so bizarre or unexpected that it does not translate well into its representation on paper. As Joe put it, "If you draw a tree the way it really looks, no one will believe you." It was one of Joe's gifts to find the middle range in which his drawings would be both realistic and credible. One senses this sophisticated balance in his pencil portraits of Pat, Alex and Ada Katz, Bill Berkson, Anne Waldman, David Hockney, Jasper Johns, and others. These drawings do show the influence of Ingres, but the similarity goes deeper than that of controlling the delicate line and subtly modeling the planes: it reaches to both artists' sophisticated understanding of the midpoint between realism and credibility.

When I look at Joe's best drawings, I do not have thoughts like these. My eyes are experiencing something too happy for thinking, and somewhere inside me there is an onrush of gratitude, for once again I feel as if I am in touch with how amazing and beautiful the world looks.

Pencil portrait of Pat by Joe, 1971. Collection: Wayne and Siobhán Padgett.

Bill Berkson reading at the Poetry Project, 1969. Photo: Sam Allen.

Bolinas

WHILE KENWARD WAS IN BRAZIL, trying to interest Broadway star Mary Martin in taking a role in *The Grass Harp*, Joe, unable to resist buying a beautiful but expensive ancient Roman ring and a Chinese bracelet, found himself broke. But after selling some of his book collection, he flew to California on a one-way ticket, on June 1.

His stay there is amply documented in his *Bolinas Diary*, so I will simply add some bits from a letter he wrote to me on June 22, when he was still coming down from the acid trip that he and twenty-four Bolinas friends and neighbors—including Diane di Prima, Bill Berkson, Allen Ginsberg, and Tom Clark—had taken the previous day to celebrate the summer solstice:

> Sharing this house now with Philip Whalen and we get along real well. I think we totally amaze each other. (Being so different.) At any rate, I really do like him. . . . And Bolinas—I really do like Bolinas. And Joanne [Kyger]. And Bob [Creeley]. And Bobbie [at that time, Creeley]. The ocean. Etc.

He then thanked me for continuing to oversee the production work on his forthcoming *Selected Writings*, adding a remark that now gives me pause: "So great that you are seeing this thing through so well. (My book.) I really do appreciate it. I mean—I'm touched. Moved. Makes me realize again how much I _____ (slurp)." This last bit was usually Joe's cartoonish way of expressing sexual attraction. Aside from this one instance, I don't know of Joe's

ever expressing any such attraction toward me. In person, there was never the slightest hint.

He then went on to say, "The thing I am afraid of most in life is being 'Brainardesque' but I'm glad you understand." I can't remember what it was that I understood—perhaps I had described his going to Bolinas as Brainardesque but understandable—but in a more general sense his remark sheds light on his refusal, in his visual art, of a signature style. It also shows that by this point Joe had internalized his rejection of other people's thinking that "they have my spirit in a bottle," as he had written nine years before in his 1961 Christmas journal.

He reported that he was keeping a new diary, which he probably expected to be published, and that he was painting eucalyptus leaves. That is, he was doing life-size realistic paintings of them and cutting them out, one at a time, to assemble into collages. It is tempting to make a correlation between the realistic leaves of the tree and the realistic leaves of the journal, both of which he would assemble into larger pieces.

His letter continued: "Would you believe that moving here is a bit on my mind? But I suspect it will go when I go. And I think I hope so." As usual, he is examining his feelings and ideas from different angles. On a more mundane level, the one-way ticket was not an indication that he had come to stay, but rather that he, who quite possibly was unaware of the option of a round-trip ticket with an open return date, simply didn't know when he would come back from California.

Back East

Joe stayed in Bolinas around five weeks, until July 6, missing
the letter I had written to him two days before that. He had
flown to New York and one day later taken a bus to Vermont
(writing an account of the ride during its ten hours). My letter,
written from Southampton, where we were again housesitting the
Porters' place, brought news of the mental breakdown that Jimmy
Schuyler had just had. Jimmy, Pat, Wayne, and I were to have
shared the house that summer, but the day after he arrived, act-
ing a bit strange, he quickly spiraled down into what the doctors
called a schizophrenic episode and had been committed to the
state mental hospital in Islip.

When Pat and I told everyone that we were so scared by his
menacing behavior that if he came back we would abandon the
house, which after all was more his than ours, Kenward invited him
to Vermont. Joe wrote from Calais that "Jimmy will probably come
up here very soon. And I can't think of a better place." For Joe, rural
Vermont was perfect for recuperation, whether from illness or the
stress of big-city life, and though in general he was right, he under-
estimated the severity of Jimmy's condition. He was well aware,
however, of his own condition, confessing to being "a bit nervous"
about Jimmy's arrival: "If it's not the same Jimmy I don't think I'll
be very good at pretending it is."[117]

But he was already doing a lot of work, revising *Bolinas Journal*
because Bill Berkson had offered to publish it immediately as a Big
Sky book. For Joe *Bolinas Journal* was "a work that (for me) has to

appear instantly or not at all."[118] Joe was also doing a "peace poster" for an antiwar group and feeling "a bit proud of myself for finally doing *something* [political]. (As late and as indirect as it may be.)"[119]

Jimmy arrived in Calais on July 21. For a week or so Joe thought that Jimmy was o.k., but then he modulated his impression: "Jimmy, by the way, is fine. A bit nervous, and a bit 'up' and 'down' fast, back and forth, but really, I think, o.k. (So long, I think, as nothing terrible happens.)" The tentativeness that had crept into his assessment suggests the off-kilter atmosphere that Jimmy brought, an atmosphere that Joe evoked in saying that he himself was "working so hard these days I'm really beginning to feel a bit crazy." As he wrote to Bill, "I'm just not too happy these days and it infuriates me because there's no reason for it. I mean—I *should* be on top of the world."[120]

Joe's usual summer routine had been broken. He wrote to Pat and me that he was not swimming, not listening to music (while he worked), and not reading, except for bits in Anne Waldman's new anthology *Another World.* He especially liked the selections of Dick Gallup's and Joanne Kyger's poems:

> Joanne and I, by the way, really hit it off. But you'll be reading about that soon, I hope [in *Bolinas Journal*]. Funny how "homosexuals" love to brag about "straight" affairs but it doesn't work so much the other way around. . . . Actually I'm teasing you. Joanne and I only slept together once and we were so drunk and so stoned "slept" is actually what we did. Tho if Peter, her boyfriend, had been away . . . for more than one night, who knows? Not me. God only knows one sex is enough to cope with anyway. And habits are hard to break. And it is, perhaps, more of a romantic notion than a realistic one. But on the other hand—who wants to be realistic? Not me. (Tho I am.) No I'm not. Realistic is being more open. Yes, I do want to be more realistic. Please pardon [this] little conversation with myself. I'm back now. [121]

Joe had taken one step further toward going to bed with a woman. There had been the pregnant moment with Pat in 1962, and then several such moments in the late 1960s or early 1970s with Anne Waldman, when close friendship nearly veered into romance. As

with Pat, nothing explicit was said or done, but Anne had sensed a sexual tension in the atmosphere around them, the kind that sometimes precedes jumping into bed.

But, aside from the one tentative incident with Royla back in Tulsa, he had never quite gotten that far. This time he had—definite progress! But he couldn't bring himself to realize his yearning. Why not? He said that it was because it would have complicated his life ("one sex is enough to cope with"). This may have been true, but I suspect that the cause was deeper: getting sexually involved with a woman might have involved too radical a redefinition of who he was. He once wrote:

Two Things I Have Never Had Are:

1. an identity crisis
2. sex in the kitchen.[122]

Despite his recurring desire to test the limits of his personality, he didn't want to risk a hard-core identity crisis.

A year or so after his night with Joanne, though, he seemed bolder, as in this short piece, probably written around 1972, entitled "Before I Die":

One thing I want to do before I die is to make it with Anne Waldman, without offending Michael Brownstein [her boyfriend]. The old have your cake and eat it too bit. The story of my life. And now that I think about it, making it with Michael Brownstein, without offending Anne Waldman, wouldn't be bad either.

This appeared in the May 1973 issue of *Oink!* magazine, which Joe knew Anne would see. Aside from the piece's witty structure and the highly unlikely and therefore comic possibility that he and the utterly straight Michael might get together, was he not publicly issuing Anne an invitation to seduce him?

At various times Joe was strongly attracted to some of his smart, beautiful, talented women friends, particularly Pat, Anne, Joanne Kyger, and, in all likelihood, Bobbie Louise Hawkins and Ann Lauterbach.

On a more mundane level—to get back to the July 31, 1971, letter to me—he said that he was "coming back to the city early this year, by the first of September, if not before," and that he wanted to visit us in Southampton.

But first there was August. Joe was writing a new journal and making found poems ("one-liners," as he called them) from two cheaply printed magazines, *Women's Household* and *Women's Circle*. These monthly periodicals consisted mainly of letters from rural women, some of them shut-ins, letters with sentences that sometimes came off sounding peculiar:

> I put sequins on everything imaginable.
> The weight of a poppy is by no means fairy-like.
> I have some cousins living in Montana or Wyoming.
> His package under the tree was always a rug.
> I think I will break camp and go like the beaver.
> I have so many hobbies I can't name them.
> I am in desperate need of an old worn-out or discarded leopard skin coat.
> I am the wife of a nationwide truck driver.
> I have a great big bundle of clear plastic with white lines all over it.
> I never know what I'll think of next.[123]

Along with playing cards, roulette, backgammon, charades, mah-jongg, and croquet, reading these letters aloud after dinner had been one of our summer rituals in Vermont, and although marijuana intensified their effect, even Pat, who did not smoke it, found them hilarious.

John Ashbery joined Joe, Kenward, and Jimmy in Vermont. John proved helpful when, in early August, another breakdown occurred, and Jimmy was taken to the state mental hospital in Waterbury.

Joe wrote: "Guess I don't have to tell you what a nightmare it was. And I couldn't begin to." He had been steady during the crisis, but it led him to reflect on his own sanity. There must have been a misunderstanding, but according to Joe, Lita Hornick, the publisher, insisted that he read the proofs for his *Selected Writings* in town,

which meant that he would have had to return to New York early in order to meet the deadline. Jimmy's new breakdown made Joe feel unable to face the city at that moment, but something more fundamental was involved: "Funny how 'little things you are supposed to do' become really impossible for me." Joe hit here on a subject that has always perplexed me. Why, from time to time, did he find it impossible to perform certain small tasks? Was it a deep-seated rebelliousness against obligation?

Jimmy's episodes had put Joe's stomach in knots, and he wasn't looking forward to the next day: "Tomorrow, a visit to see Jimmy. (I don't want to, but.) Such a gigantic face now!" Bloating was a side effect of the Thorazine that he was taking. The visit would also be infused with Jimmy's anger toward Kenward, who was unwilling or unable, like Pat and me, to have Jimmy come back to stay with him. The breakdowns had been shattering for all of us.

Some days Joe even had trouble thinking: "I'm having a hard time writing. You know how sometimes the beginning of a sentence gets lost before you get to the end of it?"[124]

But even in Joe's less happy letters there was often room for something unrelated and, to me, charming:

> Thought I saw my first shooting star the other night, but turns out it was Mars. Seems every now and then at regular intervals it swoops through the sky to a new place. (Local TV news said so.) So I still have never seen a shooting star.[125]

And he was able to keep working on what was to be called *More I Remember More*. A previous installment, called *I Remember More*, had just gone to press. He wrote to Lewis Warsh that he was "working on a new *I Remember*, much to my own surprise. I thought with no. two I had had it. Guess 29 years is a long time. (The 'stuff' continues to gush up.)" About the process of writing all three books, he wrote to Tom Clark that he had

practically no memory and so remembering is like pulling teeth.

Every now and then, though, when I really get into it, floods of
stuff just pour out and shock the you-know-what out of me. But
it pours out very crystal clear and orderly.[126]

Joe's last letter to us that summer said that Jimmy was being
released from the hospital on August 28, and with John's help was
returning to Southampton. Kenneth Koch had told me that plans
were being made to have Jimmy admitted to a psychiatric hospital
in New York, but that Jimmy didn't know about it and nothing was
settled. Taking no chances, Pat, Wayne, and I cut short our stay at
the Porter house, leaving on August 29. The Porters would return
in case Jimmy came back from New York. Joe now had to cancel
his plans to visit us in Southampton. He returned to New York
on August 31 and, in late September, came down with hepatitis, as
Pat had done soon after Jimmy's breakdown with us.

By early December Joe's health had improved noticeably:

Along with working hard and funny health all of a sudden a lot
of people seem to have a crush on me. (Pretty boys who like my
book.) Which started out fun and now is getting a bit insane.[127]

Because Joe was a notoriously hard person to buy gifts for, I asked
him what he wanted for Christmas.

"Stairs," he replied. "I can never find a really comfortable chair,
but I like to sit on stairs. I would buy some, but I have never seen
any for sale."

In my kitchen I built a freestanding wooden stairway, with
four steps about thirty inches wide, which I delivered to his loft
just before Christmas. It looked like an example from a real estate
developer's showroom, and indeed was quite comfortable. After
a couple of years Joe relegated it to his back room, using it as an
étagère, but he never discarded it, partly because it was too bulky
and heavy to lug down to the street, and partly, I prefer to think,
out of gratitude.

For Christmas Joe gave Kenward, among other things, what he
called *A Book by Me for You,* a scrapbook collection of around sixty
pages of his drawings and writings, many of which are beautiful and
witty, some "slurp."

Joe's "Tuesday, December 28, 1971" is a straightforward account of a car trip that he, Anne, Michael, Pat, and I took to Hartford to see an Alex Katz exhibition at the Wadsworth Atheneum. Joe loved the show:

> At the museum looking at *Upside Down Ada*, one of my all-time favorites. . . . How Alex all these years has remained so pure is beyond me. . . . Other all-time favorites are *Impala* (1968), *Bather* (1965), *Donald and Roy* (1965), *Private Domain* (1969), *Joe 1* (a cut-out of me six times), the Frank O'Hara cut-out and *Self-Portrait with Sunglasses* (1969).[128]

Elsewhere in the museum, however:

> As slight headache continues I'm having a hard time (upstairs among the permanent collection now) seeing individual paintings individually. Even Pollock and de Kooning, today, seem dusty and a bit sad. (Old hat.) . . . Just can't seem to get beyond the big gold frames today. (Old Masters.) Which reminds me how extroverted Alex's paintings are by comparison. So easy to look at, as they come out and meet you half way. . . . A Goya with one of his large beautiful neutral areas of "no color in particular" that neither recedes nor comes forward is the only painting upstairs that really touches me today.

I was surprised that he wasn't as enthusiastic as I was about a Zurbarán that Alex had told me was *his* favorite picture in the museum's collection.

We continued our day trip by driving to see Wallace Stevens's and Mark Twain's houses, having dinner, and stopping in New Haven to visit friends of Anne's. Then we wended our way to New Jersey where, fearful of running out of gas, we added one dollar's worth to the tank. (We must have been stoned.) Joe's diary concluded:

> New York City looks pretty good over there. When I see the city from far away I like to try to imagine someone I know in the city, in their apartment, doing whatever they might be doing. It's a hard place to believe you live in. . . .

When Joe got back that night, he wrote a separate diary entry:

That Kenward is the only person I can sing in front of is "love" tonight, even if it isn't.

This was followed by a footnote: "What a prick I am!"[129]

On January 14, 1972, Joe made the first of a series of visits to the University of Pennsylvania, in Philadelphia, where he had been invited to teach by Neal Welliver, the artist and head of the graduate art department. That day Joe gave a slide lecture, and on the 20th he gave a reading and toured the students' studios.[130] Neal recalls that Joe taught for a number of weeks and that he was very good.[131]

Between trips to Philadelphia, Joe was working eight to twelve hours a day toward his next show. He was also going out to Westhampton with Kenward. Somehow he found time to do his first series of etchings, the results of which pleased him enormously.

On top of all this, he would seem to have made a sort of sexual breakthrough, as he wrote to Bill: "Would you believe I've branched out a bit? (Girls.) You know, there really isn't that much difference. Except for the romantic part. In the head."[132] Evidence of this "branching out" is minimal. Given Joe's penchant for writing about his sex life, one wonders why he didn't capitalize on this radical departure.[133] And who were these girls? Joe was strong on honesty, but he was not above fudging the truth if he thought it was in everyone's best interest. Something in me says that this new revelation of Joe's was invented or embellished for Bill's benefit, as we shall see.

All There: The Second Show
at Fischbach

JOE'S SECOND SHOW AT FISCHBACH (April 1-20, 1972) presented drawings, pastels, watercolors, and etchings: portraits, Nancy as a de Kooning, grids filled with a variety of small images, cigarette butts, tattooed torsos, Ernie Bushmilleresque interiors, and so forth, mostly 11 x 14 inches. Gerrit Henry concluded his *ARTnews* article on the show:

> Brainard's art, then, is one of always funny, and sometimes beautiful, realism, the humor and beauty of which are aided and abetted by the silly, lovely, commonplace and everyday objects that comprise it. His latest show is (intentionally, one suspects) "minor," but what emerges as a result of its scattered thrust is a sense of the exhibition as some kind of rare, major potpourri. Brainard is approaching 30, but his art has not yet hardened (softened is, perhaps, a better word) into a form or a formula. It is, more than any noble fixation, a markedly fluid, meaningful *style,* a refreshingly old way of perceiving new things which, by its artful interweaving of skill with force of personality, is continually in the process of clearly revamping itself. The artist is, as has been said, "a creative" and diverse talent, and one of the triumphs of his new show is the unusual but undeniable equation it makes between quantity and quality. Where we have come to expect many contemporary artists to turn out series of singular last words on the dismayingly twin subjects of art and art history, we are slowly but

surely coming to see Joe Brainard's career as a continuing and sincerely comic dialogue between art and artist, an always-promising work-in-progress that is, at any recent point, all there.[134]

Despite favorable comments and good sales, Joe had another of his post-opening letdowns. On April 2 (a Sunday, Joe's least favorite day of the week), he wrote to us:

> If you want to know what it's like to have a rug pulled out from under you (don't bother) (and besides, I'm sure you already know), try having a show. I've never felt so totally empty in all my life. So empty I don't even feel bad (?). Actually, I do. I feel like *shit!*[135]

It didn't help that the exhibition did not receive a single notice in the New York newspapers, which was a bit odd in those days. During the show's run, the publication of two of Joe's small books, *I Remember More* and *The Banana Book,* did little to lift his spirits. He was casting about: maybe he would join Pat and me in Europe for part of the summer.

A month after the show, Joe wrote to me to say something that he said to me periodically, that he had been reading my work, "all of which was a total pleasure. So—thank you. *You sure are good!*" At various times he described me as "a great poet" and "a genius." The point here is that Joe took his friends' work seriously and that he was thoughtful in telling them he liked it (when he did). From his own experience he knew how the seed of artistic self-doubt can start to germinate, and how even a little praise can waft that seed away.

As the latest step in his continuing self-improvement drive, Joe compiled a new list:

Vermont 1972

Stop smoking
No pills
No painting

No writing
Exercise daily
Gain weight
Improve posture
Read science books

Why did he not want to paint or write? Because he was over-worked. As he said in "Saturday, June 10, 1972," "Boy do I look forward to Vermont. . . . This head needs a rest."[136] He expressed the same feeling in a diary piece he wrote during the long bus ride from New York to Vermont on June 16th: "I need a total rest for a while. To get into good shape physically. And to clean out my head a bit."[137]

It was unusual for him to break his Vermont routine. Routine can be crucial to someone who doesn't have the rhythms of a regular job or family obligations to give everyday life a shape. Joe's yearly structure tended to have him in New York from around October 1 to June 1 and in Vermont the rest of the year. His daily structure in New York was what he called "work and night," seven days a week. Each summer he created a Vermont schedule, usually one that combined work, reading, and physical improvement. From time to time he created smaller, temporary routines, such as having dinner at the same restaurant once a week. In general, Joe was not the kind of person to get up in the morning with no idea of what he was going to do that day. As he once wrote, "When it gets to be around four o'clock and I have no plans for the evening, I start getting nervous."[138]

On June 18, two days after arriving in Vermont with only the clothes he was wearing and his address book, Joe wrote to me and confessed that, despite his new summer health regimen, at that moment he had a cigarette in his left hand. Also he was working on a cover for Kenward's forthcoming novel, *The Orchid Stories*, a book that had been inspired partly by Joe's paintings of orchids and his willingness to explore new aesthetic territory. Joe was also working on a cover for the seventieth-anniversary issue of *ARTnews*—he had been unable to say no to its editor, Tom Hess—as well as the text for *New Work*, his own forthcoming book: "So I'm not going to give up everything until these three things are done."

I had just turned thirty. He had done it three months before:

If you are like me (which, of course, you aren't) you don't mind
turning thirty, but—don't count your chickens before they hatch.
I had several enormous delayed reactions. (Good luck!)

Near the end of June he was still slaving away on the *ARTnews*
cover, but the good news was that he had gained five pounds. It turned
out that Joe did pretty much follow his summer regimen. He kept a
reading list, which included a fair sprinkling of science books:[139]

Amigo by Dick Higgins
Gold by Andrew Wylie
The Family by Ed Sanders
Birds of America by Mary McCarthy
Triangle by Arlene de Marco
The Good People by Gavin Lambert
Youth and the Bright Medusa by Willa Cather
The Name above the Title by Frank Capra
The Naked Ape by Desmond Morris
Ceremony Latin by Bernadette Mayer
The Wonderful World of Insects by Albro Gaul
The Last of the Wine by Mary Renault
A Room with a View by E. M. Forster
The Berlin Stories by Christopher Isherwood
Yanomano: The Fierce People by Napoleon Chagnon
The Small Bachelor by P. G. Wodehouse
The Active Mind by A. R. Orage
The Last Days of Shelley and Byron by Trelawny
Veronica by Veronica Lake
The Gift Horse by Hildegard Knef
Leave It to Psmith by P. G. Wodehouse
The Spoils of Poynton by Henry James
A Passage to India by E. M. Forster
Père Goriot by Balzac
The Member of the Wedding by Carson McCullers
Understanding Ecology by Shelly Grossman
The Crystal Lithium by Jimmy Schuyler

The Human Body by Mitchell Wilson
Selected Writings by Blaise Cendrars
The Erotic Traveler by Sir Richard Burton

Endless pleasure may be had by imagining Joe outdoors in the sun in his bathing suit, coated with cocoa butter and reclining on a chaise longue and reading *The Wonderful World of Insects* while shooing away gnats, house flies, mosquitoes, no-see-ems, black flies, and deer flies.

Joe summarized his summer as follows:

> When people ask me what I did this summer I say, "Nothing," but of course, this is not entirely true. What I mean by "nothing" is that I gave up smoking and pills and all work for the summer. Which didn't leave me too much to do. So I did a lot of reading. Sunning. Exercising. And TV. So, it was a very relaxing summer. The result of which was that I gained 20 pounds. Built up my arms a bit. Got a good tan. And I got to where I could just relax and take things as they come. However, I've been back in the city for a week now, and my 20 pounds, I can feel them going. And I'm just as nervous with people as before. And as for all that reading: my head seems to have no place for information. A bad case of "in one ear and out the other." But I enjoyed the reading I did. And the being able to relax. And being with Kenward, I enjoyed that. So, for a "nothing" summer, it was a very good summer. And if I expected more permanent results (self-improvements) and I did, I had no right to. But, that I expect too much out of life is no big secret. And that I've done pretty well at getting "too much" is no big secret either. But, no satisfaction here. It seems to me that we just keep learning the same fucking things over and over again.
>
> I must say tho, that for a hopeless situation, we do pretty good at taking advantage of it.[140]

Pat, Wayne, and I spent ten weeks in Europe, and when we returned to New York in September Wayne entered first grade and I went back to teaching poetry to children.

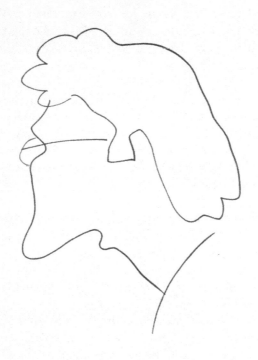

Self-portrait: 1972, by Joe.

I think it was in September of 1972 that Joe started teaching at the School of Visual Arts. Kenward was staying in Vermont until November, as he often did, Joe-less. Work had begun on an addition to the house, which the following summer would serve as a studio for Joe.

In October Pat, Wayne, Joe, and I motored to Washington, DC, for a three-day stay. It was our first visit to the capital, so it was sort of an adventure, which Joe described in a diary.[141] The day we started out, Friday the 13th, he

> got up early. Breakfast. Went to bank. Took raincoat to be cleaned. Picked up laundry. Bought small containers of shaving cream and tooth paste. (One word or two?) Postage stamps for postcards. And I got a hair cut. (One word or two?) So now I'm ready to go. I hope my bad toe nail (one word or two, I couldn't care less actually) won't give me trouble.

We spent the next morning at the National Gallery. Joe was especially interested in seeing Titian, Goya, Rubens, and Van Dyck that day. At one point he paused and wrote:

> Sitting in a sort of indoor garden with a fountain now. *Can't see any more paintings today!*
> As museums often do to me, I am reminded of my lack of patience. (As a painter.) My lack of focus. And perhaps even my lack of dedication. Although I work all the time, do I really work that *hard?*
> What I mean is that I feel I'm more of an "artist" than a "painter," which is O.K. except that, secretly, I want to be a painter.
> And although I feel the choice is mine to make whenever I feel like making it, I may be kidding myself. Not that I believe in "too late," no, I don't. But I *do* believe very much in "now." (Which is to say that if you're not doing it now, you're not doing it.) (Uh?)

We then drove over to the Corcoran, where Joe had fifteen small works in an exhibition called "Seven Young Artists," but we couldn't find the show. Joe didn't want to ask a guard where it was, he had wanted to happen onto it. So we left!

That evening we went to dinner at a steak house and got a little tipsy. Joe wrote that he was getting "very sweet vibrations from Ron of a 'I'm trying harder' nature, which I 'choose' to take as a personal compliment. (I say 'choose' because I realize that I am assuming a lot.)"

The next day we returned to the National Gallery, to see seventeenth–nineteenth-century French, British, and American painting. Joe noted:

> A Raeburn painting of a colonel in a red jacket really impressed me: the way it is painted. Slick, and accurate, and minimal, and without the device of too much style. In my head, this is how I want to paint.

He also wrote that Toulouse-Lautrec remained one of his favorite draftsmen, and that he was being "cruised by a nice-looking guy in a maroon sweater, but it all seems too complicated. I can't resist flirting back just a bit, tho."

On we went to the Museum of Science and Technology:

> One strange thing: a juke box machine from the '40s. Somehow *enormously* impressive. As an object it literally glows with a positive presence. Isolated and tough. As tho it had been chosen as *the* object most representative of our society, the weight of which it carries very well.

After a stop at the Museum of Natural History, for Wayne's benefit—he was almost six—we went back to the National:

> I'm beginning to get a clearer picture of Courbet's "contribution," though still I'm not crazy about him. I expect to be someday though. Two big paintings by David (*Napoleon in His Study*) and Ingres (*Madame Moitessier*) leave me surprisingly cold. I like the postcards of them better. When a painting doesn't "need" to be as big as it is, it sometimes bothers me.
>
> Manet. Manet has always been one of my favorite painters, and still is.
>
> Nobody, for me, is more realistic.

To pinpoint why is hard, but I think it may have something to do with a basic "black and white"-ness to his color: it hits home hard.

Manet must have had somewhat the same impact on painting as Godard did on film.

The seated woman on the left-hand side of *Gare Saint-Lazare* is not just looking out at me: her head was down, she looked up, now she is looking up and out at me. Or so one feels.

Later the diary continued:

As we walked out of the National Gallery, Washington was black, against a sky of rich hollow blue, blue to peach at the bottom. Quite a sight. (6:00 or so.) Dead tired, all four of us, we headed for the car, to go home.

A half an hour or so out of Washington, I, for some reason or another, have a vision of those fancy pink cookies, and green cookies, sprinkled with little silver balls.

Joe and Kenward spent Thanksgiving with D. D. Ryan, her husband John, and their children at their vacation home on Nantucket. D. D. was an important figure in the fashion world; John was an investment banker. One might think that in this social situation Joe was something of the odd man out, but he found the holiday quite enjoyable.

In December I sent Joe a postcard telling him how much I liked his new piece of writing, *Eight Imaginary Still Lifes*, which described seeing mental images somewhat the way he visualized the cookies when we were driving back from Washington.

Imaginary Still Lifes

BY EARLY JANUARY OF 1973 Joe had completed thirteen Imaginary Still Lifes. To write one, he closed his eyes and wrote a brief description of the still life that appeared in his mind's eye—for him an easy and enjoyable process. Some are simple and straightforward:

Imaginary Still Life No. 2

I close my eyes. I see white. Lots of white. And gray. Cool gray. Cool gray fabric shadows. (It is a painting!) With no yellow. By a very old man.

Others are more complex and sophisticated:

Imaginary Still Life No. 8

I close my eyes. I see pink. And green. And gold. All mixed up together. But now slowly evolving into three distinctive shapes. (. . .) It is a pink kimono, gently discarded upon the corner of a green dressing table, which enters the picture frame at a very sharp angle. Behind it stands a gold screen of three panels. In this particular Japanese still life one gets the impression that something is going on that cannot be seen.

OTHER AFTERNOON. KENWARD
IS WORKING ON THE SECOND
ACT OF THE GRASS HARP.
THIS MORNING IT SNOWED
A LITTLE. NOW THE SUN
IS SHINNING. WE'RE NOT
LEAVING HERE UNTIL MONDAY
MORNING. SO ___ PERHAPS I'LL
BE SEEING YOU MONDAY
NIGHT. WHY DON'T YOU
CALL? (MONDAY NIGHT) "HELLO"
TO TESSIE. I REALLY DO
THINK "BEAN SPASMS" IS A
GREAT BOOK. WHAT IS SO
AMAZING ABOUT IT IS THAT
~~IT'S ALWAYS~~ IT IS SO ALIVE, AND
ACTIVE, AND NOT-LIKE-A-BOOK.
READING IT WAS ALMOST LIKE
READING SOMETHING PERSON.
SOMETHING PERSONAL "GIVEN."
AT ANY RATE ___ IT'S VERY
FUNNY TOO. SEE YOU
SOON _____

LOVE) JOE

An example of Joe's handwriting (last page of a letter, October 20, 1967).

For me, reading *Imaginary Still Lifes* is still inspiring, and when I teach writing I ask my students to do their own Imaginary Still Lifes.[142]

Joe was also starting a series of verbal portraits of friends, using only one- or two-word sentences. The only surviving example I know of is:

Jimmy Schuyler

Trees. Baby blue. Plaid. Pajamas. Leather. Wrist watch. Pocket knife. Books. Silver. Autumn. Coffee. Scissors. Yellow. Lima beans. Belt.[143]

At the same time, he was working on an article about Anne Waldman and, above all, *More I Remember More*, which he felt would be the last of that series.

In February Joe wrote to tell me he liked the translations of the poems of Valery Larbaud that Bill Zavatsky and I had been doing. He signed his letter with a red valentine heart superimposed on the word *Love* and followed it with a postscript: "[I want] to apologize a bit for something I for the life of me can't figure out what or why." Every once in a while Joe would write a sentence like that one—there are a number of them in *I Remember*—sentences that seem syntactically contorted but are just right, which is obvious when one reads them aloud. His quirky punctuation, such as beginning a sentence with *So* and a very long dash, didn't follow a system or a theory of composition. He was well aware of his stylistic idiosyncrasies. In a letter to Anne Waldman, he noted, "I do hope I can eventually get rid of all my current dashes and parentheses, although I <u>do</u> 'understand' them. (And underlining too.) To say nothing of quotation marks."[144] In any case, although his letters and much of his other writing were written for the voice, his distinctive hand-lettering added a complementary visual joy. Just opening a letter from him was a delight.

And it was an even greater delight when he was writing in praise, as in a letter to Ned Rorem about an opera that Ned and Kenward had written:

Just a note to let you know how much I love the *Miss Julie* album. (A lot!) Never have I been able to appreciate you so much. Which of course is a total pleasure I—(sigh)—thank you very much for. You give me all the chills and goosebumps and lumps in my throat that Christmas caroling used to. Which hopefully is not too dubious a compliment. I mean it quite simply as grand praise.

I'm sitting outside in the sun in a bright blue bathing suit—the nylon of which feels sexy—drinking a tall glass of iced tea, and trying to ignore the orange splashes on the green trees all around me. Which always gives me butterflies in the stomach. As though just around the corner is another first day of school. Which rather leads me to believe—as I consider myself pretty normal—that, indeed, we never do grow up. Regardless of what the body has to say. (The gray hairs—they are streaming in at a most alarming rate!) But, in fact, I don't really care very much. And it's always good for "subject matter."[145]

Joe delivered not only praise, but himself.

Sicilian Interlude

IN LATE FEBRUARY OF 1973 Kenward and Joe flew to Paris. Joe wrote to us that he was "loving every minute of it! Walking down the streets, I picture you walking down the same streets." Being in Paris also triggered "fond memories of Washington."

In Paris Joe and Kenward joined Harry Mathews and Maxine Groffsky for a trip by train to Avignon and Nice for Mardi Gras, and then to Sicily. On February 27 Joe sent us a postcard depicting the face of a mummified two-year-old girl in the catacombs in Palermo, with a pink ribbon in her hair: "Palermo is, uh, I don't think we'll stay here for as long as originally planned." Although they did enjoy the rarified thrill of lodging at the Grande Albergo e delle Palme—because Raymond Roussel had died there forty years before—and the mosaics in Monreale, after a day or two they went on to Syracuse, which Joe described as *fantastic!* From there they drove to Taormina, where they stayed at what Joe called "my favorite hotel *in the world!* (So far.)" The small, somewhat private hotel was located not far from the ancient Greek theater that had a spectacular view of a smoking Mount Etna in the distance.

Joe's visual memory, his use of repetition, and his penchant for variations on the catalog form are combined in an unpublished piece he wrote about the tour of Sicily:

> Well, we saw lots of ruins and ate lots of fish. Did a lot of driving around the countryside: fantastic lay of the land. It was Mardi Gras time and so we saw lots of children in costumes everywhere.

And everywhere the Circus on Ice was "coming." And stucco: everywhere there was stucco. Old-worldly stucco and new candy-like stucco. (It's a thing I have a big soft spot for, stucco.) And mosaics. We saw lots of old Roman mosaics. Sexy statues. Cold churches. And cactus plant graffiti. And, in one place, there was a street almost named "Banana." White wine. And lunch. (I rarely eat lunch.) And trying to take naps. (I never take naps.) Little bars of soap. Hotel door problem locks. And light brown toilet paper good for cleaning your glasses with. Lots of postcards of Mount Etna erupting. And on one short drive I remember lots of Corot-green trees. And negative pictorial road signs. And in Palermo, many cars. Soccer-ball ticket stubs littered the streets. (Marlboro cigarettes.) Blood oranges. Mucho laundry. And good Bloody Marys at the same hotel Raymond Roussel died in. And somewhere—somewhere more around the middle of Sicily—up high—lemon trees in the snow!

But travel fatigue was setting in. By March 7 they were all back in Paris, and a day or so later Kenward and Joe flew to New York. In late April, Harry wrote to Joe: "Our trip was great, wasn't it—I feel, after it, that we shall be friends forever, and great ones too."

There is no hint in any of this that anything "happened" on the trip, but a letter that Joe wrote to Bill Berkson in May is highly suggestive. That Joe had an ongoing crush on Bill was no secret. Joe nurtured this crush, which Bill was adept at ignoring.

> You know, one of these days, I have my heart set on just you and me taking a trip somewhere. But, oddly enough, I'm in no hurry. I know it's going to happen. . . . (All of which is a big fantasy trip, I suppose, but either I don't care, or I have one hell of a lot of faith: faith that if you really want something, sooner or later you'll get it.)
>
> Which reminds me of Maxine and me, only it was she that— Guess I'd better shut my mouth.
>
> (I got nothing I wouldn't tell you, but some people, as you know, like to live differently.)[146]

When I asked Maxine, an unusually forthright person I have known for almost forty years, about this passage, she replied, "I have

no idea what he's writing about, but please use the letter if you want to. It's really intriguing."[147] In a letter to Bill a year earlier, Joe had spoken of his (supposed) forays into heterosexuality. Bisexuality was in the air, and it is possible that Joe was now hinting that Bill give it a try. Joe was not given to subtle maneuvering such as this, but who knows?

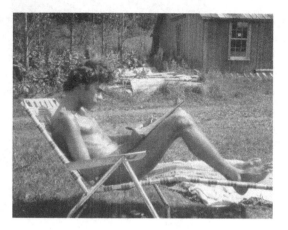

Joe on his lawn chair, writing, Calais, probably ca. 1967–68. Photo: Ron Padgett.

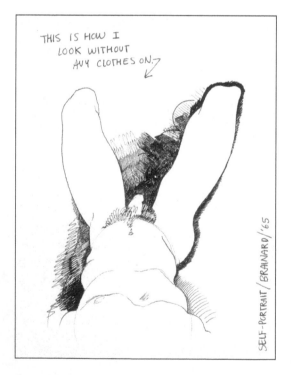

Figure drawing by Joe, using himself as the model, 1965. Collection: Pat and Ron Padgett.

Style

Sometime in the summer of 1973 Joe wrote a brief description of himself that could serve for many other summers in Vermont, entitled "Right Now":

> Out in the sun. Coppertone suntan oil on. Vermont. Calais. (1973.) With a yellow bathing suit on: one of three I got in Paris this spring which, actually, are underwear. One brown. One red. And this yellow one.
>
> A big white towel draped over a lounge chair is what I am on.
>
> What I am writing on is a National clip-board under a tablet of such very thin blue lines resting on the arm of this chair with a black Flair [felt-tipped pen].
>
> (It is not my purpose to bore you. It is my purpose to—well, I want to throw everything out of my head as much as possible, so I can simply write from/about what "is," at this very moment: *Right Now!*)[148]

Then he noticed that he had overlooked what was straight ahead in his visual field—his own two feet—which he then described. The view is the same as that of the self-portraits he did as an eighteen-year-old in his room in Dayton, alone, propped up in bed, looking down the length of his body. In fact he used this same viewpoint in many drawings over the years.

In early June I wrote to Joe:

Let me take this opportunity to remind you that my birthday is coming soon and I expect at least a drawing from you, though if you are reading Flaubert now you will probably paint more like Raeburn, so I will wait, if necessary, for a later canvas. The other day I really realized exactly what you were talking about when you were standing in front of the Raeburn in the National Gallery, because: 1. I was suddenly illuminated looking at the still life (gouache) with pink rose you recently gave us; 2. I had been back to the National with Dick and looked at the Raeburn again; and 3. I read your "Washington, D.C. Diary," which helped locate me emotionally, etc. In fact I understood, or felt I understood, not only your remarks on the Raeburn, but on your own work as well, and the battle you have with your own talent which sometimes keeps you from going beyond it. Your great talent is unquestionable . . . but I suspect that this very talent is so clever that it sometimes leads you into a sort of caricature, or overstylization, which I think you might want to avoid, or go beyond, or around. Now this will probably get too highfalutin, but here goes: in the gouache still life you gave us there are areas which are stylized (and beautifully so) and other areas which are just wonderful painting (take the breath away). In the overstylized parts a little vase or bottle will look like a (lovely) version of itself, but in the really great areas (such as the pink-orange blurred flower) the things don't really look like the objects they are painted from, and yet they are more like those things than the stylized versions! Does that make sense?

Joe quickly responded with a far-ranging, sixteen-page letter, complete with drawings and images clipped from newspapers and magazines. He was painting oil landscapes with farmhouses and reading Trollope ("*The Way We Live Now.* 831 pages!") As for my comments on his work, he replied:

"Style," of course, is a very big word.

Painting, when you get right down to it, is nothing but.

Nevertheless, yes, I know what you mean. I would try to say more on the subject except that I find it an infuriating subject because the more one thinks about it the more "fuzzy" the term

becomes and I end up nowhere. A thing, actually, I find true with most things.

One thing that I have never figured out is if I am just very dumb or if my head simply has no patience. (Either way, I fear the results are rather similar.)

He then drew a sketch of the painting he had been working on, and commented:

Actually, that drawing is very misleading. The house, which rambles into the barn, is really much smaller in proportion to the landscape it is "on" or "in," a major problem ("in" or "on") with landscape painting. Even with trees I find it a very indecisive relationship.

Another problem I run into is horizon. *Never* before have I seriously worked horizon. And landscapes, to me, are pure horizontal.

An intriguing factor is that what is not on the canvas must somehow be felt. Having always been very much into definite edges, this is throwing me sky high. I mean, that a landscape is continually continuing is a must.

Perhaps part of his struggle with the horizontality of landscapes came from his having worked almost always with a vertical format, from the poster designs of his youth to the assemblages, paintings, drawings, collages, book covers, and collaborations of his maturity.

But you know—about "style"—a thing to which I am naturally drawn—it can also be a very good thing to work against: a device I believe in very much. It keeps one going. And so even if I was ever able to overcome it, I'm not so sure that it might not be the death of me.

And so here does not lie my real problem, I think. I think, rather, that it is a basic lack of dedication to "art." Rather, to me, it is more simply "a way of life." Rather, I am dedicated to work. And to doing it for other people: "a present," which I need very much to give.

> (Now, I suspect I am being a bore.)
> So to Patty I paste in this picture.

The picture was a newspaper photo of a baby ape named Patty Cake.

The letter continued over the next several days, which he spent painting landscapes. He mentioned our "pornographic" "children's book," *Little Jeanne*, offering to publish it himself, provided he could have the chance to redo the drawings.

> Speaking of which—I have two drawings and one collage up in some show at the Whitney now. Not, alas, a very good selection. And it's too late to get the hots over being in a museum show. But, if you're up and about, I would be curious as to what sort of a show it is. And how I fare.

The writing of what he was calling *The Last I Remember* was going slowly, but, as he later reported to Anne Waldman, who, with Lewis Warsh, was its prospective publisher, he was "in no hurry; it's got to be the best, I feel, or nothing at all."[149] In early June Joe learned that the Museum of Modern Art, which had commissioned a Christmas card, had rejected his first idea—involving a die cut—as too costly. He would have to do another. Also, the Merrill Foundation had turned down his grant application.[150] But there was good news too: he had painted for seven straight hours and Jimmy Schuyler was going to be published in the *New Yorker*. He ended the letter to us with a little collage.

Later in June I notified Joe and Kenward that Lee Crabtree had committed suicide. Lee was a songwriter and musician who played with The Fugs and had worked with Kenward on poem-songs, but before that had been part of a group originally in Minnesota who ended up in New York City—Peter and Linda Schjeldahl, the painters Martha Diamond and Donna Dennis, and others. On June 22, Joe responded:

> I *do* find that someone doesn't want to live anymore very depressing. However, I do not find suicide depressing. In fact, I think to live a

life without that possibility would be unbearable: like being stuck in an elevator.

But the biggest problem I have with dead [*sic*] is making it register. Lee's dead [*sic*] has yet to really hit me one iota, and yet I know I care.

And so I suppose it is either a matter of a reality gap, or else I am enormously self-protective: a possibility which I dislike very much.

So far as I know, Joe had never attended a funeral.

Kenward had a large number of potential guests for that summer, and Joe wasn't sure if there would be an opening for Pat, Wayne, and me. He liked the Jim Dine cover on my new book in German (*Grossefeuerballe*), generously describing it as "more interesting" than the cover I had originally chosen, an adaptation of his design for *Great Balls of Fire.* That same morning, he had zipped through the proofs of his own book, *New Work,* which Black Sparrow was to publish. And then it was noon, time for chin-ups, a Pop & Toast cheeseburger ("really good"), and the stretching of a few canvases for the next day's work. He ended the letter with his usual string of postscripts, followed by:

> P.P.P.P.S. (I am wondering about the "legality" of all these "P.S.")
> ((??)) Which is not what this "P.P.P.P.S." is about. I just want to say,
> tho such a thing can not be said, alas, as gracefully and as naturally
> as I would wish, but———I very much want to actually say it
> anyway: <u>THAT I KNOW YOU ARE A GREAT POET</u>! And that I
> am very happy for both of us because of it.

Enclosed was an announcement card for "Joe Brainard: 102 Works on paper, 1966–1972," May 13–June 17, 1973, at the Utah Museum of Fine Arts in Salt Lake City.

One thing he didn't mention was what Kenward called Joe's "summer renunciation '73": no TV. In fact, the television set had been banished to the basement, but Kenward toted it back up to the music room so he could watch the news.

One day in June a car pulled up at Kenward's house in Vermont and out stepped poets Lewis Warsh and Bill Corbett. Lewis, visiting Bill

and Beverly Corbett at their summer house in Greensboro, had suggested to Bill that they drive the twenty-five miles south to drop in on Joe and Kenward. That evening they all had dinner at the Corbett house in the screened-in dining room that overlooks Caspian Lake. The two young Corbett girls played outside. At the head of the table, Bill, a high-spirited raconteur, poured the wine and led the conversation while Beverly served delicious course after course she had cooked. Dinner with the Corbetts, both at their place and at Kenward's, became a summer ritual that was to continue for seventeen years. Joe once told me how much he liked to sit next to Beverly, partly for her conversation, partly for her elegance and beauty. Bill recalls that on at least one visit Joe worked while everyone else chatted:

> I remember him coming to dinner with a bulging folder of paper and his scissors. While we had drinks he cut rapidly, squinting through the smoke from his cigarette to check his line.[151]

It sounds as if Joe was speeding.

On another occasion he brought a portable television to dinner so everyone could watch a funny documentary on the CIA's attempts to destroy Fidel Castro.

On July 18 Joe wrote to tell me how much he liked "Sides," a long poem I had sent him: "Your poem is just beautiful! (Not a very precise word, alas, but—) But it means that I liked it a lot." Then he delivered one of his gems: "So much so that, while reading it, I forgot it was a poem!"

He had been putting oil paint to the roll of canvas I had sent him:

> Boy have I been working hard! And very well, up until two days ago, which is why, today, I am not.
>
> Yesterday was painting a lobster for eleven hours solid and blew my wad so much into lobster "construction," and color, that I ended up with quite a mess.
>
> I suppose (oh, hum) I learned a lot tho. . . .
>
> One painting I am totally tickled pink with is a recent Whippoorwill on sofa: as instantly "clear" as Manet, and as minutely fine as a small Degas ballet class (well, almost).

Kenward just let out a big laugh from his studio, preceded, and now [followed] by much typing. . . .

I've been taking too many pills, but, alas, that won't continue to be much of a problem as I'm very short now.

In a separate letter, Kenward described Joe's having finished an "incredible" portrait of Whippoorwill. Joe had written to Fairfield about several such recent paintings:

> The past three days have picked up a lot. The first of which was two small paintings of Whippoorwill where I let myself "draw" a lot, indulging quite heavily in "black and white." (And with only one large brush and turp.)
>
> Good day No. 2 was my first successful large painting, also of Whippoorwill, using lots of oil and lots of "dash," with much transparent overpainting, which worked beautifully for getting the pinks and blacks, partly seen and partly "felt," under Whippoorwill's thin white coat of hair. He is lounging on the olive green velvet sofa with two patterned pillows. Very focused in. (No eliminations.) Very French. And also a bit, alas, Sargent. Nevertheless, primarily because of its size, I consider it a break-through.
>
> Good day No. 3, today, was one small brush, no medium (not even turp). A small painting again, of Whippoorwill again. Where I started out rough, focused in to very fine, and then did some very successful eliminating. The three stages of which I've often felt was the process for me (now) but today, for the first time, I was able to bring the tightness back to something as hard-hitting as rough without it's being rough. A bit, perhaps, like some Degas race track paintings I have seen, where details are somehow more "felt" than actually seen.
>
> And so, right now, I am feeling nicely optimistic.[52]

Joe also wrote to Bill, remarking that it is "so strange confronting a work you couldn't possibly have done but evidently did! And that's just how good a few of my new works really are: it's *shocking!*"

He went on to describe his Utah show as "a big fiasco. Partly cut-backs in museum funds. Partly that no other museum wanted to 'buy into' it (me). And primarily *total incompetence!*" The local

reviewer "was very nice in being more mystified than put off by such a hodge-podge of stuff."[153] This experience confirmed Joe's belief that his work was understood only in New York and Paris.

Maybe it was the pills talking, but in a letter to Anne Waldman written the day before, he said: "I quite literally (visually) feel/see myself growing older at a very speeded-up rate. . . . More than a bit spooky, yes. . . . On the other hand, no."

In August we Padgetts spent two or three weeks in Vermont. Not long after we had left, Anne Waldman and Michael Brownstein arrived.

During our stay Joe was happy to see the first copies of *More I Remember More*, but he was exhausted from painting so hard. And maybe he had run out of pills. He noticed how

> I seem to zip through one [day] only to find myself zipping through another one. Which is to say, no definition. And one of these days, I know in my heart, I'm going to realize what a fool I've been. But, right now, I seem relatively content with "Well, that's simply the way it is." Strange to me that my insane "drive," having a direction but no real purpose, doesn't displease me more than it does.[154]

Near the beginning of September, Joe returned to the city, where he replenished his pill supply. But New York was experiencing a staggering heat wave, with an air quality that the radio described as "the worst ever."[155] Weather aside, Joe felt like "a real big mess."[156]

After Kenward's trip to Kansas City for the opening of his opera with Jack Beeson, *The Sweet Bye and Bye*, Joe, with a new supply of pills, went back to Vermont in early October. On the 15th he wrote to me that he had "been working too hard (9 to 11 hours every day solid!) to be able to sit down and really write a letter." I didn't realize it at the time, but his feeling like "a big mess" was intensifying.

From New York a few weeks later, Joe wrote to Anne Waldman that he was "having a very successful thing with Juan Antonio, a dancer

with the Louis Falco Company . . . with the best sex ('loose' and adventurous) I've ever had!" [157] Joe felt free to relate his sexual adventures to Anne, who was more on his wavelength in this area than Pat and me. Besides, he knew that Pat would have preferred him to be monogamous with Kenward. She had told him so.

The Show of Oils

IN THE EARLY PART OF 1974 Joe worked hard on oil painting for his next show. Pat recalls sitting for a portrait whose face he repeatedly scraped off and repainted. Then she abruptly left town to visit her father, who was gravely ill. Joe included this uncompleted, partly faceless portrait, titled *No Portraits (Gr-r-r)*, in his show, which opened at Fischbach in April.[158]

Just before the opening, he finished what was to become one of his best-known paintings, a large Nancy diptych. This piece was unlike the rest of the show: figurative still lifes of watermelon and lettuce, Vermont landscapes, and depictions of Kenward's whippet. The largest piece in the show consisted of sixteen theme-and-variation paintings ganged together, each depicting a Cinzano ashtray with cigarette butts. It is one of Joe's best works. Except for the Nancy diptych, the new pieces were, as *Art in America* reviewer Peter Frank put it, "in a far more painterly manner, one that situates itself in the Realist tradition. . . . Brainard's plunge into realism is a deft one: the new paintings are as intimate as his former work and as visually skilled and expressive." While Frank found the show lacking in the "individual personality" of Joe's previous works, he praised the whippet pictures as "brilliant in their economy of form and brushwork" and the landscapes as "solidly and evocatively conceived," and looked forward to Joe's further development in this new vein.[159] Thomas B. Hess was more enthusiastic, finding the work "brilliant, unselfconscious, charming."[160] I thought the show was ravishing. Some of the work sold, but as usual Joe felt deflated. For him the show wasn't good enough.

In his case, post-exhibition blues was to be expected, but because this was his first show of oils, the letdown was heavier. Writing from Vermont ten weeks afterward, he still felt drained:

> I have done absolutely nothing except read [*Remembrance of Things Past*] since the day my show opened and so I feel I have practically nothing to write about.

I tried to cheer him up by saying, "Somehow I find it hard to understand how a person as successful and talented as yourself would be bothered by a single show," which showed my lack of understanding. He had made a huge emotional investment in that exhibition.

Shortly after the show closed, Joe volunteered for activities that were new to him: appearing in a movie, having big social lunches with drinks, and serving as a subject for a case history for doctors who were writing a book about fantasies. He also went to Detroit to give readings at Wayne State University and Macomb County Community College. It may have been around this time that he gave a reading and slide talk at the Tyler School of Art in Philadelphia.[161]

Joe had acted in plays before, such as book-in-hand productions of Kenward's play *City Junket*.[162] Now there were three performances at the New York Cultural Center with a cast of Brooke Alderson, Clarice Rivers, Anne Waldman, John Ashbery, Peter Schjeldahl, Steve Griffiths, Michael Andre, Kenward, and Joe, who played the part of the guide. The event was wildly diverting, but it wasn't enough to lift Joe's spirits.

His doldrums continued in May. He apologized to Bill for not writing: "I'm awfully sorry, but, really, an incredible distance has gotten in between hand and head, which, try as I may, and have, I can't bridge."[163] It was an opportune time for him to get away, this time to Washington, DC, with Joe Hazan, Jane Freilicher, and Kenward, to take part in an antiwar rally, which turned out to be "more exhausting than fun, but I'm not sorry."[164]

That summer Pat, Wayne, and I joined Joe and Kenward in Vermont for a two-week stay. Joe was working on a cover design for *Big Sky* magazine and feeling fuzzy, as he wrote to Bill:

I'm just not "with" it (me) anymore. Which I guess is one reason I don't write much: it must be such a bore for others too, being so fuzzily "down." (If I can just put my finger on *something!*) [165]

Joe usually confined negative information to his letters and diaries, so that my quoting from them might give the erroneous impression that he was gloomy and lifeless. He allowed himself those feelings mainly when alone. I think he felt that acting depressed was a selfish imposition on others, so that even during his down times he was a special pleasure to be with, and, as far as Pat and I were concerned, whether or not he was "a bore"—and he certainly wasn't—was not an issue, since we did not require or expect him to be entertaining. That wasn't why we loved him or liked being with him. But we were unaware of the depth of his malaise.

By late September Joe was back in New York, depressed. The imminent move from his Sixth Avenue loft was not giving him the lift he had expected. In a letter from Vermont, Kenward wrote to him:

About suicide: that's weird. I've been thinking about it as a possibility now and again, I mean more than ever before, not counting adolescence. Scary idea, though. Hard to "grow old gracefully." But as for you: DON'T. Good grief, you have a long ways to go yet. Besides, it'd be selfish to leave me "behind." [166]

Joe was teaching at the School of Visual Arts, even though his experience at Cooper Union hadn't convinced him that he was right for that role.* This year he entitled his course "Elusive Realism." I wrote to Kenward in late September, "Joe's first two teaching sessions were disastrous (according to him). He was thinking about quitting, last I heard." In fact, his two-year stint at the School of Visual Arts was to be the last teaching he would do for the next eight years. [167]

In the meantime, he had almost finished doing fifty drawings for John Ashbery's forthcoming *Vermont Notebook.*

* His first year of teaching at SVA (1972) also saw a large show of his drawings at the school.

8 Greene Street

IN MID-OCTOBER OF 1974 Joe moved to a loft (35 x 95 feet) that occupied the fourth floor of 8 Greene Street, near Canal. A partition separated the back area, which he used for storage and sometimes for work, and the larger and brighter front area, which he furnished with a mattress, a sofa, a coffee table, a few chairs, and a table. The big room also had an open kitchen, next to the bathroom. The far end of the room, looking west over Greene Street, was solid windows. All the walls were white and the general look was, as usual, spartan.

Although the new loft was spacious and wonderful, Joe's doldrums continued:

> Altho I'm extremely happy with my new loft, I'm not at all so with my present existence. Especially so night-wise. Rather than seeing good friends, I———
>
> To make a long story short, I'm very nervous. Drink too much. And continually horny, but mostly in the head, I suspect. None of which is very accurate: should have stuck with the long dash.
>
> Just not as happy with my own company as I should be.[168]

Teaching continued to be a chore.

One of Joe's seasonal gifts to Kenward was *A Happy New Year Scrap Book*, which contained ten original collages, paintings, and drawings. It was typical of him to give away his beautiful small works.

By March of 1975 he was back into his daily routine of "work and night." The work pace was intensifying, as he wrote to Pat in

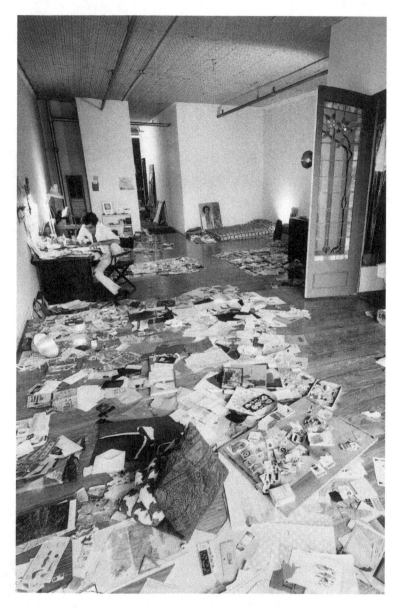

Joe in his Greene Street loft, 1975.

mid-April: "Am now into miniature theaters. Working like a fiend. And having a ball! The urge to be serious seems to have ___ 'zap!'" Kenward wrote to me:

> Joe has turned into a total maniac, there are pathways in his loft, surrounded by material sorted out according to some conceptual scheme heavily influenced by Rube Goldberg—he's doing "theatres" and tiny cut-out foods that fit into aspirin tins.

Joe's book with John Ashbery, *The Vermont Notebook*, had just come out, as had the new *Paris Review* with his cover.

In April Kenward went to Nepal for a high-altitude trek, then returned to New York and continued on to Vermont, where in late May he wrote to Joe, asking him to come up as soon as possible, and hoping that Joe's "baffled system is coming out the other side of cool turkey and hot city." Apparently Joe had stopped taking speed.

In late June Joe wrote to me from Vermont: "Seems my summer of relaxation is going to be somewhat hindered by a giant show (both rooms) in October [at Fischbach]." He asked if I could bring three packs of X-acto blades when I came to visit. Then he apologized for not seeing us earlier in the month, when Pat, Wayne, and I had returned from Delaware, where I had been teaching for three months: "a bad case of 'the downs.' Very anxious for your visit soon tho, of course." His reference to "working like a fiend" and then a subsequent case of "the downs" may have been the result of his use of Desoxyn, the "diet" pill, and then stopping, which he did in early June. It's likely he had run out of pills temporarily.

On June 30 Pat, Wayne, and I drove to Vermont for a three-week visit. Joe spent all day and some of the night working on collages in his new studio, which had become a maelstrom of snippets. Kenward was concerned by Joe's speed-focused obsessiveness— sometimes it was hard even to get him to the dinner table. Amidst it all, Joe was giving Pat painting lessons, just before she and I went back to New York.

On August 1 Kenward and I met up in Boulder to read at Naropa Institute's Jack Kerouac School of Disembodied Poetics. Then I joined Pat and Wayne in Tulsa. Joe wrote to me on August 19, asking

if he could ride back to the city with us on September 3—apparently Pat and I were planning on returning briefly to Vermont—and thanking me for having sent him the Yellow Pages of the Tulsa telephone book, whose images and logos he was cutting out for use in his small collages and miniature theaters. I had already sent him a Newark, Delaware, phone book, and Ted had sent him a Chicago directory. He was disappointed by some of the results but he had hopefully chalked up their unevenness to speed, and now he was again doing "lots of work."

The Big Show of Little Things

IN SEPTEMBER OF 1975 Pat, Wayne, and I went to South Carolina, where I was to teach for three months. Kenward stayed on alone in Vermont until around the first of December, one month later than usual. He may have done so in order to distance himself from Joe, whose speed-induced work obsession was becoming harder and harder for Kenward to deal with. At some point in 1975—probably at the end of his summer stay in Vermont or in the early fall—Joe gave Kenward a collection of small red found objects (feather, rabbit's foot, toy ring, price tag, bingo card, etc.) and original miniature artworks, mostly in the shape of valentine hearts, based on the theme of his love for Kenward. Included among them was an abject note, tucked into a coin purse, that read: "Regardless of anything I love you more than everything. I'm sorry I wasn't better. Thank you for being so good. I love you very much."

Kenward had decided to end their relationship, and the shock for Joe was so great that from time to time he could barely get out of bed. The sudden death of Fairfield Porter was an additional blow. The certain success of Joe's next show didn't mean anything anymore.

In December, Full Court Press celebrated the publication of its first three titles: Edwin Denby's *Collected Poems*, Allen Ginsberg's *First Blues*, and Joe's *I Remember*.[169] Joe's book was a composite of the three volumes published by Angel Hair—*I Remember, I Remember More*, and *More I Remember More*—and the Museum of Modern Art's *I Remember Christmas*, all of which Joe revised and rearranged.

Because of my job in South Carolina, I missed the book party at the Gotham Book Mart, which was packed with friends and admirers of the luminous three authors. Given the breakup with Kenward, it is hard to imagine Joe's enjoying it very much.

I did get back to New York in time for the opening of his show on December 16th at Fischbach. The postponement from the October opening date was probably by mutual agreement. I suspect that Joe wanted time to produce more work and the gallery liked the idea of a timely show of small works that could be snapped up as Christmas gifts.

The show was overwhelming: 1,500 collages and drawings (only half of what Joe had produced for it). In a *New York Times* review that carried a large reproduction of one of the collages, John Russell wrote:

> Brainard is a born diarist. No moment of the day is dead to him. With his nimble fingers and even nimbler wit, he has cobbled up an untold number (3,000, some say) of tiny works of art for his new show. They include . . . still life, manipulations of familiar objects (books of matches, luggage labels, pieces of string), one-line jokes written out in a misleadingly childish hand, and annotated records of specific moments—pathetic, hilarious, ironical—in his own life. Most of the works are no bigger than a postcard, and the general level inevitably goes up and down; but the ups are way up, and we sense throughout the show an ongoing energy which insists that images are there to tease, provoke, and give pleasure. In Mr. Brainard's hands they do all three of these things. This is the wittiest show of the winter.[170]

The wildly popular show attracted heavy crowds and sold well, partly because of the gift season, partly because the work was irresistible, and partly because the prices were ridiculously low. Joe insisted on keeping them low, as low as twenty-five dollars, so that anyone could afford one, and the gallery went along. Such a strategy might work well in the world of merchandising, but in the art world lowering your prices is *not* a good move. It makes museum curators and major collectors think that the value of the work is sinking, like a stock or other speculative investment. And by 1975 the idea of contemporary art as an investment had already fastened its death grip on

the art world. In effect, Joe's insistence on low prices suggested that he did not want to play that game. As he said in a feature article in *People* magazine about him and the show, "The art scene has gotten too big, too serious, too self-important, and too expensive."[171]

For the Christmas and New Year holidays, Kenward took Joe to Vermont, where Joe wrote to Rudy Burckhardt, asking him to go by the gallery and pick out "one you think would be nice to live with.... It is a show I want taken [for free by friends]." He noted that

> up in Vermont snow makes for a dramatic enough switch that after-show blues are very much less. Most amazing thing (speaking of blue) is how much yellow there is (or seems to be) in the winter sky, in contrast, I suppose, to so much blue on the ground: such an obvious warmth reversal never occurred to me before.[172]

With the show behind him, Joe told Rudy that he was "looking forward now to seeing people (friends) again." That the article about him had just appeared in a magazine called *People* gives his remark a strange afterglow. In any case, one of the article's accompanying photos showed him lying on the floor, his face and torso dotted with miniature collages and snippets for future works. There was a big smile on his face. Something that I didn't notice at the time was that his unbuttoned shirt revealed a rib cage that could have been that of a starvation victim. Unfortunately, the "diet" pills were working.

Since moving to the Fischbach Gallery five years before, he had had eight solo exhibitions and taken part in twenty-four group shows.

When Joe returned from Vermont in early January of 1976, he went back to taking speed and making collages and mixed media pieces, many of which were faster and looser than before. All over the floor of his loft were islands of small pieces of paper: a "red" island here, a pansy island there, a matchbook island, hundreds of such islands.

As Joe said a few years later, "I [worked nonstop] for three days once, with the help of a little speed, of course, but I got crazy. I was seeing little people. . . . And I sensed people behind me doing things." He also recalled, "One time . . . I spent a whole night working and doing these works and I know I was awake and doing them, but the works don't exist. I don't understand it to this day and I swear to god that I did them."[173]

The Speed Crisis

IN THE EARLY EVENING OF MARCH 26, 1976, Kenward called me to say that he was extremely worried: Joe was in a terrible state, depressed, angry, disheveled, doing too much speed, and just a few minutes ago on the phone had made frightening allusions to suicide. I told him to pick me up and we would go down to Greene Street together.

Twenty minutes later we rang Joe's buzzer. There was no response, so I buzzed other residents—all of them—but no one answered. There seemed to be only one way to get up to the apartment. I had Kenward boost me up to where I could grasp the fire escape ladder, which allowed me to pull myself up onto the fire escape itself. I started up the stairs, my heart pounding with dread and adrenaline.

Finally I reached the large windows at the front of Joe's loft. Inside, the lights were blazing. The floor of the entire loft was a riot of piles of scraps of paper, with narrow footpaths zigzagging through them. It was chaos, barely contained, and sitting in the chaos was Joe, who turned his head to see who was at the window, his eyes unusually large and brown and staring blankly, and he looked so transfixed, so odd, so utterly changed that I was frozen in terror. It took me a moment to realize that in fact this was not Joe.

I tapped on the pane and gestured to the young man to come open the window. He got up and approached hesitantly.

"I'm Joe's friend Ron Padgett," I shouted. "I'm worried about him."

"He's out now."

I wasn't sure whether to believe this person or not. Maybe he was a murderer. Maybe Joe was in a garbage bag in the back room.

"Open the window so I can come in."

"I'm not sure if I should."

"Don't be silly, I'm Joe's old friend from Tulsa. Kenward is downstairs."

As the young man unlatched the window, I yelled down to Kenward, "Joe's not here. I'll buzz you in."

The young man said his name was Frederick Fulmer and that he was working as Joe's assistant. He also said that Joe had gone out to do some shopping, which seemed unlikely, since in those days most stores around Canal and Greene—what few there were—were closed. I let Kenward in.

After some uneasy minutes, we heard a key in the lock. Joe came in, carrying the cigarettes he had just bought and looking very wound up—maybe *crazed* is the word. I had never seen him like this. Having spent most of the past year in Delaware, Tulsa, Maine, and South Carolina, I was out of touch with how he had changed. Maybe he had been taking extra speed to combat the letdown after his show.

When he saw Kenward, he tensed and his face darkened.

I put it to him point blank: "What's going on?"

"What do you mean?"

"Don't give me that," I said with a gruffness that I had never used with him. "What's the problem here?"

"*He's* the problem," said Joe, glowering sideways in Kenward's direction like a dog protecting his food. It was a look I had never seen on his face (and would never see again). It was the opposite of "Joe."

Kenward looked anguished. Frederick had faded to the side of the room.

"Give me a break!" I said. "You're going to tell me that Kenward has burnt you out on speed?"

"I can handle speed."

"You're joking. Look at you!"

"O.K., it's gotten a little out of hand."

"More than a little. You're completely fucked up. You've got to go into a program."

"I don't need to."

Kenward said, "I can find a good one."

"I don't want anything from *him,*" Joe snapped.

"This is not about Kenward. It's about you. You know you have to stop—and stop *right now*—don't you?" I said.

"Yes, I know," he admitted. "But I can do it on my own."

"You think so?"

"I know so."

"You're kidding yourself."

"No, really, I know I can."

"All right, then let's do this. You try to kick on your own. But if I hear one word of your taking any speed—*ever* again—I'll do two things. First, I'll punch you in the fucking nose as hard as I can. Second, I'll have you committed to a mental hospital. I swear I will. I did it with Jimmy and I will do it with you." I disregarded the fact that these unbelievable words were issuing from my mouth.

Frederick said quietly, "I'll stay with him, to make sure."

I snapped back, "Are you part of the problem? You do speed too?"

"No, but I know a lot of people who do."

"Who *are* you, anyway?"

"I work for Fischbach, and I'm a friend."

Joe confirmed this.

I looked at Kenward and asked, "What do you think?"

"It sounds o.k.," he said. He was crushed.

I made Joe promise to answer his phone and buzzer, and I reminded him of my threat. I meant business. Then I "broke character" and told him I loved him, and that I would phone tomorrow.

Kenward and I staggered downstairs relieved that Joe was alive.

Five years earlier, Joe had written that speed made him go too quickly from one thing to another:

Here lies the problem with pills ("ups"). A problem I find much easier to cope with though than that of a day not being completely consumed, digested, and up-chucked ("product"). A mad fiend, yes—but I'm willing to pay. The time will come.[74]

The time had come.

But the crisis involved more than speed. I soon learned that Kenward, finally fed up with Joe's being available mainly in the summer (and then sometimes only partly present, due to speed), had fallen out of love with him and begun an affair with Steven Hall, a poet he had met during our visit to Boulder the previous summer and whom people described as a younger and handsomer version of Joe. Joe could not handle this rejection. As for the mutual anguish and recrimination that the two of them felt, that was between them. I wasn't qualified to give them advice and it wasn't my place to intrude. I felt that all I could do was to show sympathy for both of them.

That night marked Joe's cold-turkey good-bye to amphetamine, with only a cautious and very rare use of it. It also began a period in which he slept twelve to fourteen hours a day. Frederick looked after him for a while. Then Pat and I, who by that time had keys to his loft, would drop in to check on him.

One day Pat walked down to Greene Street and found him asleep. She tiptoed over to a chair and sat down to rest. When Joe woke up and found her there, he seemed a bit put off by it, but then he apologized and told her he appreciated her concern.

It also dawned on him how much Kenward meant to him:

> I suddenly realized that he was the only person in the world that I knew that well, that I could relax with completely. We'd been together for ten years; there's nobody in the world I know that well. That's a great, incredible thing. . . .[75]

In this instance the word *relax* has a much deeper background than usual. Kenward had supported Joe with admiration, social opportunities, money, and love, and ultimately by being someone Joe had come to feel very close to. It took all this for Joe to relax "completely."

During this period Joe spent his waking hours in a state of lassitude, but he began to eat more, to feel better, and to read. He found himself reading all day, mostly fiction. For a while the other world of stories replaced the other world of his art. Gradually, though, he started making collages and drawing again.

Easing Off

The Bond

BEGINNING IN THE MID-1960s, our lives, though never disconnected, had in some respects diverged. Pat and I had become parents, which meant we were less free to circulate. And slowly but surely Joe had moved further into sexual adventures. It wasn't just that Pat and I were (happily) encumbered and he wasn't, it was also that when the three of us were together, she and I didn't talk about diaper rash and he didn't talk about cruising. Though Joe knew that Pat and I thought his being gay was O.K, he rarely talked to us about his sex life, partly because he knew that she wanted him to "settle down" with Kenward. There was so much she and I would never understand about his adventures—and Joe didn't expect us to. But it did mean that a certain part of his life was beyond us, and vice versa.

Also, Joe moved into a more moneyed world, whereas I doggedly pursued the vie de bohème of the impecunious poet. When the three of us went out to dinner, Joe begged us to let him pay, since he liked certain restaurants that he knew were too expensive for us. We reciprocated as best we could by having him to dinner at our place.* She and I took public transportation, but Joe, who had an aversion to the noise, filth, and danger of the subway, took taxis. Financially he was always generous with us, as he was with many others. Perhaps he felt some guilt about having money, for he never forgot what it was like to be poor. For my part—and I can speak for Pat as well—I was

* Actually, those dinners were terrific too. By the late 1960s Pat had become a good cook.

happy he had spending money, and it was nice not to feel any envy toward him for it. Joe inspired none.

I don't want to exaggerate the distance that family, sexuality, and money created between us for a while, because deep down it didn't matter all that much; mainly it meant that we saw each other less often, though we always "caught up" during our Vermont visits. Later these issues faded away when Wayne grew up, Joe was less involved in nightlife, and Pat and I were earning more money. And I think Joe was always grateful that from the start we had felt that his being gay was neither here nor there.

Not that I knew all that much about it. Being gay was a lot more nuanced than I had imagined. For example, going out to dinner one night, the three of us encountered a young man in the street who was behaving in a loud, flaming manner. Joe said, "He's the kind that gives queers a bad name." I chuckled, but later I thought about the politics of it—or rather, lack of politics. (Joe never jumped onto anyone's bandwagon.) I think he disapproved of the young man's aggressive behavior because what it amounted to was inverse machismo. Joe felt that publicly flaunting your sexuality—gay or straight—was not only bad manners, it was probably an indication that you had a problem with it.

Out-to-Lunch-ness

Reviews of the collected *I Remember* were enthusiastic. Michael Lally, in the *Washington Post Book World,* said:

> *I Remember* is a memoir, a catalogue poem, an underground classic, a well-crafted piece of work, but most of all a total delight. Brainard takes one of the oldest and most familiar of poetic devices, the list (of the Bible, of Whitman, of the Surrealists' attempt to make it new), and couples it with a mania for trivia more personal than any craze could be, and it works.[176]

Jonathan Galassi, noted that *"I Remember* limns, suggestively, and with tremendous economy and flexibility the outlines of one individual's very individual mind."[177] Galassi, then an editor at Houghton Mifflin, liked the book so much that he wrote to Joe, asking to see new work.[178]

The beauty of it all is that Joe made it look so easy. And in some ways it is. Take the following (rearranged) examples:

I remember (spooky) when all of a sudden someone you know very well becomes momentarily a *total stranger.*

I remember being talked about as though I wasn't there.

I remember having a friend overnight, and lots of giggling after the lights are out. And seemingly long silences followed

by "Are you asleep yet?" and, sometimes, some pretty serious discussions about God and Life.

I remember searching for something you *know* is there, but it isn't.

I remember wondering if goats really *do* eat tin cans.

I remember rocks you pick up outside that, once inside, you wonder why.

I remember how that "powdered cheese" you put on spaghetti smelled suspiciously like dirty feet to me.

I remember, at parties, after you've said all you can think of to say to a person—but there you both stand.

I remember sneezing into my hand, out in public, and then the problem of what to "do" with it.

I remember silent moments in church when my stomach would decide to growl.

Few people can read Joe's book and not automatically recall their own parallel memories, and the "I Remember" format is so clear that even non-literary people can use it to write down those memories.

The first *I Remember* was published when Kenneth Koch was doing his pioneering work in teaching children to write poetry. Finding that Joe's "I Remember" format was a natural for children, Kenneth presented it in his *Wishes, Lies, and Dreams,* a book read by thousands of poets and teachers who then used this format in classrooms across the country (sidestepping the sexual content, when necessary). Subsequently the "I Remember" device has been promulgated in many books about writing and yet most people are unaware of its origin.

Of course, children have a lot less to remember than adults, and the content and tone of their work are usually different from those of

grown-ups, but the most successful variations on *I Remember* show the same qualities as Joe's original: clarity, specificity, generosity, frankness, humor, variety, a rhythm that ebbs and flows from entry to entry, and the sense that no memory is insignificant. Even the smallest one can exert a mysterious tug, and when clearly recalled it can release a flood of other memories, as Proust's madeleine did.[79]

The favorable reviews must have cheered Joe up during the summer of 1976, which he spent in Vermont, still recuperating from speed and his show. In a turnaround, he was now consoling Kenward over the latter's breakup with Steven Hall. In a letter to Anne Waldman, Joe even confessed, in a somewhat lighthearted way, that he himself would like to "make out" with Steven, of whom he had been devastatingly jealous. Maybe Joe was just saying something outrageous for Anne's enjoyment, but I suspect it was the expression of something darker, perhaps of a desire for revenge against Kenward. It has always seemed odd to me that Joe wanted to fall madly in love but was unwilling to allow Kenward the same hope, odd because Joe was not a possessive or unjust person.* Kenward had stopped feeling terribly jealous about Joe's polygamy, but he had continued to fear that Joe would fall in love with someone else. Maybe it had been Joe's turn to feel that same fear.

On July 17 I wrote to Kenward from Maine, where Pat, Wayne, and I were visiting the Katzes. Kenward had invited us to Vermont for September, but it turned out that my job in South Carolina required that I be there by the end of August. However, I asked Kenward to tell his handyman Ralph Weeks to keep an eye out for an affordable old Vermont farmhouse.

In November I sent Kenward a postcard from South Carolina, asking about Joe, from whom I had had no news. Not long after this Pat, Wayne, and I received a letter from Joe:

> It has taken me God only knows how many weeks to get around to writing you this note to accompany the enclosed things for you all: primary example of my continual "out-to-lunch-ness."

* Or a dishonest one: in his 1977 interview with Tim Dlugos, he exaggerates or goes into momentary denial when he says, "I've never been possessive of Kenward."

"Time" is certainly taking its own time in the healing dept. No "news" except a show in March in (ugh) Pittsburgh: How I hate sending work away without anyone I love seeing them. (Sniff) and—believe it or not—it gets better and better (my work) even tho it becomes more and more of a torture to do it. (All one big mystery to me). But—mysteries are no longer so mysterious to me. . . . I sleep a lot, work a lot, and go out almost none. My reputation as a suicidal speed-freak is evidently in full bloom still and tho I shouldn't give a damn I, of course, do. Kenward is out of the picture for now, but—who knows? (Certainly not me.) But the picture I am painting is probably more depressing than in fact it is: actually, it is just rather bland: almost a comfort at times.

O.K. Shape: 1977

IN MARCH Kenward sent us a letter in South Carolina offering to sell us ten acres of his property in Vermont, which suggested, among other things, that Joe was not out of the picture. Pat and I felt very close to Kenward, but if he had thought that he and Joe were splitting up permanently, his having Pat and me nearby would have been a painful and awkward reminder for all of us. As it was, she and I were elated by the prospect of building a cabin or house in the woods on what would be our own property. Replying to Kenward, I mentioned having gotten "a nice letter from Joe the other day. He sounded better, a little weary, but really better."

In the late spring I finished up my year's work in South Carolina and we geared up for returning to New York, but Pat was called to Tulsa, where her mother had suffered a heart attack. When her mother died, in June, Joe wrote to her, "The thought of death . . . is never as sad as that of pain, and so I guess I was glad to hear that it could have been worse, but wasn't." He went on to say that he hoped Pat and I would stay at Kenward's for a spell before we took the plunge into camping out and starting work on our house. As for himself:

> You'll find me in O.K. shape, but totally boring. All I do is read. And wander around. And do dishes with relish. A probably not too unusual syndrome, as it sure was easy to fall into.
>
> Virginia Woolf. Henry James. Turgenev. Muriel Spark. Thomas Hardy. (Etc.) Muriel was worst. And Turgenev was best. . . . My only indulgence is a joint every night. And sleep like a baby.

In late June Pat and I bought the ten acres and camped out while overseeing the cellar excavation, dowsing, and foundation pouring. Then, with Ralph Weeks and his eighty-three-year-old friend Harold Clough, we got the first-floor subfloor in and capped it.

Joe and Kenward spent a week or so in Boulder, taking part in the Naropa Institute summer writing program. A lot of old friends were there, such as Anne Waldman, Dick Gallup, Larry Fagin, Allen Ginsberg, and Michael Brownstein. "Just like Bolinas," Joe said. In a letter to Dick, I wrote: "Kenward and Joe came back pleased with their Naropa trip, and Joe mentioned how he had really liked being with you out there. He said the old distance [between you two] was gone for him and it made him happy."[180]

After graduating from college with a degree in art, Joe's little brother John, whose idolatry for Joe had made him want to be an artist too, decided to move from Tulsa to New York. From Vermont Joe mailed him the keys to the Greene Street loft and told him he could stay there until he found his own place. At Greene Street John discovered a box that contained all the books Joe had published, books that John read nonstop one after the other. Joe's frank, autobiographical pieces were a revelation, one that made John feel an even greater admiration for his big brother.

Shortly thereafter, Joe wrote to John, sending him money and asking him to contact a certain person and to buy some pills from him, and to mail them to Vermont, but to keep it a secret, since Kenward disapproved. Apparently Joe was very judicious in his use of speed that summer, for Kenward noticed nothing. Pat and I had been so absorbed in the rigors of camping out and in our newfound mania for home construction that we paid little attention to anything else. In September we drove back to South Carolina for a final fourteen weeks of work there.

In October I wrote to Joe, asking him to read with Bobbie Louise Hawkins at the Poetry Project at Saint Mark's Church, where upon my return to New York I was to take the position as director. His reply was relatively upbeat:

I'd love to read with Bobbie except that I don't think I want to read this year. For starters—I'd feel funny reading at the church,

being so much "out of it" right now. (Tho, of course, that may change.) And/but for enders—at the rate I'm going now, I wouldn't have anything special to read.

So I'd best say "no" (with thanks and sorry) and hope that you will convey to Bobbie my reasons for declining.

Came back to the city all eager to socialize and stuff a lot, which I've been doing a lot, but am already feeling myself a bit ready to wane.

Show to Paris [has been shipped] off, and will open in a few days. Several other shows are definite, and some in the works, around the country this year, but I plan tomorrow to put my foot down, and only do the definite ones. . . .

Still reading a lot, tho mostly now as "glue." The latest being George Eliot's big Jewish novel *Daniel Deronda*, which is (was) terrific.

Also terrific is Jasper Johns's new retrospective at the Whitney. . . .

Kenward is happy with [his opera] *Washington Square* and, actually, I liked it a lot too.

Everybody seems much more "up" and "together" this year, which, of course, is a good sign.

If this letter is rather dull (Boy Scouts' honor) it is more due to today than to me: am feeling fairly on top.

Was he still dabbling in pills? Maybe, maybe not. In any case, he must have had moments of optimism, for in late September he told Tim Dlugos that he thought his next show would be oil portraits— the challenge he had struggled with before—and nudes. (The show never materialized.)

When Joe came back from Vermont, he and his brother John had their first serious, personal conversation, one that lasted an entire Saturday afternoon. John confessed that he had sneaked a look into one of Joe's boxes and found his books and read them and loved them. Joe gave a big sigh of relief: John was the first family member to learn about his "real" life, and he hadn't disapproved. On the contrary. Now it was John's turn to tell Joe about himself. Back in 1973, when John was a senior in high school, Joe had written him to say that he could always be counted on and that if John was

completely honest with him it would allow him to be completely honest with John. In retrospect, John thinks that Joe, assuming that he too was gay, was giving him permission to come out. Since John was soft-spoken, gentle, and polite, Joe was now mildly surprised to learn that John was straight.

Over the next few years, Joe invited John to parties, introduced him to people and places, took him to dinner, and made him know that he would always help him in any way he could. They saw even more of each other when, in 1979, John moved into his own loft in SoHo.

In the fall of 1977 Joe painted a large banner on canvas—the largest painting Joe had ever done—for a benefit, cochaired by his friend Bill Katz and Jacqueline Onassis, for Louis Falco's dance company. Other contemporary artists also donated work, among them Andy Warhol, David Hockney, Marisol, Robert Indiana, and Richard Lindner. The event—a special performance by Falco—was followed by a gala dance and dinner, where Joe was introduced to Jackie Onassis. It must have been a zenith moment for the skinny stutterer who had been ineligible for membership in his high school's social set.

Softer and Quieter: 1978

THE FOLLOWING UNPUBLISHED PIECE by Joe is called "January 13th," and although the year is missing, I am tempted to ascribe it to 1978, because part of it sounds like a description of some of the paintings—of the view out his window—Joe did about then:

> Mozart is coming out of the machine—real soft—just for company. Like that of a cat, in a room. A bright red Campari and soda sits off to my right, just within arm's reach. A moment away from the ashtray: a deep blue enameled disk, inlaid with a sliver of white moon and sprinkled with silver specks of something, to represent the stars. All somewhat obscured by three cigarette butts, snuggled up close together—spoon-style—that each says "True" in tiny blue letters, if you look real close. My left leg, over the arm of the chair, swings back and forth, and back and forth. (Shoes overhead cross room.) Outside my window snow is falling down, against a translucent sky of deep lavender, with a touch of orange, zigzagged along the bottom into a silhouette of black buildings. (The icebox clicks off, and shudders.) And it's as simple as this, what I want to tell you about: if perhaps not much, everything. Painting the moment for you tonight.

At some point Joe added a comment to the manuscript: *"Slow!!"* He never published it, but he didn't discard it, either. I think it is beautiful.

In January of 1978 the Root Art Center at Hamilton College in Clinton, New York, mounted a retrospective of seventy-eight of his

works from 1966 to 1977. The impetus for the show, along with a talk and a reading by Joe, came from poet David Lehman, who was teaching at Hamilton. The Fischbach Gallery made the selection. Joe appreciated everyone's effort, but as usual he found it hard to wax enthusiastic about out-of-town shows. He didn't even tell Pat and me about it.

We had moved back to New York in December. It turned out that my new job at the Poetry Project left me little energy for socializing. Of the correspondence between Joe and me in 1978, all that remains is a postcard I sent, inviting him to dinner. It's likely that we used the phone instead of the mail, since this was the first time in several years that we were both consistently in New York at the same time. (We almost never talked on the phone when I was out of town. I had the antiquated notion that long distance was too expensive for casual conversation.)

In April Joe did a beautiful and funny black-and-white Nancy poster for a special benefit event at the Poetry Project. At the beginning of June he went to Vermont for the summer.

Pat, Wayne, and I followed in late June, and at the beginning of July we started framing the first floor of our house. The plans for the structure had changed; instead of a summer cabin, we were putting up a two-story, winterized house. The project became all-consuming. Camping out next to the building site, Pat and I got up at 6:00 AM and, when the two carpenters—Ralph Weeks and Harold Clough—arrived at 7:00, we all went to work, and when Ralph and Harold knocked off at 4:00, Pat and I continued until dinner and sometimes afterwards. Joe and Kenward were uphill only 200 yards away, but Pat and I, with a scant ten weeks in which to build, were so obsessed with our grand project that we went up to see them perhaps only once a week. Every couple of weeks they would come downhill and express amazement at our progress. As I wrote to Kenward (and tangentially to Joe) on September 12:

What a summer! By far the most productive and satisfying one I've ever had. It was all like a miracle, the house growing, me, little ol' me working with Harold and Ralph! I loved it. We didn't

get up the hill much, but perhaps in light of your social life this summer it's best we left you at least some peace.

Kenward and Joe had had a lot of visitors. In fact, so many of them had stopped to ask for directions to Kenward's house that the locals thought it must be up for sale. Joe had gone back to painting, completing at least one successful picture (jocularly known as *Dog in Fog*) of Kenward's white whippet outdoors at the screen door at night, looking straight in at the viewer, so that what one sees of the dog, in a haze of light against the door screen, is only its black eyes and black nose.

Most of Joe's collages done in 1978 were softer and quieter than the edgy, witty ones of his 1975 show. The new work, in an agreeable array of light browns, creams, grays, and whites, exuded a peaceful lyricism. Some of these works veered toward sentimentality. That Joe had a soft heart was obvious to his close friends, who got letters from him signed "Love, Joe" with *Love* written in large letters and underlined four or five times, or accompanied by the drawing of a red valentine heart, and he had from time to time created what amounted to private valentine artworks as gifts for his close friends and lovers. But he never allowed his private sentimentality into work destined for public viewing. Instead he found ways to modulate such feelings, as in the tattooed torso drawings from the early 1970s that included the names of friends next to standard tattoo designs for valentine hearts.

In the fall of 1978 I stepped off the number 6 train at the Astor Place subway stop and saw a large poster of bright petunias, pansies, daisies, and poppies, all with their faces looking straight out at me, and I knew it was Joe's. I knew it because he had told me that Time/Life had commissioned two posters and I knew it because it was so "Joe," and I was thrilled with pride to think that hundreds of thousands of people were down in subway stops all over the city seeing this beautiful thing by my friend. Joe probably considered the flower poster a step backward, but for me it was wonderful to see an advertisement that was actually a piece of art, and one that even an average person could admire. I trotted up the subway steps feeling that life was all right.[181]

The Person I Always Thought I Was

IN THE WINTER OF 1979 Joe did a series of drawings from a live model, a sign of his desire to get back to basics. Meeting once a week four or five times, he, Susan Rothenberg, Lois Lane, and Elizabeth Murray met at Murray's loft on White Street, always using the same female model. Although Elizabeth doesn't recall looking at Joe's drawings, she does remember that he enjoyed these sessions. When the model became unavailable, Elizabeth had trouble finding a replacement, and in April she told Joe that the sessions would be suspended for a while. They did not resume. He never showed the results to me or anyone else I have spoken with, but they might have been among the drawings found in his loft after his death, along with nudes done as early as March of 1978.

It might have been around this time that Joe began taking classes at the New York Academy of Art, an institution that specializes in academic technique.[182] I think that, given his unerring hand and his knowledge of draftsmen such as Holbein, Ingres, Lautrec, and Degas, the school had little to teach him. It was as if he had, in his forties, gone back to complete the art school education he had abandoned. His academic drawings of nudes from around that time were extremely accomplished, but most of them, lacking Joe's earlier iconic images, could have been done by any highly talented draftsman. Or were they the beginning of an expression of another Joe, like the one who had written in his diary, "I'm not even myself anymore"?

Joe's thirty-seventh birthday seemed to have brought with it a crisis of sorts: "But let me tell you what is really freaking me out these days: that the person I always thought I was simply isn't anymore: *does not exist!*"[183] Had he finally burned away so many layers of his personality that he had discovered a new self? If so, who was this new self? He didn't say. Or was he simply getting a contact midlife crisis from Kenward's fiftieth birthday, which loomed only one month away?

Keith

ON APRIL 27, 1979, Joe and Ann Lauterbach threw a big birthday party for Kenward at Ann's loft on Duane Street. Among the many guests was Edmund White, a former lover of Joe's. Ed was accompanied by a handsome young actor named Keith McDermott, who had been in the Broadway hit *Equus* and was about to take a role in a new Robert Wilson play. Joe had admired Keith in a Broadway play by Christopher Isherwood; the two now met for the first time. For Joe it was love at first sight, and Keith was quite taken with Joe as well. But before the party ended, Keith had vanished.

A few days later, Joe and Kenward went to Vermont. In late May Joe wrote to Yvonne Jacquette to tell her how much he liked her recent show, then went on to talk about himself:

> I came up to Vermont early this year, as I really wasn't functioning all that well in the city, and—anxious to make some changes in my life—knew a change of place would help. So, I've given up sugar and coffee, exercise daily, and meditate an hour each morning. The result of which—so far—is that I fall asleep in the middle of books a lot. . . . Am still not working much, other than little things here and there, and some drawing, and, indeed, am getting a bit worried about it. I've about come to the conclusion that—indeed—talent is a fragile thing, and can easily be abused, and that I have abused mine considerably. I just hope (for *my* sake) not beyond repair.

It was a little more than three years since Joe had for the most part abandoned speed and still he had not discovered a new and dependable work rhythm. But what did he mean when he talked about abusing his talent? Was it that he had willfully expended too much energy in producing 3,000 works in a relatively short

period of time? Three and a half years after the show, was he still drained, psychically, if not physically? Was his artistic confidence truly crumbling?

In another way he was recharging himself. That summer he and Keith began a correspondence that became hotter and hotter.

For Pat and me, this summer was like the previous one: physical labor on the house all day seven days a week. From time to time Kenward had us up for dinner and, since the stream on our property was ice-cold, he invited us to use his shower anytime. Pat and I were like two rustics in tattered work clothes trudging onto the lawn of a manor house: there was Joe, stretched out in a bathing suit on a chaise longue, reading Dickens, drinking iced tea, and deepening his suntan.

He got plenty of exercise, though, due to an unusual circumstance. Back in the 1970s the television series *The Waltons* was so popular that some of its characters had become household names. Richard Thomas, who played the part of John-Boy, started writing poetry and eventually met Kenward, who invited him and his family for a visit. As soon as Kenward's caretaker, Ralph Weeks, mentioned in the local post office that "John-Boy" was coming to Kenward's, the one-lane dirt road past Kenward's house saw a dramatic increase in the number of cars creeping by, their occupants scanning the area for any sign of the TV star. Pre-adolescent girls on horseback would clop past, plaintively calling toward the woods, "John-Boyyyy! Oh, John-Boyyyy!" Joe, sunbathing in his skimpy bathing suit, was repeatedly forced to leap up out of his lawn chair and dart into the house.

He was already skittish enough, as he described in a short piece from 1971: "Sometimes the [nearby] waterfall has a way of sounding so much like a car coming that I jump up and run into the house for nothing."[184]

The word spread that John-Boy was very protective of his privacy.

A local girl told me that she had actually seen John-Boy. He was camping out in a tent. When I asked her how she knew it was John-Boy, she replied that she got a very good look at him, and she

described the location. I didn't have the heart to tell her that the fellow she had seen was me.

Over the next few years I would occasionally phone Joe and say, "Hello, John-Boy? This is John-Boy calling."

Back in New York in October, I invited Joe to do a cubistic drawing of me for the back cover of a forthcoming book. He accepted, but soon afterwards he wrote:

> On third or fourth or fifth thought, I really can't do this. Much as you must know I'd like to. For *you*. And because it seems a great idea. But first things have simply got to come first—and no fudging.[185]

I can't recall what he meant by "first things." Maybe he was referring to his commission to design the curtain and décor for the Joffrey Ballet Company's *Postcards,* which was scheduled to premiere in Seattle the following year.[186]

It's more likely that he meant that he had to get back into a solid work rhythm, after spending a relaxing and delightful week in mid-October in Key West with Ed White and White's boyfriend, Chris Cox. Or maybe he was nervous about seeing Keith, who, after an acting job had kept him in Buffalo for several months, was expected back in town in a day or so, near the end of the month.

When Keith returned, their relationship ignited in the mad love that Joe had always dreamed of.[187] Joe immediately wrote to Kenward, who was less than thrilled by this news. In fact, he responded by saying that for a while maybe he and Joe should lead separate lives. As Joe put it, "Kenward and I are very much on the outs."[188]

After a few months Keith, now between acting jobs and looking for a sublet, accepted Joe's extraordinary invitation to move in with him. Up till then their relationship had been paradise, but soon it became apparent that the twenty-four-hour proximity wasn't quite working out. Joe was accustomed to living alone, and Keith began to feel underfoot.

In February Joe wrote to Anne, "I am still with Keith, and not with Kenward. And in every area of my life I am totally insecure: love-wise, artistically, financially, etc." His use of the word *love-wise* is interesting, since that was the title of a song lyric Kenward had

written years before.[189] To maintain some order, every day he drew self-portraits and exercised.

By the time Joe's birthday (March 11) rolled around, things had improved between Joe and Kenward, and in early June, Joe changed his mind about spending the summer in New York and phoned Kenward to ask if he could come to Vermont instead. He was on tenterhooks: his work was not going well and he feared that his days with Keith might be numbered—and he had stopped smoking!

Joe and Keith's passionate beginning was, as the song says, too hot not to cool down. But they remained lovers off and on for nine years, until the spring of 1989, and friends thereafter. For much of that time, Joe alternated his New York evenings between Keith and Kenward. Sometimes when he went out with Keith he would invite his brother John and John's wife Caroline. Sometimes when he went out with Kenward, he would invite Pat and me. Once—probably in late 1979 or early 1980—Joe called to ask if he could bring his new friend Keith to dinner at our apartment. He did, and we had a pleasant evening, but that was the last time we saw Keith for a number of years. Joe, well aware of our feelings for Kenward, decided to keep the situation compartmentalized, for our comfort as well as his own. He knew that Pat would have preferred that he stick with Kenward, and that though I did not think he must be monogamous, I too felt loyal to Kenward. However, in a letter to me in Vermont in late June, Joe, still in New York with Keith, made one last try by offering to tell me all about their relationship. I never responded to this offer. Instead of being open and generous, I protected myself: I didn't want to get involved.

In the same letter, Joe told me that he would be coming up "to Vermont for July and (assuming all goes well) August." He added that he was "still quite smitten with Keith. His sweet generosity has a lot to do with my being able to come up."

Joe did come up for two months, both of which seemed peaceful enough to me, but by the middle of September he and Kenward had decided to remain friends but to go their separate ways.

A few days later they made up.

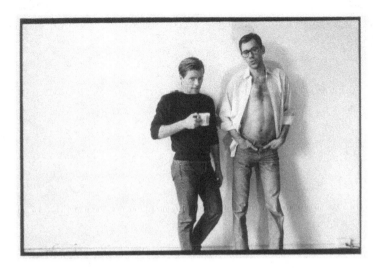

Keith McDermott and Joe, New York, 1980. Photo: Christopher Cox.

The Real Joe

I'd Like to Look like James Dean

IN HIS 1977 INTERVIEW with Tim Dlugos, Joe said:

> I have a definite goal which is totally unrealistic: I'd like to look
> like James Dean, I'd like to be a genius painter, be rich—I mean,
> I really have this idea—I'd like to be charming and socially love
> everybody and have everybody love me. I sort of make small steps
> in an attempt to be that person.

To be sexually attractive, brilliantly gifted, wealthy, charming, and
loved—what person wouldn't want to be all these things? But most
people have only a few such aspirations, and sooner or later tend to
give up on them. Joe set his goals very high and kept them there for
a very long time. Even though he never looked like James Dean,
he did have a lot of appeal. Even though he never became rich, he
had money to spend. Even though he continued to stutter a bit and
sometimes feel self-conscious, he indeed was a very charming per-
son, just by being who he was. And he was certainly well loved. That
leaves being a "genius painter."

His admirers were mad about his work—and still are—but for
many years Joe's opinion of his work fluctuated. In 1963, riding an
emotional aesthetic high, he produced work that he called (with the
youthful hyperbole typical of us in those days) "without a doubt *the
greatest things ever seen.*" Later on he was a hard and generally accu-
rate self-critic. But over the years, he took an increasingly dim view of
his work, seeing it as lightweight, facile, and lacking in the qualities of

the high art of the oil painters he so admired, such as de Kooning, Manet, Goya, Katz, and Porter. Perhaps he had begun to believe the asides of the few critics who, amid their laudatory remarks, classified his shows as minor. It wasn't enough for him to have won over a conservative critic such as Hilton Kramer, because Kramer, although describing Joe's 1975 Fischbach show as "very amusing and endlessly fascinating" and "very deft and a lot of fun," still could not restrain himself from characterizing Joe's work as "minor" and "lightweight stuff."[190]

Why critics feel the need to classify art as major or minor is a question to be addressed elsewhere, as is the matter of their assuming that small, intimate works must be of minor importance, unless, of course, they are by an artist who has *already* been classified as major.

Did Joe unconsciously equate his skinniness with being a "lightweight" artist? Or is the parallelism coincidental? I tend to think that he linked the two notions.

Regardless, it is not uncommon for artists to measure themselves occasionally against the greats. Some artists acknowledge that they are not Giotto or Ingres or Hokusai, but this does not keep them from working. However, for others—including Joe—the comparison weighs on them, gradually wearing them down, and eventually they measure their progress and decide to pack it in.

Joe's still lifes and landscapes in oil demonstrate how accomplished his technique was in that medium. However, for him the ultimate challenge—and his nemesis—was oil portraiture. His friends sat for him, enjoying everything about it except his frustration with the results. Time and again, his sitter would be delighted by the day's work, only to learn that later Joe had scraped the face area with a pallet knife and rubbed it out with a turpentine rag, as with the one of Pat he included in his 1974 Fischbach show, which was the only time he showed what he knew to be an unsuccessful or incomplete work. That he did so is a measure of his deep frustration.

A thread of self-doubt runs throughout Joe's interviews, letters, diaries, and other writings. Knowing that from childhood his intelligence had been assessed as average or even slightly below, he questioned his mental prowess. "I'm inarticulate," he told Dlugos.

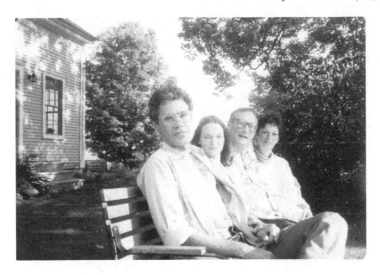

Joe, Anne Waldman, Kenward, and Ann Lauterbach, Calais, early 1980s.

Whenever he tried to think deeply about a particular idea—such as the idea of style or the idea of honesty—the deeper he went the fuzzier his thinking became, to the point that it all ended up sounding meaningless. Sometimes he attributed this cerebral "failure" to a lack of intelligence, sometimes to a lack of patience.

It was this same lack of patience that, he felt, kept him from sticking with a single artistic direction, like Katz and Porter. Instead, he was "just making art"—miscellaneous pieces. Added to this was the fact that the diversity of his production meant that he had no signature style, hence no continuity for the people who might buy his work. As he put it, he had no "commodity." You could not buy a "Brainard" the way you could buy a "Warhol." Back in 1971 Joe had glimpsed his variousness in a positive light:

> No Alex Katz me. I admire his focus—but I am beginning to admire my lack of focus too to bring *everything* together in some way. I think maybe that's the direction I'm headed. Assuming I keep going. And assuming the pieces are accurate enough to somehow fit together some day. (Exciting enough.) (Needed enough.) (Wanted enough.) (Beautiful enough.) (Etc.) [191]

But by 1976 "assuming I keep going" had become an issue. How could he keep coming up with new concepts for show after show? Besides, by 1976 the art world had become, as he said in *People* magazine, "too big, too serious, too self-important, and too expensive." Joe's modesty and humanity show in this remark, but his conviction really came through when, sometime after late 1977, he quietly decided not to show new work anymore. He needed breathing space.

The Vermont–New York Rhythm

IN JANUARY OF 1980 Joe wrote to me, asking for help with the introduction he was preparing for a reading of mine and apologizing for not being more available:

> I do miss seeing you and Pat and Wayne, but life is strange now. And I kept waiting for something to "happen." Which is not very realistic at all of course. But . . .

On April 1 he wrote to us:

> Regardless of how it may appear, I really did and do appreciate your card of birthday greetings and dinner invitation, but . . . !
>
> But I have *really* been depressed and frustrated of late. Depressed because of Kenward (to make a short story shorter) (for now) and frustrated because of problems occurring from doing sets for a new Robert Joffrey ballet: an homage to Satie. But I did somehow manage to get the front curtain drop finished, and the interior sets are going to be much (whew!) simpler. Though perhaps no less frustrating, as Robert Joffrey—(grrr!)—is a real pain in the ass.
>
> I apologize for not explaining all this better to you but—as you may have noticed—I'm not at all "with words" these days. And then too—of course—it's not all that simple: especially with Kenward. Am still very much in the dark myself what is going on.

Wayne, Pat, and Joe, Calais, ca. 1981. Photo: Ron Padgett.

So for now will you simply forgive my silence? Till soon I hope.
For I do love you both very much. Miss you. And look forward
to better days together ahead.

A week later he was feeling better:

Good to hear from you. And thanks for the kind words. And
sure I'll read at the benefit [at the Poetry Project]. Would like to.
(*Unless* I'm at some crucial point with the Joffrey sets, though I
hope to be done with them by then.)

And dinner sounds good too. Though I'd rather take you all
out, for a change, this time. But let me wait a bit longer, till I can
plan ahead with more confidence, O.K.?

It turned out that he did pull out of the reading, but with good rea-
son: to spend that weekend in the Hamptons consoling a friend and
art collector, "a very sweet elderly man" whose companion of thirty
years had died recently. Perhaps it was during this visit that Joe did
a series of drawings that he gave to his host.

Beginning in the early 1980s, our social lives took on a more regular
rhythm. Every year, Kenward went to Vermont around May 1; Joe fol-
lowed a month or so later. Pat and I, now with our own house, would
arrive in mid-June and stay until around Labor Day. A few times Joe
rode back to New York with us; the rest of the time he stayed until
the end of September. Kenward usually came back to the city in late
October, though some summers he had to fly off to some distant city
for one of his operas or musicals.

During our eight- to ten-week summer vacations in Vermont,
Pat and I saw Joe and Kenward four or five times a week. Together
we had dinner, swam in Kenward's pond, grocery shopped, went to
the health club and the movies, went antiquing, swapped books, and
walked in the woods.

We all read the weekly scandal sheet *The Star,* which Joe had dis-
covered in the supermarket. He particularly liked the feature called
"What They Are Wearing," color photographs of female movie stars
in casual wear or dressed to the nines, captioned with either lauda-
tory or catty remarks.

Some days Kenward and I played tennis in Montpelier, followed by a serious raid on the root beer stand. Sometimes Pat and I would stop by Kenward's on our way into town, just to chat for a minute.

It was probably in the summer of 1981 that Joe ratcheted up his self-improvement regimen and, with Kenward, joined a health club near Montpelier. A few summers later Kenward dropped out, after one incident in which he felt he was being attacked by a Nautilus machine. Henceforth he would leave Joe off at the club while he himself did the grocery shopping and other errands in town.

This is jumping ahead a bit, but beginning in early July of 1986, when I joined Joe's Montpelier health club, he rode into town with me and we worked out together, twenty or so times each summer. I was hardly a jock, but as a kid I had played baseball and basketball, and in high school I had taken up tennis. In other words, the guy-stuff world of sports and phys-ed was not foreign to me, and I was curious to see how someone so unathletic as Joe was handling it.

He was perfectly at home in the gym. Dressed in loose-fitting tan cotton pants, his signature gray T-shirt, and traditional black Keds sneakers, he dutifully completed a Nautilus and free-weight circuit, keeping a progress chart of weights and repetitions. After he memorized the program, he dispensed with the chart. Besides, at his health club in Manhattan he had learned to vary his routines.

The SoHo Training Center was exclusive. Its clientele included John F. Kennedy Jr., Cher, and other celebrities. Joe told me that famous people liked this club because it offered privacy, the unspoken rule being that the clients pretend not to recognize each other. Apparently the trainers were top-of-the-line: Joe was always relaying to me some cutting-edge bit of technique.

Joe was genetically destined to be slender. If in high school he had been a 135-pound stringbean, now he was a sleek and wiry 160 pounds. Since the time years ago when his trim abdomen had elicited a compliment from Joe LeSueur, he had often left his shirt—pure white, as a foil to his deep suntan—unbuttoned to the navel. Now his abs were washboard. Although Joe never became heavily bulked-up, he was all muscle. One day in Vermont I noticed his bulging upper arm and I asked, "Are those *your* biceps?" He flexed his right arm, muscleman style, and when I exclaimed "Jesus!" he

gave me a sideways smile and rolled his eyes. It was so much fun seeing him enjoy the way he looked.

Each summer, Kenward worked on various literary projects, as did I; Joe worked sporadically, but seemed to spend more and more time reading. (Every summer he reread all of Barbara Pym's novels.) He helped more with household chores, even doing some of the cooking. His specialties were cheese soufflé, Tulsa-style potato salad, and mashed potatoes, skins and all, loaded with cream and butter and topped with grated cheese for a final heating in the oven. His dishes were visually striking. For example, his strawberry shortcake, centered on the plate, was topped with whipped cream and surrounded by a ring of strawberries arranged with their tips turned up, and with one exemplary strawberry on top. His bacon, lettuce, and tomato sandwiches looked like paintings of perfect BLTs: the lettuce extended evenly on all sides beyond the bread, the tomatoes were sliced to perfection, and, side by side, the four parallel strips of bacon lay flat from end to end. But it wasn't just that Joe's aesthetic sense extended to the food he cooked: he seemed to find a quiet satisfaction in cooking and in the household routine in general. In Vermont, dailiness became for him a pleasurable way of life, and so he was an even greater pleasure to be around.

In New York the rest of the year, Pat and I, now both working full time, would see him maybe once every six weeks, usually with Kenward. But by then the frequency didn't matter. As Joe told writer and small press publisher Dennis Cooper, who had asked if we saw a lot of each other, "We're such good friends we don't *need* to see each other much." We never said so, but by then we knew that the deep bond among us three Okies would never be broken.

The Long Beach Exhibition

BACK IN SEPTEMBER OF 1980, the Long Beach Museum of Art had mounted a two-month exhibition of 111 pieces by Joe, borrowed from the collection of Robert Butts with additional pieces from the collections of James Bridges and Jack Larson and of Don Bachardy and Christopher Isherwood. The idea for the show was Butts's; Joe suggested adding things from the other collectors, all of whom lived in the vicinity. Bridges (film director), Larson (actor and director), Bachardy (artist), and Isherwood (writer) were friends of Joe's. Never excited by out-of-town exhibitions, and especially those that would have nothing new in them, Joe apologetically declined the museum's invitation to be present at the opening.

He was reading. I wrote to Kenward in Vermont in late September:

> Patty and I took a walk the other day and ended up at Joe's. He looks good, still reading, though. I've decided to try to get him back to the frock and beret, but how? I dunno. Maybe talk to him so much about it he'll start painting just so I'll shut up? This marathon reading must stop: it's driving me nuts!

In the late spring of 1981 Dennis Cooper's Little Caesar Press brought out Joe's book *Nothing to Write Home About*. I wrote to Joe in Vermont:

I've just finished *Nothing to Write Home About,* which was terrific. I don't like a couple of the pieces, but some of them are as good as anything you've ever done, and the tenderness in some of them (such as "My Friend," a masterpiece) seems to indicate a new direction in your writing, as does "Oh My Gosh!" And one of my all-time favorites is "Ten Imaginary Still Lifes." It is really beautiful, so spare and personal. This work has always had a strange fascination for me. And it reminds me (as your Saint Mark's reading did) that, as everyone knows, you are funny and direct and original, but you are also a good writer. Well, I'd better stop praising you or you won't believe me.

My saying that I didn't like a couple of the pieces was true, but it was also a tactic for making my praise more credible. I feared that he was forgetting how good he was—the book's very title was self-deprecating. The title also suggested that the book—particularly one piece called "Imaginary Sexual Fantasy"—would be unsuitable for his parents. In "Exercise No. Eleven" from "Towards a Better Life," he wrote:

Sit down and write your mother a long letter revealing all your deepest and darkest and most perverse secrets.
Conclusion: Behind every horrified mother is an honest son.

Joe felt there was no way for him to be completely open with his parents without upsetting them. While this is true of the great majority of us, it was particularly true in Joe's case, given the vast changes from his life in Tulsa to his life in New York.

In April of 1981, Joe wrote to Anne:

Keith and I had to split. It is unbearably painful, each day. But we know what time does. Yes I will be in Vermont this summer. And hopefully by August, more than a shell of myself.

The next month he wrote to Keith:

I've got a hell of a lot of work to do on myself, and I've got to do it alone. Of course I will never be able to forget about you, but

I do think that the less we are in contact right now, the easier it will be for me not to be obsessive about you. . . . Never forget that I love you *intensely*.[192]

The change in his relationship with Keith exacerbated his insecurity:

Boy have I been a mess these past three days: totally depressed and apprehensive about *everything*. Bursting out in tears over nothing. Being quite simply neurotic, I suppose you might call it.[193]

In Vermont in June, Joe wrote to take me up on my offer to pick up his mail at Greene Street and bring it, along with copies of his new book, to Vermont later in the month. He wanted to mail out the book before it became, as he put it, "old hat."

In August I wrote to a friend:

Patty has started oil painting, with some surprisingly quick results, actually two very nice little oils. Part of the idea was that maybe we could sort of trick Joe back into painting, via using him as a teacher, but he wouldn't bite, not at all. He still looks fine, but continues to read *all* day, novels, and he can't remember *anything* about the books except whether or not he "liked" them![194]

Sometime that summer Joe had a sudden influx of cash, but it didn't distract him from his main purposes:

I have money up the ass right now, as a batch of collages came back from the American Embassy in Paris (from an extended loan) and they instantly got snapped up via the Fischbach Gallery.

Speaking of which (money) I just turned my back on a bundle. Halston asked me to do some flower patterns to be silk-screened on evening gowns for his spring collection. I was mighty tempted to say yes, I can assure you. But . . .

But now is a time when the issues I've got to confront (art-wise) are very basic. And I can't afford any "clutter" from side-issues.[195]

He stayed in Vermont later than usual. In October, Kenward reported that Joe had started painting again, which made me jump for joy.

Beginning in the early 1980s Joe and his brother John made several trips to Tulsa, to try to "be better" about visiting their parents.

The Prince

ALL HIS LIFE Joe had dreamed of an all-consuming love that would go on forever. Although from time to time he joked about it to Pat and me, singing "Some day my prince will come," deep down he nurtured this romantic fantasy. Keith fulfilled that fantasy, and when their relationship eventually modulated itself back into the everyday world, Joe felt a lingering regret over the dissolution of his ideal. But he remained enormously grateful to have experienced true romance, and he would go on feeling very close to Keith.

But he had not stopped loving Kenward. Over the years, through the dark and bumpy patches, the bond between Joe and Kenward had eventually deepened into a fusion of love and friendship that had, by 1984 or 1985, resulted in a full and clear-eyed acceptance of one another. Even Joe's relationship with Keith at its height had never kept him from spending summers with Kenward. Eventually, in endless small and daily ways, Joe and Kenward came to treat each other with great kindness, in a quiet companionship that became profound and unconditional.

Midlife

NOVEMBER OF 1983 BROUGHT a surprising request from Joe: he asked Pat and me for a loan, something like $800, if memory serves. The IRS had ruled that some of his deductions over the years were not allowable, and he had to pay up. Of course he did not horde his money in a bank. When he had extra money, he gave it to friends.

Joe couldn't bear to see people he liked in financial need. He sent Keith checks regularly, insisting that it gave him pleasure to know that he could alleviate someone's problems so easily.

In another case he learned that the friend of a particularly likeable waiter at a favorite restaurant had AIDS and was too ill to fly back to his native Australia to see his family. Joe gave several thousand dollars to the waiter, telling him that *he* should use it to go back to visit the childhood home of his dying friend. The waiter, an aspiring actor, was finally convinced to accept the money, and he did make the trip.

Joe refused to lend money. The emotional weight and bother of being a creditor was too heavy for him, so he just gave it away, no strings attached. As he wrote in a letter to Jimmy, "Please always feel free to give *anything* I give you away."[196]

Since 1980, both Pat and I had had full-time jobs, which meant that we weren't free during the day and we didn't go out much at night. But we always had Joe and Kenward over for dinner.

By the early part of 1983 Joe had simplified his life. He drew for an hour or so each day and went to the gym three times a week. At

night he read novels or went out, with Kenward one night, Keith the next. In fact he described himself as "quite social." [197]

Later in 1983 he offered us a string of excuses for not accepting our invitations, and in mid-December I suggested that he seemed to be avoiding us in New York. His reply:

> I *love* seeing you and Pat in the city. And I don't really know why I don't take the initiative to have it happen more often. (?) Except that in the back of my mind I have this vision that you all work hard all day, and just like to stay home at night. Then too, for the past few years, between Kenward and Keith, my nights have been pretty occupied. And not seeing you all in the city has become— more than anything else—just a habit.
>
> As for these days in particular, I stay in mostly, reading. Because I'm really quite dull—do not recommend myself highly—and don't find it easy to get out of the house, even when invited. (Though in fact I usually enjoy myself once I do do it.)...
>
> (Though I try not to show it, this is a very frustrating time in life for me, so I beg your indulgence.)

I replied with an excited description of the first Caribbean vacation Pat and I had ever taken, and suggested that he go with us on our next one. But in the meantime I told him:

> Let's see each other more here in the cold, dark city, I mean let's go out and do something, not just be trapped at dinner in our tiny apartment. Patty and I do work fairly hard during the day, but we do drag ourselves out to something at night every once in a while, too.
>
> As far as feeling frustrated about oneself, I know you have, and I want you to know that I haven't been all that happy about what I've been writing for the past four or five years. I don't write enough and what I write isn't good enough. But I don't know what else to do but just keep trying, huh? And try to enjoy every-thing else. Maybe you and I should collaborate on a book to be called *Midlife Crisis Can Be Fun!*

Maybe we were feeling an aftershock of the news that had arrived that past July in Vermont. I had told the news to Pat, Joe, and Kenward: Ted had died. I have no recollection of telling them, and neither Pat nor Kenward has the slightest memory of being told, but a letter from Joe to Keith sheds some light:

> It's a funny thing about sorrow. I cried five or ten minutes over Ted's death, and then pretty much put it out of my mind. But now the least little thing—(like *The Waltons* on TV!)—and the tears start flowing. [198]

Despite the fact that we all expected Ted's fast living to catch up with him, we couldn't believe that it had. He was forty-nine. Joe and I were forty-one.

Old Reliables

1984 WAS A HECTIC YEAR FOR ME: from January through June and from September through December, I was extremely busy. In my appointment book for that spring there is only one entry for Joe, involving a drawing he did for the cover of a catalog I was producing at my job as publications director of Teachers & Writers Collaborative, a nonprofit group. From time to time I dropped by Joe's loft to say hello, on my way to and from my chores at Full Court Press, which was located in his neighborhood.

On June 18, a few weeks before Pat, Wayne, and I were to go to Vermont for the summer, he wrote to me, describing my new book as "really beautiful to look at, to hold, and to read." The book in question was a new edition of my translation of Apollinaire's *Poet Assassinated*. His letter was low-key: "Re-reading some old reliables, like *Madame Bovary* and *Great Expectations* and several Barbara Pyms. Play at work from time to time, but . . ."

By the way, I would like to dispel the often repeated notion that Joe read nothing but Victorian novels. He did read them, but by no means exclusively. Among his favorite authors—not counting his friends—were E. F. Benson, Jane Bowles, Colette, Dickens, E. M. Forster, Barbara Pym, Muriel Spark, Mary Renault, Elmore Leonard, Christopher Isherwood, Jane Austen, Denton Welch, Marguerite Yourcenar, Turgenev, Nadine Gordimer, and J. R. Ackerley. He read *Remembrance of Things Past* twice, but Proust wasn't among his favorites, nor were many of the heavyweight novelists of the twentieth century, such as Joyce, Faulkner, and Mann. He read

for the pleasure of characterization.

July and August in Vermont flowed by agreeably: we saw Joe and Kenward often, trading dinners and going into town together to shop or see an occasional movie.

Back in New York in the fall, we resumed the same routine as in the previous spring, except that we got together for a holiday dinner just before Christmas.

1985

To CELEBRATE THE ACQUISITION of the Robert Butts collection of Joe Brainard material, the University of California at San Diego mounted a small exhibition and hosted two readings, one by me on February 14, one by Joe the day after. Butts, who lived in Los Angeles, had for years been an ardent collector of Brainardiana—manuscripts, letters, magazines, books, drawings, collages, paintings—anything he could afford. Joe gave him things from time to time. In a Joe-like act of generosity, Butts donated nearly his entire collection to the library and spent many hours cataloguing it.* For me it was fun watching Joe being lionized in laid-back La Jolla.

Back in New York, the pace of our social lives picked up in late April: a Kenneth Koch book party on the 25th, a Glen Baxter opening at Holly Solomon Gallery the next night, dinner with Joe, Kenward, and Glen and Carole Baxter on the 28th, an Anne Waldman book party on the 29th, and a reading by Anne on the 30th. A few days later Kenward read. We saw Joe at all of these.

On June 1 Joe and Kenward went to Vermont, where Joe wrote to ask me to send him a special drawing paper. He had been invited to do sixty drawings ("I couldn't very well say anything but yes") for *Sung Sex*, a forthcoming volume of Kenward's poems. That summer (and in the summer of 1987) he produced many brush and ink drawings, but he remained unimpressed with the results, as he confided

* Later he would show even greater selflessness in changing the collection's name from The Butts Collection to The Joe Brainard Collection.

to Bill Berkson, referring to "quite a few [drawings] I don't like."[199] I thought some of them were beautiful, but others did seem a bit dashed off, especially some of the abstract ones. The published book contained 125 drawings, and when I look at them now, I feel much the same as when I first saw them, although the beautiful ones seem more deeply beautiful.

In several letters to Keith that summer, Joe mentioned that work was not going badly:

> I make myself—(like going to school)—work three hours every morning from nine to twelve. And usually some in the afternoon too. And it's going pretty well.[200]

> ...Two recent drawings in particular I especially like. One is looking down at my naked legs, one propped up on the knee of the other, with a distant landscape in the triangle of space in-between, which involves some pretty tricky (no mean feat) foreshortening. The other is a super-realistic drawing of eight cherries on a small white oval dish.[201]

On July 2 Pat and I arrived in Vermont, and soon afterward we made our annual trek down to the Chelsea (Vermont) flea market with Joe and Kenward. Some days she and I would sunbathe with Joe at the pond, talking about what we were reading or having for dinner that night or what good mail we had gotten recently, in that lazy way that seems possible only on a long summer vacation.

On September 8 Pat and I went back to New York and our jobs. Joe followed, probably near the end of the month. We all reverted to our urban patterns. We had dinner in November, and in December we saw each other at a John Ashbery book party at Fischbach.

The Diminutive

WHY ARE SOME PEOPLE ATTRACTED to small things? Joe loved diminutive objects: very small porcelain dolls; miniature dollhouse furniture; charms (he assembled charm bracelets and necklaces that he gave to friends, one that included a tiny sarcophagus from which a tiny mummy emerged, a silver accordion that had moving parts, and a row of cancan girls whose legs flew up in unison); delicate cameos and broaches; and postage stamps. When his sister Becky and brother John were children, Joe sent them dozens of small gift-wrapped Christmas boxes, inside each of which was a single object, such as a miniature Coke bottle (that turned out to be a cigarette lighter).

Joe was always on the lookout for such items, even in his sleep. In a letter to Jimmy Schuyler, written probably in the spring of 1966, Joe said:

> The other night I dreamed that I found this beautiful little doll in an antique shop. She was about 6" high made of opal sandwich glass. She had on a lace dress covered with opal sandwich glass little beads. . . . I also dreamed a few nights later of a pair of tiny silver high heels about the size of a little finger nail. . . . The best thing that I found on the trip back [from Great Spruce Head Island to Calais] was a little doll (white) in a little bottle.

If Joe loved tiny things, he had a corresponding aversion to things that were larger than they needed to be, such as certain paintings

that, as he said about a David and an Ingres in the National Gallery, looked better in their postcard reproductions. As for his own work, Joe once said, "One thing I can not possibly imagine doing is something larger than life [size]."[202]

For Joe the diminutive had surprising power. He once wrote to Jimmy that he had

> just finished a collage which is quite simply the isolation of that little teddy bear: the English one that I have lived with for years and is really the most beautiful and favorite object of mine. He is isolated in a solid mass of cigarette butts. But of course he wins.[203]

The image of the small teddy bear appeared again and again in Joe's work, sometimes with a valentine heart on its chest. Somehow Joe managed to avoid the gooey sentimentality that one might expect to find in such an adorable image. Joe won.

1986

FOR MY BIRTHDAY Joe sent me a receipt, dated October 27, 1919, and itemizing a stay in a Paris hotel called the Prince Albert. Although this document had no special historical significance, its faded paper, typography, and handwritten numbers gave off a highly evocative glow. It was right up my alley. Joe was always able to come up with such an item, and he knew the right person to give it to, as if making the perfect placement of the perfect object was like working on the big collage of his life.

Although Joe forced himself to make art during the summer, he rarely seemed pleased with the results:

> Mornings are for work, and as I get up at six o'clock, that's a long six hours to fill with (so far) not much more than doodling. But (so far) it's the discipline that counts. (First things first.) [204]

> Work (grumble-grumble) isn't going too well, though I have done some drawings for a small literary magazine called *Exquisite Corpse,* and a book cover for *Writing Down the Bones* subtitle: *Freeing the Writer Within.* [205]

In a November 13 letter to Bill, Joe described being back in the city as "strange because first my parents were here for a week, and then I was working on transforming my ambiguous back room into a real studio, and then I got the flu, which laid me real low." Joe's parents

had visited New York briefly once before, not long after his brother John had moved there, but it was still unusual to see them in the context of the big city. On this second visit his parents stayed for about a week, spending three days in Connecticut with John and Caroline, and three or four days in Manhattan. One evening John and Caroline drove them down for dinner with Joe and Keith. The partner symmetry was evident, but Joe's parents showed no recognition of it.

Joe's letter to Bill was written partly to accept his invitation to do some drawings for *Serenade,* a collection of Bill's poems, even though Joe warned him that "nothing comes easy or fast these days."

Private Lessons

It seemed that everyone in tulsa knew how to drive, except Joe. In our senior year I drove him out to a remote spot and gave him his first lesson. He was completely baffled, as if he had no idea of how anything on a car worked: it was a miasma of buttons, gauges, levers, and pedals. After a few minutes, I suggested that he seek professional instruction.

One summer in Vermont approximately twenty-five years later—and after no professional instruction—he told me he *really* wanted to learn to drive. Would I consider giving him lessons? Recalling our initial attempt, I had him sit on the driver's side and acquaint himself with the various controls. He assured me that he had been studying Kenward at the wheel, and by now had a pretty good idea of how things worked. "o.k.," I said, "let's start at the beginning. First, put the key in the ignition. No, it goes the other way. Good. Notice that the gearshift is in park, where it should be. Now turn the key clockwise and when the engine starts, give it a little gas—I mean push gently on the accelerator." Joe turned the key, but the engine would not start. How could that be? Kenward's car always started easily. Joe tried again. *Rrruh rrruh rrruh.* Nothing. "Let me try," I said. We changed places. *Vroom,* the car started right up. I shut it off. We changed back. Joe turned the key again. *Rrrruh rrruh rrruh.* So I reached over and started the car and told him to hold down the brake pedal with his right foot and to shift into reverse. *Fruump,* the engine died. Joe, with a look of total dismay, said, "I think we had better try this again later." As in never. He dreaded imposing on people and he didn't like being

dependent on them, but being chauffeured about was something he decided he would have to accept.

I tried to explain to Joe that he didn't have to be frightened by thunder and lightning, but he continued to be visibly scared by them. He certainly took no solace in my joking reassurance that if you were hit by lightning you'd never hear the sound. Actually the electrical storms at Kenward's house in Vermont were sometimes quite dramatic. During one Pat and I, who are not particularly afraid of such weather, took Wayne out to the car and waited until the crashing subsided. Joe had gone up to the bedroom and gotten under the covers, fully dressed.
Joe mentioned another "fantastic thunderstorm":

I'm sure I cannot describe how bad and terrifying it was. Let's just say that the house was shaking, and we were shaking, and that we "saw" (actually saw) lightning hit near the house twice. Once it hit the car which the rubber tires (?) grounded. We saw giant sparks. No damage tho. All it did was rip a big hole in the earth and throw big clumps of earth and grass all over the car.[206]

Another time, we were all sitting in Kenward's living room during a storm when a shower of sparks shot out of the hanging lamp fixture, and a glowing sphere, slightly smaller than a bowling ball, rolled out of the fireplace and across the floor toward the front door, where, just as the thunder exploded around us, it vanished.

The only true phobia, or near-phobia, that Joe had was of gas ovens. I think he had once heard a story about an oven that had blown up an entire house, and decided that he would never light one. Anytime he needed an oven lit, he would apologetically ask someone to do it for him. One summer I decided to show him that, if lit properly, gas ovens were not dangerous at all. I demonstrated on Kenward's. It lit right up. Then I turned it off and had Joe follow the same procedure, step by step. When the gas gave that ignition *harumph*, Joe recoiled. If I had been more of a get-back-on-the-horse type I would have had him light it again and again, but the look on his face . . .

Hermes

IN 1986 JOE LEARNED ABOUT a Spanish woman named Hermes who gave facials at attractive rates right in her apartment. Hermes was a middle-aged, pleasant, proper woman. She and her husband alternated between living in Spain and New York, and when she was in town Joe went to see her once a week. Her facials were wonderful, both in their effect on one's skin and on one's urban stress. What he liked especially was that when you got up out of her easy chair and walked outside, it was as if your face had been erased. The erasure lasted only fifteen minutes, for inevitably one's personality redrew the features, but Hermes was worth it, and one could always go back next week for another erasure.

1987

IN FEBRUARY AND MARCH OF 1987 the Mandeville Special Collections Library of the University of California at San Diego held a second celebration of its acquisition of the Robert Butts collection with a larger exhibition of 146 works. By this time Joe was convinced that his work simply wasn't up to snuff, he had no interest in furthering his career or reputation, and he didn't understand why everyone was making such a big deal out of it all. But he took part in the festivities—reading with Bill on February 19 and attending the reading by Kenward and Anne the following day—because he knew that Butts's feelings would be hurt if he didn't. Joe understood the pleasures of collecting—and then releasing the collection—and he appreciated Butts's devotion, but seeing his work placed in an institutional archive was perhaps too much like having his spirit put in a bottle. Too final.

Since Joe had not had a gallery exhibition in eleven years, many people assumed that he had stopped making art. He had made attempts at working, but his feelings about it seemed half-hearted, disparaging, or pessimistic. Many years later I was surprised to find, in a letter to Anne written in September of 1987, a ray of optimism: "No major breakthroughs work-wise, though I am doing a bit better than last year. Which was a bit better than the year before."

For Pat's birthday in November, Joe took her, Kenward, and me to dinner at one of his favorite restaurants, La Trattoria di Pietro

281

e Vanessa on Lafayette Street, a small, unpretentious place whose owner, Vanessa, greeted Joe with a great friendly flourish and during the meal stopped by the table to chat. Joe was the ideal customer: good natured, unpicky, and generous. The bill came to around one hundred dollars. Joe left a fifty-dollar tip.

The Dam and Hawaii

JUST AFTER NEW YEAR'S DAY OF 1988 I got a card from Joe with
a reproduction of Fantin-Latour's painting *White Cup and Saucer*
(1864). (It also depicts a silver spoon.) These objects are set against an
espresso-colored background that absorbs the light, and the whole is
painted with simplicity and directness, as if to say, "Here is a coffee
cup, a saucer, and a spoon, with some light on them. That's it. Look."
I can see why Joe picked this card, especially given his memory of
doing the breakthrough drawing of a coffee cup back in Tulsa and
of having returned to the subject in another of his drawings, a par-
ticularly beautiful one, for *The Vermont Notebook*.

The early summer of 1988 brought a torrential, extended rainfall to
northern Vermont. Fed by several streams, the beautiful five-acre
pond below Kenward's house swelled to alarming proportions, edg-
ing closer and closer to the top of the earthen dam on the spillway
side of the pond. The spillway itself was flowing at top volume, but
the pond level kept rising. If the water spilled over the top and
washed out the dam, there was no telling what might happen to the
houses downstream. Someone driving past noticed two figures—
Kenward and Joe—frantically working in the rain to shore up the
dam, and immediately notified state officials of the danger. The dam
held, barely, but soon afterward an official notified Kenward that
either the pond had to be drained or the dam had to be replaced.

Work on a new dam, spillway, and flood plain—a sizeable earth-
works project—began on July 5, 1989. To avoid the all-day roaring

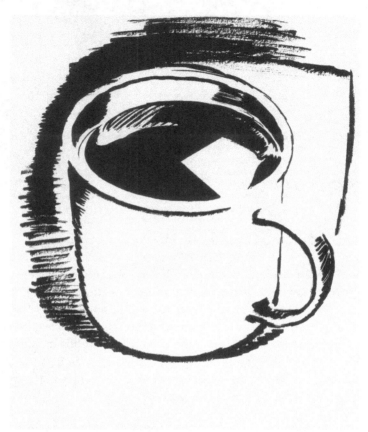

Drawing by Joe for John Ashbery's *Vermont Notebook*, reminiscent of the 1960 coffee cup drawing (now lost). Collection: Patrick Merla.

and beeping of earthmoving equipment, not to mention the eyesore of a gigantic muddy hole in the ground, Kenward and Joe took off for Hawaii. They spent a few days in Honolulu, then about a month on Maui. Joe found it *"embarrassingly* beautiful." He read, walked along the beach, and engaged in a kind of hydrotherapy: "It's the ocean after breakfast, the pool after lunch, and the hydro-spa after dinner."

He was amused to learn that the well-known television actor Jim Nabors ("Gomer Pyle") owned a house on Maui—a recent rumor was that Nabors and Rock Hudson had bought rural property together in northern Vermont—and Joe reported that he and Kenward saw Corbin Bernsen's mother (on *The Young and the Restless* soap opera) entering a jewelry store "in the lobby of *the very same hotel* we are staying at."

From the Maui Intercontinental they went on to the Hana-Maui,

but not for long. A bit too la-de-da and sports-oriented (horse-back riding!) for us. So it's back to another glitzy high-rise right on the ocean. With (slurp) a European health spa and *six* swimming pools!

He seemed to be using Hawaii the way he sometimes used Vermont, as a place to recuperate. Maybe he thought that with the change of atmosphere the swollen glands in his neck would go back down, as they had the previous summer.

A Real Nice Life

FOR JOE 1988 had followed the usual pattern. As he wrote to a friend in January of 1989, he had "no news. Mostly I just draw and read, go to the gym, and see friends. A real nice life."[207] One wonders if there is a secret, rueful irony in that last sentence.

A few months later, Joe and Keith stopped being lovers, though they remained close friends.

The planned publication of Bill Berkson's poetry collection, *Serenade*, with Joe's drawings, had fallen through, but in October of 1989 the project was revived. Joe was happy to hear this, but felt that he should do all new drawings, since some of the old ones were, in his opinion, embarrassingly similar to others that had already appeared in Kenward's *Sung Sex*. When the new publisher backed out, the project fell dormant again.[208]

In February or March of 1990, Joe came down with shingles on one side of his face, his ear, and his scalp. One day when I was about to drop by to see him, he warned me that the rash looked awful. It did. But with medication it eventually disappeared. That summer in Vermont, he had a persistent sore throat and slightly swollen glands in his neck.

Otherwise he seemed fine. And in addition to reading, he was working on collages and ink drawings. He seemed to take special pleasure in floating around on the pond: "So picture me this afternoon out in the middle of the lake—white swimming trunks—floating around on a bright red air mattress, blissed out of my mind."[209]

That same summer I wrote the following piece:

Joe Floating

Today I saw Joe floating around the pond "on his stomach," as we say. Or rather, I saw a suntan and a black bathing suit floating around. He reminded me of a tone arm that had come loose and was floating around inside a space capsule whose old lp's were slowly, gently bouncing off the walls, while outside the sky went on and on.

Aside from a yeast infection in his throat, Joe felt good, as he wrote to Keith:

It's been a totally idyllic summer. Some beautiful weather, and I find myself in a calm and grateful (to be here) state of mind.[210]

Pat's sister Tessie, visiting us in Vermont, told us that she didn't want to be an alarmist, but she wondered if Joe had ever been tested for HIV. (Tessie had worked with AIDS patients at San Francisco General Hospital.) It turned out that Pat had been asking herself the same question. When she and I returned to New York in September, she worked up her courage and called Kenward to ask about Joe's situation. Kenward promised that both he and Joe would get tested, even though their relationship had not been sexual for at least ten years.

In late October or early November, Joe phoned us. I was standing in the kitchen when he told me, "I got the results. There's good news and bad news. The bad news is that I *am* HIV-positive, but the good news is that my T-cell levels are high enough that I don't have to take any medicine." Leave it to Joe to try to put a positive spin on it, to soften the blow.

I paused—steadying myself in an abyss—and said, "How do you feel about this?"

"I accept it," he said, "though I don't *embrace* it."

We talked for a while and agreed to have dinner soon.

"One thing," he added. "Please don't tell anyone, except Tessie. I don't want Kenward to know." Once again he was trying to soften the blow.

Joe, New York, April 19, 1988. Photo: Susan Cataldo.

Maintaining an abnormal normalcy, I promised secrecy. Then we said good-bye.

I hung up and turned to Pat. We burst into tears.

Joe then notified Keith, who recalls having tested positive sometime in the year before Joe's test. When the idea came up that Keith might have been the transmitter, Joe said to him, "But you don't think I would care about *that*, do you?" Joe's response was not only clearheaded, it was intended to lessen his lover's anguish.

Pat has a gut feeling that Joe may have suspected or even learned of his HIV status as early as 1987. She can pinpoint a particular evening when he invited just the two of us out to dinner: his manner was unnaturally distant, his mood very odd. He might have just gotten bad test results, or he might have been on the verge of telling us. She also remembers that it was around then that he began to take superlative care of himself, joining the exclusive Crosby Street health club and buying nice clothes.

Joe's brother Jim recalls that even as a child Joe had preferred coordinated and stylish outfits, but in junior high school, where it was unwise for a boy to exhibit too much fashion consciousness, he had dressed conventionally. In the early 1960s he had worn paint-spattered old clothes, but a few years later his wardrobe became presentable. Beginning around 1987, though, he allowed his good taste in clothing to have free play. He bought expensive white shirts whose cotton felt like an exquisite blend of silk and velvet, along with Armani jackets, trousers, and suits that fit him as if they had been designed for him.

Workouts and wardrobe aside, Joe had gotten more and more handsome as the years went by. I had always liked the way he looked, though I hadn't given it much thought: he looked fine because he was Joe. Beginning in the mid-1980s, several friends—male and female—commented on how he had taken on the kind of handsomeness that the mature Humphrey Bogart had, one that didn't fit a template of standard good looks but was even better because it was a manifestation of character, genuine and irresistible.

When his hair began to thin he tried a restorative medication, with little success. And he failed to achieve one of his (and my) continuing self-improvement goals: good posture. He remained slightly

swaybacked and a bit slouchy. One of the strictures preached in the Tulsa Public Schools in our childhood was the importance of good posture. In many ways Joe and I had thrown off the Tulsa bourgeois life, but we never did rid ourselves of that precept of Mrs. Evans, our first grade teacher.

Despite his diagnosis, Joe's daily routine remained much the same. In the middle of November 1990 he wrote to me to apologize for having missed a reading of mine and to compliment me on some new works I had sent him. He also said he was looking forward to Thanksgiving dinner at our place. In general, he didn't seem different. He continued to read, visit the health club regularly, and go out with friends for dinner and entertainment at night. It was amazing to me how much he managed to enjoy himself. He did, however, take Tessie's suggestion that he switch to an AIDS specialist at New York University Medical Center.

Actually Joe had already selected that facility for himself. It turned out that for the past several years he had been visiting friends and acquaintances, most of them suffering from AIDS, in hospitals around the city. Anticipating his future, he had settled on New York University Medical Center.

In January of 1991 I told Joe that I wanted to buy our collaborative work, *Sufferin' Succotash,* which we had put up for sale in a benefit show of poet-painter works for the Poetry Project at the Brooke Alexander Gallery. One third of the proceeds would go to the Poetry Project, one third to each of the collaborators. Joe wrote to me: "Hey, I have a great idea. Let me give it to you for your birthday. (Never know what to give you.)" In other words, I would pay only the Poetry Project's one-third share. What struck me was that Joe was thinking of an excuse not to acquire more of anything, including money, and of my distant birthday, half a year away.

In January or February, Joe and his brother John had a brief visit with their parents in Tulsa.

Venice

IN THE LATE SPRING OF 1991, Kenward took Joe to Venice. Joe, who had never been there, sent us a postcard:

> Three days in very clean and civilized Geneva. Then an eight-hour train ride through the Alps to Venice. Room with a terrace on the Grand Canal. Blood red orange juice for breakfast. And seven straight days of sun! We walk, nap, and eat. And walk, nap, and eat. . . .

They also visited some museums, including the Peggy Guggenheim, where Picasso's cubist still life *Pipe, Glass, Bottle of Vieux Marc* (1914) was Joe's favorite.

Joe's card also said: "Sad news of Jimmy." Jimmy Schuyler had died on April 12. At the time of the trip, Kenward still didn't know that Joe, whose seemingly minor symptoms of ill health could be explained away, was HIV-positive. All I could think of was *Death in Venice:* I kept having the irrational fear that Joe would die there on this trip.

The necrology continued when my father died in May. Joe's letter of condolence said:

> I'm so sorry to hear about your father. I have such fond memories of him. As a very sweet and generous man. And as a folk hero of sorts. Larger than life: half Clark Gable, half John Wayne. You have my sympathy and my LOVE.

During the summer we followed the Vermont routine of the past decade: reading, sunbathing, health club, dinner at home or in town, the occasional movie, the drive up to the Corbetts for dinner. Joe did some drawings and wrote several things, among them what might be called an Imaginary Portrait:

Jimmy Schuyler: A Portrait

Let me be a painter, and close my eyes. I see brown. (Tweed.) And blue. (Shirt.) And—surprise—yellow socks. The body sits in a chair, a king on a throne, feet glued to floor. The face is hard to picture, until—(click!)—I hear a chuckle. And the voice of distant thunder. [211]

Back in New York in October, Joe made up for missing my last reading by sending me a note about a recent one: "I *absolutely loved* your reading." The next month he sent Pat a note:

Happy Birthday! I don't think you like jewelry much anymore. And I'm certainly not going to give you another scarf. So I'm solving the problem with a check. And LOTS OF LOVE.

I can't recall the exact figure, but I do remember Pat's looking at the check and saying "Oh, dear," so my guess is that it was for around $1,000. Joe's generosity came as no surprise, but now we knew that he was also being practical: he was starting to disburse his worldly goods. Back in the early 1970s he had clipped out a picture showing Gandhi's few possessions at the time of his death. Joe once spoke of the picture as something that he himself could

use (I hope) as inspiration for myself. . . . You know, as much as it is against my nature, I *really* do think that life would be better if all I had was on my person. [212]

At the time he was speaking in practical terms: he wanted to avoid "weight" and complications in his life. But now, twenty years later, it was as if he had written that an unencumbered *death* would be better.

Being Normal

AFTER JOE TOLD PAT AND ME that he was ill, we began to see him and Kenward more frequently, often at dinner at our place. Tessie was usually invited too. For their after-dinner smokes, Joe and Pat, accompanied by Tessie, would retreat into the bedroom, where Joe would tell them his latest test results. He seemed to enjoy this little conspiracy, and the three of them intentionally kept it on that level. But by the spring of 1992 his T-cell count had dropped to a level that called for medication; in April he began AZT. At this point he decided he could no longer conceal his illness from Kenward.

In June a few weeks before Pat and I were to come to Vermont, I sent Joe a newsy letter describing a dinner at George and Katie Schneeman's, a book I had gotten for Pat, office politics, etc. I think it was the last letter I wrote to Joe, and its normalcy reflected the way I had decided I would be around him from now on. I imagined that he would want to be treated how he expected me to treat him: as Joe. His illness would provide abundant abnormality, and I suppose I wanted to help him have at least some part of the day that was . . . what? Ordinary? A part that allowed him, from time to time, to forget his illness? Was that possible? I don't know quite what my thinking was, except that I knew that he would not want me to lock him into the role of the pitiful victim.

My strongest memory of the summer of 1992 was an afternoon, probably in late August, when Joe, Pat, Wayne, and I went for a walk in a high meadow up in the woods on Kenward's property, as we had done many times before. Despite my determination to keep things

as regular as possible, in the back of my mind was the feeling that this could be the last time we would take our favorite walk together. For years Joe had taken summer snapshots of everyone, a role that now seemed to have passed to Wayne, who was handy with a camera. In the pictures, Pat and I seem our usual, though now visibly older selves, but Joe has the beginnings of a wasted look.

In October Joe and John made what they felt might be Joe's final visit to Tulsa to see their parents, who still knew nothing of his illness.

Glad to Be 51

IN EARLY JANUARY OF 1993 Pat, knowing that she was going to have to choose between Joe and her job, left her position as associate director of Teachers & Writers Collaborative. During the day she and Joe went to movies on a regular basis. He took special pleasure in going over the list of movies they'd seen together.

Sometimes when he walked he felt a sharp tingling in his feet—a side effect of his medication. He told Pat that he could live with that. He was still keeping his condition secret from most people, though he probably told a couple of friends who also had AIDS.

Despite his illness—or perhaps because of it—he seemed to have found an inner calm and a deep pleasure in the most basic activities, as he wrote to a friend:

> [I had] dinner at Pat and Ron's—(fried chicken, mashed potatoes, gravy, spinach, and biscuits: yum yum). . . .
>
> I really seem to enjoy comfort a lot. And peace of mind. Not too many decisions to make. And—best of all—a good night's sleep.[213]

At the same time, he dismissed yet another piece of his past work, *Bolinas Journal:* "Of all my books none embarrasses me more. What could I have been thinking of? Makes me glad to be fifty-one." Just as he had gotten rid of most of his artworks, now he was ridding himself of the emotional baggage of his literary production.

Back in early 1991 Kenward had developed a leg infection that did not heal, and despite the fact that he had put on a lot of weight and that diabetes ran in his family, his doctor did not test for diabetes. When Kenward's leg bandage would come undone in the street, he would fume in frustration, but Joe would calmly kneel down and rewrap it.

In the spring of 1993, when Kenward was in Seattle for a read-through production of his musical *Postcards on Parade,* he noticed that he was drinking abnormal quantities of liquid, as much as six quarts of soda a night, for what seemed to be an unquenchable thirst. A local doctor's diagnosis was diabetes.

Joe quickly educated himself about diabetes and began a tough-love program for Kenward, making sure that he took blood-sugar readings every day, tugging him into going for walks, and monitoring his new diet. He continued to look after Kenward this way until his own illness made it impossible.

In caring for the "needy," Joe was steady. Not only did he give money to his impecunious friends and donate money to charities—from child welfare to gay-and-lesbian organizations—but also he was quick and resourceful in emergencies, such as once when John Wieners went bonkers in a restaurant; when Jimmy had the schizophrenic episode in Vermont; when one of Kenward's young relatives was floundering in a pond and Joe swam out and saved him; and, when he and Kenward were involved in a serious auto accident, he immediately made sure that Kenward was O.K., then rushed to check on the occupants of the other car, without even looking at himself. [214]

Metaphysics

JOE AND I CAME FROM pragmatic parents who had grown up during
the Great Depression and whose view of life was formed by the specter
of poverty. Contemplation of philosophical or metaphysical issues was
a luxury that only "comfortable" people could afford, and besides, our
parents had the ready-made religious or ethical precepts of Christianity.

In high school Joe had quietly lost his faith, perhaps a faith he
had never really had. After our move to New York, although we
had long, serious, and probing conversations about art and personal
conduct, we didn't talk at length about philosophical or religious
issues. There was something about who we became in New York
that screened out such conversation, even though my undergraduate
studies covered a wide gamut of philosophers and theologians, and
I assume that Joe, thoughtful and living alone, asked himself many
of the same questions as I did: Is life ultimately meaningless? Why
was I born? Is there life after death? What exactly is the human
spirit and where does it come from? How and when was the universe
created (if it was)? Is there a greater spirit somewhere in the uni-
verse? Can eternity exist? What is "reality"? For reasons I still cannot
fathom, we did not explore these questions together.

Joe wrote (but never published) a short undated piece entitled
"Religion":

> I think I genuinely try to keep an open mind about religion.
> Not, however, so much because of religion as because of
> keeping an open mind.

Knowing very little about Tibetan Buddhism, I'll grant you that it's a lot more interesting than Protestantism.

But "interesting" (Let's face it, folks) is a slightly dubious compliment.

And so, to tell you the truth, I just can't quite buy it.

As a way of life, I believe a more truly accurate source (or means) can be found totally, if somewhat abstractly, from within each of us as individuals.

Religion as a "device" towards this discovery I can certainly understand, but, like psychology, not especially admire.

I guess you might say that I believe in the wind, as *I believe* in the stomach, as I believe in you. As I believe in me. As I believe, period. And (taking advantage of feeling so "up" ((pill)) today) I shall venture to say that I believe in a perhaps almost non-existent form of believing: as pure as gold, without people.

All of which (believe it or not) has something to do *with total cancellations!*

And I believe in the fullness of the/this resulting void.

To my knowledge this is the "deepest" thing—that is, philosophical without humor—Joe ever wrote. The last three sentences are convincingly mystical, a quality I don't associate with Joe. The more usual Joe emerges in a short piece called "Life and Death According to Joe Brainard," in which he uses humor as a mitigating device:

Death is it. That's it. Finished. "Finito." Over and out. No more. I think the best way to understand death is to think about it a lot. Try to come to terms with it. Try to really understand it. Give death a chance! [215]

In our writing, both Joe and I tended to respond to the intractable questions with humor. However, imbedded in the humor in this short piece is a straightforward message: you live, then you die, and

that's it. There is no afterlife, so it's best to focus on the time you have and live it to the fullest. *Carpe diem* all over again.

As early as his twenties, Joe, who claimed to be unable to imagine himself as a geezer, had expressed a horror of growing old. And though he didn't go so far as to have a live-hard-die-young attitude, he did lean in that direction for a number of years. He wanted an exciting life, one that accepted no comfortable stasis, and so from time to time he had pushed himself near the edge. But my strongest sense of Joe came not from that side of him, but from his fundamental sweetness and gentleness, which never left him.

Summer 1993

By the time Pat and I arrived in Vermont in early July, Joe was having an abdominal pain that was relieved only when he bent slightly at the waist. We took him to Burlington, about fifty miles away, to see a specialist at the University Health Center. After the appointment, we strolled through the nearby Robert Hull Fleming Museum, and for a moment it was like the old days, the three of us free and looking at art.

With his friends who didn't know how seriously ill he was, he continued the charade:

> I came down with some mysterious stomach thing—(cramps, bloating, pain)—and the doctors still can't figure out what it is. However, I had a sonogram yesterday, so maybe I'll know something by tomorrow. This has been going on for almost two months, and I am getting very bored and grumpy! The only thing that offers some relief is lying flat on my back, so—picture me reading a lot.[216]

Pat, Kenward, and I drove him back to the hospital for an endoscopy, an examination that enables the physician to look at internal organs and to take pictures. An hour or so after the procedure, Joe handed us a color photocopy of a view of a bile duct in his pancreas. The duct, attacked by cytomegalovirus, was inflamed and swollen, making it difficult for bile to pass through. Hence his abdominal pain. Joe seemed more interested in the fact that such a picture could

be taken than he was in the fact that it was of his very own interior, though when I asked him how it felt to have the endoscopy tube go down his throat and inside him, he widened his eyes and said, "It's *very* invasive."

In the last week of September Pat, Kenward, and I drove Joe back to Burlington for him to have a stent (a short tube) inserted in his bile duct to hold it open. The procedure required an overnight stay in the hospital, his first—a sign to us that his condition was worsening. Temporarily relieved of pain, he took long walks along the country roads around Kenward's to build up his stamina for the long flights of stairs up to his loft in New York.

Into the Tunnel

BACK IN THE CITY a few weeks later, Joe found himself not going out. A new medication had to be administered intravenously through a saline lock that was taped to his arm at all times, keeping a needle in the vein. This ordinary IV device was soon replaced by a more complicated one that extended far up into the vein. A visiting nurse came by once a day to check on this delivery system.

Pat went to Joe's every day to provide moral support, to make sure the correct medication was hooked up to the IV, to sit and talk with him while he was waiting for the plastic IV bags to finish their slow delivery, to tidy up his place, and to run errands. She also took him to his doctor's appointments. Evenings after work, I started going back down to Greene Street with her to deliver a small serving of what we had just had for dinner at home. Joe's appetite was feeble, but he would inhale the aroma and say "Mmmm" in a tone that was appreciative and nostalgic. Then he would take a few bites and apologize for not being able to eat more at the moment.

One evening as we made our way up his stairs we encountered Kenward on his way down. He was so overcome with grief that he averted his face and continued down the stairs.

On certain visits, Joe would point across the room and say, "Look at the new plant Frank Bidart sent. I don't know what it is, but it's unbelievable." Frank Bidart had written Joe a fan letter in the 1970s, but it wasn't until 1991 that the two met, at Bill and Beverly Corbett's home in Boston, where Joe had gone to take part in an evening of homage to Jimmy Schuyler at MIT. Bidart was quite taken by Joe's

seemingly natural ability to say the most perceptive things in the simplest way, and by his gentle manner, so taken that he rang Joe up in New York and asked if they could perhaps go to some art galleries together. For the next year or so, Frank would periodically travel from Boston to New York just to go to galleries with Joe. He also sent him oversized envelopes stuffed with unusual postcards, which he knew Joe enjoyed. In the fall of 1993, when Joe's illness kept him pretty much confined to his loft, Frank placed a standing weekly order with a florist who excelled in exotic plants and imaginative floral arrangements. Years later Frank told me, "I knew Joe only for two short years, but he changed the way I saw things. He *opened up* my life."

On December 14 Joe checked into the Co-op Care division of New York University Medical Center for more extended drip treatments. We had hoped he would be released before the holidays, but the stay stretched on and on. At one point a doctor inserted—perhaps *implanted* is the word—an IV in the middle of his chest. I had read that for some patients this type of IV is emotionally devastating. The past summer Joe had told Pat that he would never agree to such a device, but now he seemed to take it in stride.

During the day, as he received medication, he and Pat passed the hours by talking and observing the nurses and the other patients and their families. He kept track of his favorite nurses, even though some weren't assigned to him. His patience—a quality he had always felt he lacked as a painter—was extraordinary. From the beginning to the end of his medical treatment Joe was a model patient: he followed doctors' orders, he was polite, he never complained, and he even showed concern for whatever problems the doctors or nurses might have. He didn't want to make them feel bad.

At the hospital there was a young man whose condition had worsened to the point that he was being transferred, probably for the last time, into the main hospital. On hearing this news, his parents looked crushed. Joe got up out of his chair and, pulling the drip apparatus behind him, walked over and offered them some words of consolation. This was an extraordinary act for a shy person who never risked intruding on anyone's privacy, and it shows how he had become more open to his own compassion.

However, as his condition worsened, he did briefly express regret or irritation, but only a few times, and, as far as I know, only to Pat.

At night he was joined in Co-op Care by a friend—at first me, then Pat, and, most often, Kenward—or a health-care aide, in his private room that looked like a pleasantly understated motel accommodation for two. At first Joe refused visitors: he didn't want people to see him diminished and he didn't have the energy to be "up" for their visits. Finally he admitted Ann Lauterbach; then Frank Moore, a friend with AIDS; Irma Towle; and doubtless several others. A few floors up was the cafeteria, where patients could eat with their friends and relatives. We brought Joe's tiny meals to his room: Jell-O, custard, and chocolate milk that he barely touched.

By the time he was released, it was clear that he would be unable to negotiate the long flights of stairs between his loft and the street, so he was taken directly to the Upper West Side ground-floor apartment that belonged to his brother John and sister-in-law Caroline, who occasionally used it as a pied-à-terre. Twenty-four-hour home-health aides were in attendance, most often a young man named Rey, who showed great steadiness and reliability. Pat continued her daily visits; I came up after work every couple of days.

Over the next several months Joe was weakened by greater abdominal pain and finally, unable to eat or drink anything, was fed and hydrated intravenously. He returned to Co-op Care, and a day or two later, when he was moved into the main hospital, we all suspected what it meant. Soon afterward, pneumonia set in.

If he was left alone, it was never more than for a few minutes: Kenward, Pat, John, Caroline, Rey, or I was there—alone or in small groups or all at once. At one point Keith was able to visit briefly, gazing down at Joe as he slept.

One night around 2:30 in the morning, as Pat and I walked down First Avenue from the hospital toward our apartment, we noticed a lone bicyclist heading up the street. It was Keith, worn down by anxiety and helplessness.

The doctors told us that treatment for the pneumonia was not working and that all they could do now was keep him comfortable. That is, maintain his dosage of morphine. By this time he was

unconscious, but at one point, with only John at his bedside, he raised his head and muttered something to him, something muffled by the oxygen mask.

"What? I couldn't hear you," John said, bending near.

Joe repeated his message, and then lapsed back into unconsciousness.

A few minutes later John told me that Joe had tried to tell him something. "It might have been: 'I'm so lost,' but I'm not sure." John looked stricken.

I remembered that when my father was dying, he too was given morphine, which eased his physical pain but induced hallucinations, some of them unpleasant. It crushed me to think that Joe's final hours might be a similar phantasmagoria, and I despised myself for allowing even the possibility, but to keep myself together I told myself that there was nothing I could do about it now and that my guilt could wait.

The pneumonia deepened and, in the afternoon of May 25, Joe's heart slowed down, and stopped. With him were Kenward, John, Caroline, Rey, Ann, and Pat. Beneath the hospital gown, he was wearing his trousers and socks, guarding these last vestiges of dignity to the end.

Walking into the hospital lobby a few minutes later, I saw Kenward and Ann coming toward me. "It's over," Kenward said quietly. The two of them held me as I cried, and they cried too.

Finally I said, "I'm going upstairs."

The others were standing in the hallway outside his room. I went in alone. He looked as if he had just concluded a terrible combat. I touched his foot and said, "Oh, Joe."

John and Caroline drove Pat and me home. Just as we pulled up in front of our building, out of nowhere came a deafening machine-gun fire of hailstones that pummeled the roof of the car for fifteen seconds, then suddenly stopped.

The Meadow

KENWARD'S PROPERTY IN VERMONT, on a one-lane dirt road off another dirt road, is mostly wooded. It has several logging trails up through the hilly woods, one of which leads to a high meadow, a private meadow, a meadow that, a few steps before you reach it, you would never have imagined would be there.

To say that this is a quiet spot is obvious but inaccurate. Yes, the meadow is free of the sounds we call noise. But it has the soughing of wind in the stand of pines and spruces near the center of the meadow, and those that encircle it, along with the birches, maples, and the rattley poplars, as well as the milder sound of the wind in the high grass and weeds, where hawkweed, buttercups, wild violets, milkweed, and wild strawberries nod in the breeze. From the edge of the surrounding woods come the chirps and melodies of birds you can't identify, even though their songs are familiar. It is all these natural sounds that make you realize how quiet the spot is: if there were no sounds at all, you would feel that something was wrong, whereas the wind and the birds tell you that everything is O.K. You relax enough to hear the quiet. But it is not the same quiet you might hear in a similar meadow. It is palpable.

In the stand of evergreens in the middle of the meadow is an inner clearing, its ground covered with a soft bed of pine and spruce needles. Resting on them is a more or less spherical chunk of quartz, around three feet in diameter, flat on top. There is no other rock like it in the meadow, and only a few in the woods beyond. This one was moved here by Harold Camp, Kenward's caretaker and friend, as an

indication that there is something special about this meadow. This is where Joe's ashes are scattered, according to his wishes.

The ashes were portioned out to close friends, who, at different times, visited the meadow and scattered them. I don't know where the others scattered theirs. When it came time for Pat and me to disperse our portion, we couldn't decide how or where to.

At a gift shop in Montpelier we bought a small box covered with a cotton fabric whose pattern had little multicolored flowers similar to those in a Book of Hours. We took this box up to the meadow, along with another piece of nicely printed fabric, a ribbon, and our portion of the ashes. We poured the ashes into the box, replaced its lid, wrapped the fabric around it, and tied it with the ribbon. I dug a hole, where we placed the box, covered it with dirt, and disguised the traces.

Later we would say, "I didn't feel quite right about scattering" and "I couldn't think of how to scatter them." We didn't delve into why burial seemed easier for us. We simply agreed that for now we wouldn't mention it to anyone. All of us were too hurt by his loss, and we didn't want anyone to think we had done something that somehow might be inappropriate. We had heard stories of families that kept grandpa's ashes on the mantel above the fireplace and of ashes that were hurled from an airplane over the ocean, but these seemed too morbid or melodramatic for us, and, though in his younger days Joe did indulge in the occasional dramatic gesture, we felt that ultimately it wasn't quite the "Joe" he had become. The pretty box, however, reminded us of him—a gift.

"Saint Joe"

IT IS TEMPTING to think of Joe—someone so basically gentle and generous and whose life led him toward renunciation—as a kind of saint. Edmund White, his friend for many years, did not give in to the temptation of hagiography in his affectionate essay on Joe, even though he titled it "Saint Joe."[217] Brad Gooch wrote an article that mentioned Joe's renunciation of art and said that some of Joe's friends thought of him as a kind of bodhisattva.[218] For it seems that only a person with a strong spiritual nature could give up a successful artistic career.

Many people who knew Joe have asked the same question that one of Eileen Myles's poems asks: "Joe / How come you / stopped / making art?"[219] A few days before Joe LeSueur died, he told me that near the end of his memoir of Frank O'Hara he was going to answer Eileen's question. We will never have his answer.[220]

It is possible that Joe, like any number of other wonderful artists, had his "hot" years, and that when he felt himself cooling off he was smart enough to know it. But Joe never mentioned anything along those lines, and some people who knew him, such as Ed White, feel that had he lived he would eventually have resumed making art full-time. I'm not sure I would go that far, but in any case the hot years theory just doesn't ring true to me. So what is the answer?

Part of it, as I have pointed out in this book, lies in Joe's frustration with what he felt was his inability to become a great oil painter, added to his disaffection with the art world's growing megalomania. But it wasn't just that Joe questioned the value of his work and the

value of showing it, it was also that he came to question the value of his making art at all. All these answers can be seen as negative reasons for stopping.

I believe that there was a positive reason as well. Although I cannot say that Joe became more saintly, I do believe that there was a subtle and powerful undercurrent in his life that became identifiable only when he stopped thinking of himself primarily as an artist, an undercurrent that slowly grew stronger and stronger, and was undeterred—perhaps even strengthened—when he learned of his fatal illness.

Back in early 1970 Joe and Anne Waldman sent each other a list of questions for what they called written interviews.[221] Some of the fifty-seven questions Joe sent to Anne were tailored to her life and interests, but others say a lot about who *he* was and what seemed important to *him*. For example:

> How much do you think you have "chosen" the way you live? The way you are? I mean—how much do you think you are a self-made person?

Ted Berrigan's master's thesis (1961), whose subtitle was "The Individual's Problem of How to Live," tackled the question of how an individual *can* shape his or her own life in the face of a society that really does not want anyone to be highly individual. The choice of subject was a natural one for Ted, who was in the process of consciously creating a new self, and he endlessly discussed and promoted such ideas among Joe, Dick, and me when the three of us were still in high school in Tulsa. Joe was particularly ripe for this line of thought, and in the next few years he showed how much an individual *can* shape his or her own life. He wanted to move to New York and become an artist on his own terms, at any cost, and that's what he did. However, Joe saw self-determination not as a one-time program, but as a way of life: he continued to shake up his routines, to start all over, to reinvent himself. What none of us knew was that this process can become emotionally exhausting, and it was when Joe reached that point and then went beyond it that he settled into being the person who later would be called "Saint Joe."

Does it ever make you mad that you are "Anne Waldman"? I mean—do you ever feel like too much of a neat package?

This question is reminiscent of Joe's shying away from people who think they have him all figured out, only this time the wariness is directed toward oneself. Joe did not want to become a neat package to himself, which is why he made periodic ruptures and found various ways to start over with a clean slate, both as an artist and as a person. Five subsequent questions in his list show that as early as 1970 he had entertained the possibility of a really radical change, even of "giving up" art:

> Does the confinement of being who you are bother you?
> Just what do you want out of life?
> Have you ever been tempted to chuck it all and just make movies?*
> Does poetry ever seem as silly to you as painting sometimes seems to me? (*Very.*)
> If you can imagine your remaining years, how do you imagine them?

Perhaps for him "Joe Brainard the artist" had become too neat a package, and it was time to break out of it and become whoever he would become.

In a 1973 letter (quoted earlier), Joe referred to what he felt was his "basic lack of dedication to 'art.'" For him, art was "simply 'a way of life'" that enabled him to fulfill his need to give people "a present" and perhaps be loved in return. Gradually, in the mid-1980s, Joe's need to make art diminished as his own life became his art.

How did that happen? Over several decades, Joe slowly discovered that what he was looking for in his art was very much like—if not identical to—what he was looking for in his life. It was a gradual and complicated process that had begun with his "awakening" in high school and accelerated with his moving to New York. The first written evidence of it is in his 1961 diary "Self-Portrait on Christmas Night," in which he acknowledged his need to be honest and open ("so much undressing to do") and disparaged the use of amphetamine

* In high school and college Anne had wanted to be an actress.

as "not 'the way things are' but 'the way we'd like them to be.' It would be so easy if I always took them, and don't know why I don't *want* an escape. . . ." What he wanted was the opposite of escape—a plunge *into* reality.

Throughout the 1960s and 1970s, this impulse manifested itself as a drive toward simplicity. In his life the key was, as he put it, "to keep things simple," even though from time to time he intentionally complicated his life to avoid getting in a rut. The drive for simplicity also shows in the clarity of his prose style, its short declarative sentences and its avoidance of ornamentation and Latinate vocabulary. As Jimmy Schuyler wrote to Joe, "There's never any fuzz about what you write."[222] Joe modestly ascribed his own prose style to a lack of sophistication and a small vocabulary, but actually he capitalized on his limitations to write works of great clarity.

Joe admired Ernie Bushmiller's *Nancy* comic strip not only because of its title character, with whom I think he partly identified and who is the epitome of simplicity, but also because of the clean line of Bushmiller's drawing. What Joe admired about Raeburn was his unfussy style ("slick, and accurate, and minimal, and without the device of too much style"). For Joe, clarity and simplicity were prerequisites for the accurate perception of the here and now. In his own art, he presented objects in ways that emphasized their realness, even though he was by no means a photo-realist painter. For example, his depictions of cigarette butts take on an intensity that highlights the fact of their existence, partly because they are arranged in interesting patterns that are so subtle that they do not call attention to themselves. When he arranged dolls or bow ties or bottles of Prell shampoo in an assemblage, he allowed them to be ultimate versions of themselves:

> Working on a new construction that I am a bit suspicious of: it is practically floating together. (As though I am not really needed.) I do love it though: each object is crystal clear, but equally so, so they all seem to belong together very much. It is constructed in the simplest possible way: one thing on top of another. It has no theme except color: emerald green, royal blue, cherry red and black. It is not all gooky, which I am glad of. Also there is purple,

and stripes of clear rhinestones. It is very geometrical. And of course very dramatic. Sometimes what I do is to purify objects. That is what I have done in this construction.[223]

Notice: "Crystal clear . . . simplest possible way . . . purify."

Joe's visual fascination with the way things *look*—a fascination that Carter Ratcliff has said that most of us have as children but that Joe miraculously brought unscathed into his adulthood—gradually developed into a fascination with the way things *are*.[224] And to get closer to reality, he tried to minimize the preconceptions, memories, and ideas buzzing around in his brain. He expressly went about this clarifying process in a 1973 diaristic piece called "Right Now" (quoted earlier), in which he described his surroundings at the moment and then said:

> (It is not my purpose to bore you. It is my purpose to—well, I want to throw everything out of my head as much as possible, so I can simply write from/about what "is," at this very moment: *Right Now!*)

I want to go back to a diary piece (for Tuesday, July 15, 1969) that I quoted earlier, and give an expanded excerpt, in which Joe went beyond talking about his recent paintings of wildflowers:

> What I am trying for, I think, is accuracy. That is to say "the way things look." To me. This is really very hard to do. And, I imagine, impossible. What I really hope for, I guess, is that, by just painting things the way they look, something will "happen." That is to say, a clue. A clue as to what I want to do. In much the same way, I am writing this diary now. I am telling you simply what I see, what I am doing, and what I am thinking. I have nothing that I know of in particular to say, but I hope that, through trying to be honest and open, I will "find" something to say. Or, perhaps, what I *really* hope for, is that the simplicity of the writing will be interesting in itself. Whether I say anything or not. Anything, that is, of any importance.

A great many of Joe's letters and diaries include a description of where he was at that moment, and one whole diary entry, entitled "January 13th" (quoted earlier), is entirely devoted to such a description,

ending with "And it's as simple as this, what I want to tell you about: if perhaps not much, everything. Painting the moment for you tonight."

This attentiveness to the here and now is evident even in *I Remember,* ostensibly a book about the there and then. Given the book's content, one might assume that Joe was focused only on the past, but actually his attention was also on the dynamics of the flow of memories across the screen of his mind in the very moment of recollection and composition. Writing *I Remember* was a way of saying good-bye to the past while staying in the present moment.

A similar impulse toward the clarity of the here and now seems to have been at work in his periodic cleaning out of his studios, getting rid of all the art supplies and repainting the walls white, or in his moving to an unfurnished apartment or loft that would allow him not only to start over, but to do so in a clean-slate ambience conducive to a *tabula rasa* mental state, just as he particularly liked a good facial because it "erased" his face.

All of this seems to me to constitute a phenomenology of self as a step toward a more fundamental sense of reality. I think that this is something true and basic about Joe, perhaps one of the unifying principles of his life and work.

For someone who was so talented and had so many astute friends who admired his creative genius, for someone who had produced such a dazzling body of work, for someone who was on the brink of even greater and glitzier success, walking away from all that can be mistaken for saintliness, especially when one does not know that his "walking away" was gradual and difficult.

I don't know if *saintly* is the best word to describe a person who is kind, generous, loving, and compassionate, whose spirit has moved continually toward honesty, openness, and clarity, and whose fascination with reality has ultimately led him to an acceptance of who he is and the way things are—even of his own terminal illness—but I do know that Joe, with his aversion for inflated pronouncements and his awareness of his own foibles, would hardly have thought that *saintly* applied to him. I just don't know what other word to use.

Endnotes

Childhood and Adolescence

1 From an unpublished school essay, "My Story—Joe Brainard" (1958).

2 Joe's answer is in "My Story—Joe Brainard."

3 The first quotation is from "My Story—Joe Brainard." The second is from the *Tulsa Tribune,* July 8, 1958.

4 *Tulsa World* or *Tribune,* 1956, probably July. In 1957 Joe was again the first to enter, in July.

5 *Tulsa Tribune,* February 26, 1960.

6 From a 1977 interview with Tim Dlugos, published in *Little Caesar,* no. 10, 1980.

7 The word *nice* was to be the leitmotif of an essay by John Ashbery that begins, "Joe Brainard was one of the nicest artists I have ever known. Nice as a person and nice as an artist." John's essay, "Joe Brainard," appeared in *Joe Brainard: Retrospective,* Tibor de Nagy Gallery, 1997; reprinted in *Joe Brainard: A Retrospective* by Constance M. Lewallen, University of California, Berkeley Art Museum/Granary Books, 2001.

8 Letter, April 30, 1960.

New York

9 The friend was Patricia Mitchell.

10 Interview with Dlugos.

On the Bowery

11 *Tulsa World,* April 30, 1960.

12 The building no longer exists.

Undressing

13 Joe's inscription was written in response to the one I wrote (May 18, 1961) in Joe's yearbook: "Joseph—of all people to sign your

book—me! It's rather odd, writing to someone whose ears must be terribly tired of my senseless babbling already. The nights in the Silver Castle, the times at John's, the endless hours we've mulled about and spent working hard or just goofing. We've had a very realistic relationship (to prove it: I've never once written a poem about you (or Gallup)). You've learned a lot from me, things I've poured into your brain over cups of coffee. I hope, Joe, that you've also heard the things I've felt, hope you realize how important you are to me. But I've learned from you too—things silent and almost unsayable. Please trust me, whether you believe me or not. You're stronger than you look; when I think of how I've shifted the weight of so many of my problems on you—and my awful jokes—when I joke don't ever take me seriously on the outside—I'm usually very serious when I joke, but it's not what I'm joking about that I'm serious over. You're more independent than you look, too. And much more mature than I in many ways. We know that friendship, love of man is more than giving him *things*—it is a giving of the self. Only this year have you and Pat [Brown] made me see better what I really am. Because of my selfishness and egoism—I haven't given you nearly so much as you've given me. Forgive me for that. I ask forgiveness, for a moment, so I can gather my forces and try to be good. You are essentially good, down deep in your soul lies Goodness, and God-ness. There is a little of God in me now. But there's always the future. I want to know you forever, Joe. I only feel that way about a few people. People change. Let's hope that I can change for the better—then I can help people and give to them. I have no worries about your future. Find a girl and love her."

93 First Avenue

14 This quotation and the one that follows it are from Joe's *Selected Writings*.

15 Joe brought the top section back to New York and, more or less disowning it, asked Ted to write on it. When Pat and I said we liked it, Joe gave it to us.

Dear Diary

16 Interview with Dlugos.

17 It wasn't until rather late (June of 1971) that Joe decided that "Back in Tulsa Again" should be included in his *Selected Writings*. The

works in that book are in chronological order, with one exception: "Diary Aug. 4–Aug. 15" comes first, at his request.

18 Postcard postmarked August 13, 1962.

19 The entry in Ted's journal is dated November 8, 1962. The clipping is undated, but on it Ted wrote "1962." The painting is an oil, *Portrait of Pat with Still Life.*

20 These quotations are from Ted's journals in the Manuscript and Special Collections at Butler Library, Columbia University.

BOSTON

21 Berrigan journal, January 9, 1963.

22 From an unpublished manuscript entitled "A True Story."

23 A few miscellaneous comments. Joe was right-handed. The banana man may have been a real childhood memory: fruit vendors with carts did go up and down the streets of Tulsa selling fruits and vegetables. The baseball score was right out of Ted's work and conversation (Ted was a Boston Red Sox fan, whereas Joe could never remember whether a home run was a good thing or a bad one), and the "wind and the empty tree" are reminiscent of Ted's "Sonnet XVII," which begins "Each tree stands alone in stillness" and ends "Dear, be the tree that your sleep awaits / Sensual, solid, still, swaying alone in the wind," with many references to trees and wind in between. Of course, Ted had already appropriated lines of Joe's and used them to make "Sonnet XV" and "From a Secret Journal," both in *The Sonnets.*

24 From an unpublished manuscript entitled "A True Story" in my collection.

25 Undated entry identified only as "Tuesday," but probably from July 1963.

26 Interview with Dlugos.

BACK IN NEW YORK AGAIN

27 This work is in the Ted Berrigan archive in the Manuscript and Special Collections at Butler Library, Columbia University.

Joe LeSueur and Frank O'Hara

28 See Tony Towle's delightful *Memoir 1960-1963* for information on this and more.

29 Interview with Dlugos.

30 For a moving account of those days, see Joe LeSueur's "Joe" in *Pressed Wafer* 2, 2001, pp. 179–187.

31 From a one-page cartoon collaboration called "Gay Boy" (ca. 1965), collection of Kenward Elmslie.

32 See Reva Wolf's *Andy Warhol, Poetry, and Gossip in the 1960s* for more information on Joe's friendship with Andy.

33 My source for this anecdote is Ted Berrigan, in a conversation with Bridget Polk that she recorded on tape.

34 Letter to Jimmy Schuyler, July 5, 1964.

35 Brad Gooch, *City Poet*, pp. 430-431.

36 Unpublished manuscript in my collection.

37 From *Great Balls of Fire*.

Kenward

38 Undated letter (perhaps October 1964) to James Schuyler.

The Alan Gallery

39 Gruen and Willard's reviews were from January 9, 1965, Stuart Preston's from January 10. Incidentally, the opening proved fortuitous for John Ashbery, who in an interview said, "I met an editor in New York in an art gallery, at the opening of an exhibition by Joe Brainard. This editor was named Arthur Cohen and he worked for the Holt publishing company. He said to me, 'Oh, you're John Ashbery, what would you say to publishing a new collection?' My god, someone was interested in my poetry! And so I put together a new collection, *Rivers and Mountains*. ..." (Interview with Olivier Brossard in *Oeil de boeuf* no. 22, December 2001, p. 11, published in French and here translated by me.)

The Umbrellas of Cherbourg Apartment

40 Joe, letter (undated, early 1965) to Jimmy Schuyler.

Westhampton Beach

41 F. W. Murnau's *Nosferatu* (1922), in which Ruth played the role of Lucy.

Tulsa Again

42 From "Tone Arm" in my *New & Selected Poems*.

Europe

43 According to Bill Berkson, the American contingent, except for Pound and Allen Tate, had been selected by Frank O'Hara.

44 Undated letter written on the train from Spoleto to Rome, probably July 3 or 4, 1965.

45 Letter to Pat and me, postmarked July 1, 1965.

46 Postcard to Pat and me, postmark illegible.

47 Letter postmarked August 9, 1965.

48 Letter, April 1968.

Between Paris and Avenue B

49 For one party Kenward's invitation list included Larry and Clarice Rivers, Joe Hazan and Jane Freilicher, John Gruen and Jane Wilson, Frank O'Hara, Kenneth and Janice Koch, Frank and Sheila Lima, Edwin Denby, Alex and Ada Katz, Joe LeSueur, Ned Rorem and Joe Adamiak, Barbara Guest, Donald Droll and Roy Leaf, Arthur Gold and Robert Fizdale, Panna Grady, Mike Goldberg, J. J. Mitchell, Alvin Novak, Chuck Turner, Jimmy Schuyler, Rose Slivka, J. M. Edelstein, John Button and Scott Burton, Andy Warhol, Ellen and David Oppenheim, Barbara Harris and Arnold Weinstein, Diane Wakoski, Barbara Rose, John and D. D. Ryan, Bill Berkson, Morris Golde, and Robert Dash.

50 Undated letter, but very likely October 1965.

51 It's possible that this work drew part of its inspiration from the show that had preceded Joe's first exhibition at Alan, called "Ten Centuries of Japanese Folk Art."

52 The four reviews did not appear in *Kulchur*. They have never turned up.

53 Letter postmarked January 10, 1966.

54 At that time neither Joe nor I was aware of Jess's similar procedure using *Dick Tracy* comics.

55 Letter begun February 18 and finished February 28, 1966.

56 I couldn't help but think of Joe's diagram when I saw Kazimir Malevich's painting *Plane in Rotation,* called *Black Circle* (1915), in which a black circle is positioned "off" against a white background in such a way as to make the positioning everything.

57 Letter of April 8, 1966.

58 Interview with Dlugos.

59 When Pat and I were greeted by my mother and stepfather at the dock in New York, we had exactly twenty-five cents left. My mother loaned us some money.

The Death of Frank O'Hara

60 Joe wrote to Jimmy, "At night Pat and I sew up a storm."

61 Undated postcard.

62 Charles Whitman's killing spree took place on August 1, 1966.

63 Letter, probably in March of 1967.

Starting Over

64 *ARTnews* Annual 32, 1967.

Denmark in Providence

65 We immediately distributed copies to Ted, Kenward, Dick, Tony Towle, Larry Bensky, Arthur Cohen, Aram Saroyan, James Laughlin, Donald Droll, Roy Leaf, Joe Hazan and Jane Freilicher, Philip Whalen, John Myers, Nell Blaine, Lorenz Gude, Joe Ceravolo, Man Ray, Jimmy Schuyler, Lauren Owen, Anne Waldman, Lewis Warsh, Frank Lima, Tom Veitch, Paul Taylor, Lita Hornick, Marguerita Russo, David Shapiro, Lee Harwood, Michael Brownstein, Edwin Denby, F. W. Dupee, Laura and Phillip Mathews, Charles Alan, John Perreault, Robin Owen, Fairfield and Anne Porter, Clark Coolidge, Jim Brodey, Johnny Stanton, Barbara Guest, Tom Raworth, Jean Tinguely, Niki de Saint-Phalle, Michael McClure, Glenn Godsey, William Saroyan,

Lorenzo Thomas, Jim Dine, Maxine Groffsky, Harry Mathews, George and Katie Schneeman, Renée Neu, Andy Warhol, Gerard Malanga, Peter and Linda Schjeldahl, Bill Berkson, Lee Crabtree, Lewis Meyer, Marcel Duchamp, Alex and Ada Katz, John Ashbery, Don Bachardy, Lewis MacAdams, D. D. Ryan, Stanley Kunitz, Kenneth Koch, Jasper Johns, Jackie Monnier, Tessie Mitchell, Jack Larson, Jim Bridges, Bill Dorr, Ella Rengers, Kynaston McShine, Barbara Harris, Leo Lerman, David and Ellen Oppenheim, Robert Dash, Arthur Gold, Robert Fizdale, John Gruen, and Jane Wilson.

Southampton and Vermont

66 Letter to Anne and Fairfield Porter, June 9, 1967.

67 Letter to Fairfield Porter, August 29, 1967.

68 Letter to Bill Berkson, summer 1967.

Jamaica

69 Joe's complete diary for this trip, titled "Jamaica 1968," is in his *Selected Writings*.

70 Undated letter to Jimmy Schuyler.

71 Later published as *The Adventures of Mr. & Mrs. Jim & Ron*.

72 Letter to Jimmy Schuyler, mid- to late July 1968.

The Unfinished Clause

73 *Art International* 13, May 1969.

74 *ARTnews* 68, May 1969.

75 This is in the "New Plant" segment of "Nothing to Write Home About" in Joe's 1981 book of the same name.

76 The Wednesday, May 21 entry in "Diary 1969" in *Selected Writings*. In it Joe also confesses to writing it so that he could have more new things to read that night at the St. Mark's Poetry Project.

77 From an unpublished diary dated Sunday, June 1 [1969].

78 The manuscript mentioned in item 6, which he planned on calling *Self-Portrait*, was eventually published by Hornick's Kulchur Press as *Selected Writings*.

79 Both quotations are excerpts from an unpublished diary.

80 Letter to James Schuyler, from Calais, ca. June 25, 1969.

81 Diary entry for July 29.

82 In his later years, Joe melted when he saw elderly couples walking together and holding hands, and he was always concerned with how old people are treated.

83 Unpublished entry dated July 29, 1969.

84 Joe mistakenly dated these two July 31 entries as August 1.

WRITING "I REMEMBER"

85 Interview with Dlugos.

86 Letter, October 7, 1969.

87 From "Diary 1969" in *Selected Writings*.

88 This sense of Vermont as a safe rustic haven was reinforced by the terrible events that happened elsewhere seemingly every summer: the riots in Watts (1965), the Austin sniper (1966), the riots in Newark and Detroit (1967), the assassination of Robert Kennedy (1968), the confrontations in Chicago at the Democratic National Convention (1968), the riots in Harlem and student clashes with police at Columbia and elsewhere (1968), the murder of Sharon Tate and six others (1971), and others, all enveloped in the hideous Vietnam War.

WAITING

89 Published in *The World*, no. 17, November 1969.

90 Journal entry for October 31, 1969. In volume 5 of Ted's journals housed in the Manuscript and Special Collections at Butler Library, Columbia University.

664 SIXTH AVENUE

91 Letter postmarked November 14, 1969.

92 From *Selected Writings*, p. 63.

93 Letter, April 8, 1970.

94 The poem, "Listening to Joe Read," appeared in my book *You Never Know:* "I'm reminded that what made him great / was not that he was a great reader (he wasn't) / but that he was Joe: 'History.

/ What with history piling up so fast, / almost every day is the anniversary / of something awful.' Was Ted / in the audience at the Ear Inn / in 1983? I think I hear his chortle. / Joe's voice in my ear and his ashes / up in the meadow now dark, it's night. / I have plenty of time to say all this, / as long as Joe has time on this tape to read / as many times as I want to play it, / as if he's here, as of course he is, / inside this little brain, / its wheels turning round and round "

95 This excerpt and the several that follow are from the April 8, 1970, letter to me.

96 E-mail to me, March 5, 2002.

97 Letter to Bill Berkson, from Calais, July 1970.

98 Letter to Bill Berkson, from Calais, probably July or August of 1970.

99 Joe dated the work 1971 and it was published in 1971, but the only time that it could have been done was in June of 1970, though I don't recall visiting Vermont before going to London. One of Joe's letters, written most likely in 1970, talks about doing the collaboration.

100 Letter, probably August 1970. Joe published *Sufferin' Succotash* as half of a back-to-back volume, joined with *Kiss My Ass,* his comic collaboration with Michael Brownstein. Subsequently both *Sufferin' Succotash* and *The Origins and History of Consciousness* were published in my book *Tulsa Kid.*

The Cut-Outs

101 Letter to Jimmy Schuyler, probably June or July, 1969.

102 Letter to Bill Berkson, probably written in New York City in the fall of 1970.

103 Letter to Bill Berkson, from New York City, probably September or October of 1970.

104 Letter to Bill Berkson, from New York City, postmarked September 15, 1970.

105 From New York City, postmarked October 12, 1970.

106 Letter to Bill Berkson, from New York City, a few days before October 28, 1970.

107 Letter to Bill Berkson, from New York City, postmarked December 1970.

108 Letter to Bill Berkson, postmarked December 1970.

109 In *Selected Writings*.

LOOKING AT PICTURES

110 Interview with Dlugos.

111 *Tulsa Sunday World*, January 31, 1971, "Serious Artist; Non-Serious Art" by John English.

112 Letter to Bill Berkson, from New York City, written very late December 1970 but postmarked January 3, 1971.

113 "Some Train Notes" in *Selected Writings*.

THE FISCHBACH GALLERY

114 *Art International* 15, October 1971.

115 John Gruen, in *New York* magazine, May 24, 1971.

116 Letter to Bill Berkson, from New York City, postmarked April 20, 1971.

BACK EAST

117 Letter, July 20, 1971.

118 Letter to Bill Berkson, from Calais, late July or early August 1971.

119 Letter, July 20, 1971.

120 Letter postmarked July 28, 1971.

121 Letter postmarked July 31, 1971.

122 From *Gegenshein Quarterly*, 1975.

123 Excerpts from Joe's "From Women's Household July 1971."

124 Letter to Bill Berkson, from Calais, August 12, 1971.

125 Letter postmarked August 18, 1971.

126 In my Afterword that appeared in both the Penguin and Granary Books editions of *I Remember*, I quoted Joe's remarks to Lewis Warsh and Tom Clark, but I cannot now locate my research notes that had the exact dates of those letters of the summer of 1971.

127 Letter to Bill Berkson, from New York City, postmarked December 7, 1971.

128 "Tuesday, December 28, 1971" in *New Work,* pp. 42–47.

129 "Tuesday, December 30th, 1971" in "Selections from N.Y.C. Journals 1971 & 1972" in *New Work.*

130 In a piece published in 1975 in *Gegenshein Quarterly,* Joe mistakenly referred to the University of Pennsylvania as Penn State.

131 Letter from Neal Welliver to me, 2002.

132 Letter to Bill Berkson, from New York City, probably early to mid-March 1972.

133 The only other mention I have been able to find is in a letter to Keith McDermott, postmarked June 26, probably 1985: "I've slept with girls. I've slept with strangers. But I've never slept with a girl stranger before." Keith remembers the occasion of these remarks and is certain that "slept with" here is literal, with no sexual connotation.

ALL THERE: THE SECOND SHOW AT FISCHBACH

134 *ARTnews* 71, April 1972.

135 Joe gave this paragraph the title "Sunday, April 2nd, 1972" and printed it as an entry in the "Selections from N.Y.C. Journals 1971 & 1972" section of *New Work.*

136 In *New Work,* p. 62.

137 Unpublished manuscript.

138 "Four O'Clock" section from "Self Portrait: 1971" in *New Work.*

139 I have forgotten where I found this list.

140 *New Work,* p. 67.

141 Published in *Z* no. 1, 1973.

IMAGINARY STILL LIFES

142 *Imaginary Still Lifes* was published in several stages in magazines, but the most definitive version was as a booklet called *Ten Imaginary Still Lifes,* published by Boke Press in 1997.

143 In a letter to Bill Berkson, from New York City, postmarked January 6, 1973.

144 June 1979.

145 August 1979.

Sicilian Interlude

146 From Calais, postmarked May 24, 1973.

147 E-mail, March 11, 2002.

Style

148 In *Stooge* no. 9, late 1973, no p. nos.

149 Letter, September 1–2, 1973. Eventually Joe decided that this new material did not merit a separate volume.

150 As he said in a letter of June 5, 1973, to Anne Waldman: "It's all my own fault really: won't play the 'project' game in the application." This may have not been the only reason for the rejection. I once heard that all applications for Merrill grants had to get past John Meyers, at that time the director of the Tibor de Nagy Gallery and the secretary of the Merrill Foundation, who once said, "I think Joe Brainard is a dear boy but I don't see what people see in his work."

151 *Pressed Wafer* 2, p. 173.

152 Letter written ca. July 9, 1973.

153 Letter to Bill Berkson, summer 1973.

154 Letter to Bill Berkson, from Calais, postmarked (probably late) August 1973.

155 Letter to Bill Berkson, no date.

156 Letter to Bill Berkson, postmarked October 3, 1973, but written some days earlier.

157 Undated letter.

The Show of Oils

158 Many years later the portrait resurfaced bearing a face painted by an unknown hand.

159 *Art in America* 62, May/June 1974.

160 *New York* magazine, April 29, 1974.

161 Artist John Moore recalled Joe's visit to the Tyler School of Art: "I met him at Fischbach. We were both showing there at the time. I really liked his work and the *I Remember* books. I had read parts of them outloud in a painting class I was teaching, and I think I mentioned that to him when we first met. I was teaching at the Tyler School of Art in Philadelphia at the time, and invited him to come down to Tyler as a visiting artist. When I picked him up at the North Philadelphia train station, he was very nervous, and not making eye contact. The train station was about a 20-minute drive from the Tyler campus, and he was chain smoking and stuttering in my car while we were making painful attempts at conversation. I kept thinking that his talk was going to be a disaster, and I would never again be asked to suggest a visiting artist. When we got to Tyler, he went straight into the men's room and I went into the studio to make sure chairs were set up, the microphone was working, the projector was in place, etc. The room was pretty full. He came in (although it was more like he just suddenly appeared) and I showed him how to turn off the lights and run the projector. He took his place in back of the podium. When the room got quiet, he began to read and it was a total transformation. His voice was strong and clear, there was no stuttering or hesitation and I could hardly believe it was the same person. He read for about 20 minutes and then showed a tray of slides, mainly Nancy pieces. The students loved him, but the shyness began to return when they came up to him after his talk. I drove him back to the station and it was a bit more comfortable than on the way up." (E-mail to me, February 28, 2003.)

162 The venues were Ruth Kligman's loft on West Fourteenth Street, the Rothko Chapel in Houston, and Barnard College.

163 New York City, postmarked May 21, 1974.

164 Letter to Bill Berkson, from New York City, postmarked May 28, 1974.

165 Letter to Bill Berkson, from Calais, postmarked July 3, 1974.

166 Letter, late September or early October 1974.

167 Writing to Keith McDermott in July of 1982, Joe mentioned that his teaching was to begin on October 12. And in another letter (undated, though because of a reference to Edwin Denby it could easily be 1983), Joe wrote to Keith: "Did I tell you that—due to

popular demand—(ah gee shucks)—I've been invited back to teach this year?" The teaching involved going to Philadelphia once a week, most likely to the University of Pennsylvania, where he had taught ten years before. According to Keith, Joe grew to enjoy this experience, but after two years he felt that it was time to do something else.

8 Greene Street

168 Letter to Bill Berkson, from New York City, postmarked November 14, 1974.

The Big Show of Little Things

169 Full Court Press consisted of Joan Simon, Anne Waldman, and me.

170 *New York Times,* January 4, 1976, p. 27. I have inserted an ellipsis in this quotation to indicate a few words that I deleted because they are probably typographical errors in the original.

171 From "Think Tiny, Says Joe Brainard—And a Show of 1,000 Miniatures is the Result." *People,* Vol. 4, No. 25, December 22, 1975.

172 Letter postmarked December 26, 1975.

173 In an interview with Anne Waldman, published in *Rocky Ledge* 3, November/December 1979.

The Speed Crisis

174 From an unpublished piece called "Today," dated 1970 by Joe.

175 Interview with Dlugos.

Out-to-Lunch-ness

176 February 8, 1976.

177 *Poetry,* Vol. 129, December 1976 issue.

178 Because he felt that he didn't have a viable new manuscript, Joe didn't follow up immediately on Galassi's invitation. Off and on he kept fiddling with the manuscript, but eventually the material seemed old to him, and in August of 1980 he abandoned the project.

179 Since the early 1970s, many writers and artists have been inspired to create their own variations on *I Remember,* among them Ted Berrigan, Kenward Elmslie, Ray Johnson, Harry Mathews, Anthony Rudolf,

Anne Waldman, and me. Juan Antonio choreographed a piece in which the dancers recited passages from Joe's book, mixed with their own memories, as they danced. French writer Georges Perec's volume *Je me souviens*, a French parallel to *I Remember*, is dedicated to Joe. Subsequent to that, Marie Chaix translated *I Remember* into French.

O.K. Shape: 1977

180 August 10, 1977.

Softer and Quieter: 1978

181 The flower poster, *Blossom*, was followed about a year later by the second one, *Stay Ahead of the Game*, which looked like an imaginary game board.

The Person I Always Thought I Was

182 The New York Academy of Art has no enrollment records from that period.

183 From "Oh My Gosh!" in *Nothing to Write Home About*, pp. 47-48.

Keith

184 "Sometimes" from "Vermont Journal 1971," a selection of which appeared in *Sesheta* 2, spring 1972. I don't think Joe ever republished the "Sometimes" portion.

185 Letter, October 26, 1979.

186 The Seattle premiere date was June 12, 1980. The New York City production at Lincoln Center on March 14, 1991, used only the curtain design, which was gorgeous.

187 See Keith's account of his life with Joe, "Homage to Joe," in *Loss within Loss*, edited by Edmund White.

188 Letter to Anne Waldman, November 7, 1979.

189 "Lovewise" was recorded by Nat "King" Cole and others.

I'd Like to Look like James Dean

190 *New York Times*, December 20, 1975.

191 Letter to Bill Berkson, from Calais, late July or early August 1971.

The Long Beach Exhibition

192 Letter postmarked May 15, 1981.

193 Letter to Keith McDermott, October 19, 1981.

194 Letter to Michael Brownstein, August 21.

195 Undated letter to Keith McDermott.

Midlife

196 Undated letter, probably ca. 1970-72.

197 Letter to Bill Berkson, from New York City, postmarked March 27, 1983.

198 Undated letter, but in the postscript Joe added: "Another phone call, another death! Edwin Denby, this time. Committed suicide last night with sleeping pills." Edwin died on July 12, 1983.

1985

199 Letter to Bill Berkson, August 1988.

200 June 26, 1985. (The postmark is blurred, but 1985 is likely.)

201 July 29, 1985.

The Diminutive

202 Letter to Fairfield Porter, summer (perhaps August) 1973.

203 Possibly ca. 1966 or 1967.

1986

204 Letter to Keith McDermott, postmarked June 26, 1986.

205 Letter to Keith McDermott, postmarked July 2, 1986.

Private Lessons

206 Letter to James Schuyler, August 3, 1969.

A Real Nice Life

207 Letter to Bill Berkson, from New York City, January 30, 1989.

208 *Serenade* was finally published in 2000 by Zoland Books.

209 Letter to Bill Berkson, from Calais, August, possibly 1990.

210 Undated letter, but certainly August 1990.

VENICE

211 Enclosed in a letter written in middle or late August 1991 to Bill Berkson.

212 Letter to James Schuyler, from Calais, July 3, 1970.

GLAD TO BE 51

213 Letter to Bill Berkson, from New York City, probably April or May 1993.

214 "Three days ago I dove into the lake with all my clothes on to save a six-year-old boy from drowning. How I swam back to shore with one arm, I really don't know. But I did. And am awfully proud of myself. (Another fantasy fulfilled!) And the event has greatly restored my faith in acting impulsively and instinctively, for which I am grateful." Letter to Keith McDermott, postmarked August 12, 1983.

METAPHYSICS

215 A longer version, entitled "Death," was published in *Selected Writings*. I haven't been able to locate the source of this shorter version.

SUMMER 1993

216 Letter to Bill Berkson, from Calais, postmarked August 1993.

"SAINT JOE"

217 *Art in America* 85, July 1997.

218 *Artforum* Vol. 39, No. 6, February 2001.

219 "Worst Seat in the House," in *Pressed Wafer* 2, March 2001, p. 121.

220 However, Joe LeSueur's book, *Digressions on Some Poems by Frank O'Hara*, offers other insights into Joe.

221 The manuscript for these unpublished interviews is in the Anne Waldman Archive in the special collections of the Harlan Hatcher Graduate Library at the University of Michigan.

222 Letter, August 13, 1968. Quoted in *Pressed Wafer* 2, p. 116.

223 Letter of July 1965 to James Schuyler, quoted in Schuyler's article "Joe Brainard: Notes and Quotes," in *ArtNews,* April 1967 issue.

224 In a panel discussion at the New York Studio School, January 18, 1999.

Bibliography

Ashbery, John. "Joe Brainard" in *Joe Brainard: A Retrospective*. New York: Tibor de Nagy Gallery, 1997. This catalog also includes an essay by Robert Rosenblum.

Ashbery, John, and Joe Brainard. *The Vermont Notebook*. Los Angeles: Black Sparrow Press, 1975. New edition, New York: Granary Books, 2002.

Brainard, Joe. *The Banana Book*. New York: Siamese Banana Press, 1972.

———. *Bolinas Journal*. Bolinas, Calif.: Big Sky, 1971.

———. *The Cigarette Book*. New York: Siamese Banana Press, 1972.

———. *The Friendly Way*. New York: Siamese Banana Press, 1972.

———. *I Remember*. New York: Angel Hair, 1970. First part of the complete, later book of the same title.

———. *I Remember*. First collected edition. New York: Full Court Press, 1975. Two additional collected editions. New York: Penguin, 1995. New York: Granary Books, 2001.

———. *I Remember Christmas*. New York: Museum of Modern Art, 1973.

———. *More I Remember*. New York: Angel Hair, 1972.

———. *More I Remember More*. New York: Angel Hair, 1973.

———. *The Nancy Book*. Los Angeles: Siglio Press, 2008.

———. *New Work*. Santa Barbara, Calif.: Black Sparrow, 1973.

———. *Nothing to Write Home About*. Los Angeles: Little Caesar, 1981.

———. *Paintings*. New York: American Art Catalogues, 2021.

———. *Selected Writings*. New York: Kulchur, 1971.

———. *Some Drawings of Some Notes to Myself*. New York: Siamese Banana Press, 1971.

———. *Ten Imaginary Still Lifes*. New York: Boke Press, 1995.

———. *12 Postcards*. Calais, Vt.: Z Press, 1975.

————. *24 Pictures & Some Words.* Hemet, Calif.: BLT, 1980.

————. *29 Mini-Essays.* Calais, Vt.: Z Press, 1978.

Dlugos, Tim. "The Joe Brainard Interview." In *Little Caesar* 10, 1980. Condensed versions in *The James White Review,* Vol. 18, No. 1, Winter 2001; and in *Joe Brainard: A Retrospective,* edited by Constance M. Lewallen.

Elmslie, Kenward. *Bare Bones.* Flint, Mich.: Bamberger Books, 1995.

Ferguson, Russell. *In Memory of My Feelings: Frank O'Hara and American Art.* Los Angeles: Museum of Contemporary Art, 1999.

Gooch, Brad. *City Poet.* New York: Knopf, 1993.

James White Review, Vol. 18, No. 1, Winter 2001. A special Joe Brainard issue.

LeSueur, Joe. *Digressions on Some Poems* by Frank O'Hara. New York: Farrar, Straus and Giroux, 2003.

Lewallen, Constance. *Joe Brainard: A Retrospective.* Berkeley and New York: University of California, Berkeley Art Museum/ Granary Books, 2001. Includes essays by Lewallen and Carter Ratcliff, interviews with Joe Brainard, and excerpts from his writings.

McDermott, Keith. "Homage to Joe." In White, Edmund. *Loss within Loss.* Madison: University of Wisconsin Press, 2001.

Padgett, Ron. *Great Balls of Fire.* New York: Holt, Rinehart and Winston, 1969. Revised edition, Minneapolis: Coffee House Press, 1990.

Pressed Wafer 2, March 2001. This issue features a section devoted to Joe, edited by Elaine Equi and David Trinidad.

Shamma, Yasmine, ed. *Joe Brainard's Art.* Edinburgh: Edinburgh University Press, 2020.

Waldman, Anne. "Interview with Joe Brainard." In *Rocky Ledge* 3, November/December 1979.

Wolf, Reva. *Andy Warhol, Poetry, and Gossip in the 1960s.* Chicago: University of Chicago Press, 1997.

Yau, John. *Joe Brainard: The Art of the Personal.* New York: Rizzoli Electa, 2020.

Index

Coffee House Press began as a small letterpress operation in 1972 and has grown into an internationally renowned nonprofit publisher of literary fiction, essay, poetry, and other work that doesn't fit neatly into genre categories.

Coffee House is both a publisher and an arts organization. Through our *Books in Action* program and publications, we've become interdisciplinary collaborators and incubators for new work and audience experiences. Our vision for the future is one where a publisher is a catalyst and connector.

LITERATURE
is not the same thing as
PUBLISHING

Funder Acknowledgments

Coffee House Press is an internationally renowned independent book publisher and arts nonprofit based in Minneapolis, MN; through its literary publications and *Books in Action* program, Coffee House acts as a catalyst and connector—between authors and readers, ideas and resources, creativity and community, inspiration and action.

Coffee House Press books are made possible through the generous support of grants and donations from corporations, state and federal grant programs, family foundations, and the many individuals who believe in the transformational power of literature. This activity is made possible by the voters of Minnesota through a Minnesota State Arts Board Operating Support grant, thanks to the legislative appropriation from the Arts and Cultural Heritage Fund. Coffee House also receives major operating support from the Amazon Literary Partnership, Jerome Foundation, Literary Arts Emergency Fund, McKnight Foundation, and the National Endowment for the Arts (NEA). To find out more about how NEA grants impact individuals and communities, visit www.arts.gov.

Coffee House Press receives additional support from Bookmobile; Dorsey & Whitney LLP; Elmer L. & Eleanor J. Andersen Foundation; the Gaea Foundation; the Matching Grant Program Fund of the Minneapolis Foundation; Mr. Pancks' Fund in memory of Graham Kimpton; the Schwab Charitable Fund; and the U.S. Bank Foundation.

The Publisher's Circle of Coffee House Press

Publisher's Circle members make significant contributions to Coffee House Press's annual giving campaign. Understanding that a strong financial base is necessary for the press to meet the challenges and opportunities that arise each year, this group plays a crucial part in the success of Coffee House's mission.

Recent Publisher's Circle members include many anonymous donors, Patricia A. Beithon, Anitra Budd, Andrew Brantingham, Kelli & Dave Cloutier, Mary Ebert & Paul Stembler, Kamilah Foreman, Eva Galiber, Jocelyn Hale & Glenn Miller Charitable Fund of the Minneapolis Foundation, the Rehael Fund-Roger Hale/ Nor Hall of the Minneapolis Foundation, Randy Hartten & Ron Lotz, Dylan Hicks & Nina Hale, William Hardacker, Kenneth & Susan Kahn, the Kenneth Koch Literary Estate, Cinda Kornblum, Jennifer Kwon Dobbs & Stefan Liess, the Lenfestey Family Foundation, Rebecca Rand, Sarah Lutman & Rob Rudolph, the Carol & Aaron Mack Charitable Fund of the Minneapolis Foundation, Gillian McCain, Mary & Malcolm McDermid, Robin Chemers Neustein, Daniel N. Smith III & Maureen Millea Smith, Enrique & Jennifer Olivarez, Robin Preble, Nan G. Swid, Grant Wood, and Margaret Wurtele.

For more information about the Publisher's Circle and other ways
to support Coffee House Press books, authors, and activities,
please visit www.coffeehousepress.org/pages/donate
or contact us at info@coffeehousepress.org.

Printed in the USA
CPSIA information can be obtained
at www.ICGtesting.com
JSHW012047140824
68134JS00035B/3311